D1443875

New Urban Housing

Published in North America by
Yale University Press
P.O. Box 209040
New Haven, CT 06520-9040
USA
www.yalebooks.com

First published in Great Britain in
2006 by Laurence King Publishing
Ltd, London

Text © Hilary French 2006
This book was designed and
produced by Laurence King
Publishing Ltd

All rights reserved. No part of this
publication may be reproduced or
transmitted in any form or by any
means, electronic or mechanical,
including photocopy, recording or
any information retrieval system,
without permission in writing
from the publisher.

Library of Congress Control
Number: 2006923988

ISBN: 0-300-11578-4

Printed in China

For Jessie

Hilary French

New Urban Housing

WITHDRAWN

CONTRA COSTA COUNTY LIBRARY

3 1901 04122 4116

Yale University Press

Contents

6

Introduction

1 *Une Cité Industrielle: étude pour la construction des villes*, plate 2, 1917, by Toni Garnier.

If there is to be an urban renaissance, we need ideas and proposals about the city for public debate, landmark statements that will influence the future of our cities.
Lord Rogers of Riverside, 'Visions of the Future', in *Living in the City: An Urban Renaissance*, 2000.

This proclamation comes from the introduction to a publication accompanying the international competition Living in the City – one of many recent competitions, conferences and debates that have reawakened the interest of the public and of architects alike in the design of high-density housing within the context of the contemporary city. Architects have long been involved in the design of one-off houses, carefully crafted signature works for wealthy individual clients, but the design of multiple housing has only intermittently engaged their attention. In the early twenty-first century, the new interest and motivation to find alternatives to outmoded and unsustainable conventional models for housing is attributed to a whole range of factors – changing demographics, changing work patterns, increased life expectancy, and technological innovations that have resulted in constant connectivity.

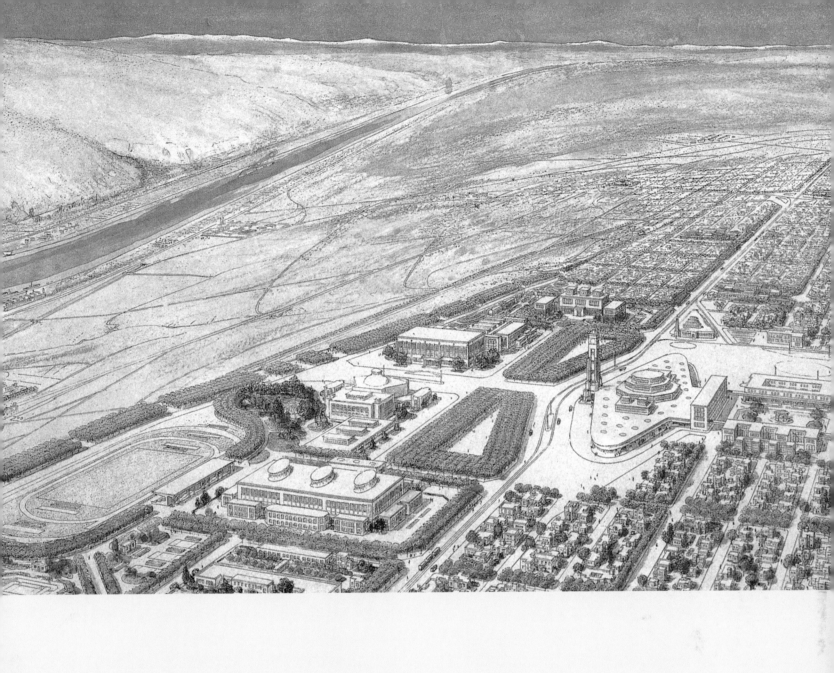

which might specify improved construction, sanitary engineering and better-planned accommodation, might also add to the building costs. The provision of good quality housing at low enough rents was not seen as an architectural issue, but was just one part of a much more complex infra-structural matrix of sanitation systems, transport planning and social and financial matters that, together, form the bigger picture of urban design.

It was not only property developers who took an interest in this type of urban housing. Industrialists saw investment in property as a way to maintain a reliable workforce. Others were motivated by moral or religious incentives and formed organizations to promote improvement in workers' housing. One such organization was the Society for Improving the Condition of the Labouring Classes, founded in 1844 and based on an earlier society, The Labourer's Friend, which had existed since 1827 to support agricultural workers. The new society was intended to promote interest in urban issues. Although few were realized, its ideas, which were radical for the time, included the provision of allotments and the setting up of loan funds in order to build sustainable communities, not just to provide dwellings.

The society's first housing experiment at an urban scale was designed in 1849 by Henry Roberts. On a site in Streatham Street in Bloomsbury, central London, it is a five-storey-high block with dark brickwork and double-hung

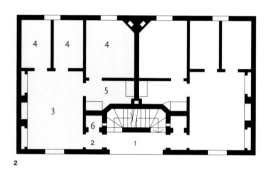

2

2 Model dwellings, London, 1851, Henry Roberts. Floor plan of a pair of flats, 1:200.

Families are separated in self-contained flats with unoccupiable minimal circulation space between them.

1. circulation
2. entrance lobby
3. living room
4. bedroom
5. scullery
6. WC

3 Model houses for families, Streatham Street, London, 1849, Henry Roberts. An early urban housing experiment providing self-contained flats.

Historically, the design of urban housing, by its nature complex, and in particular the apartment block, has been associated with housing the poor. Any detailed study of housing design must take into account socio-economic issues, which are of crucial importance during the design and construction phases. Over time, however, such issues become less relevant as funding mechanisms, subsidy programmes and political systems change. As an introduction to a series of recent examples that have made a contribution to different aspects of the design of housing, this essay will attempt to take a broad look at the relatively short history of the apartment block and associated ideas for the architecture of urban housing.

The early years

As a result of rapid industrialization and dramatic rise in population, London in the early nineteenth century had significant problems caused by lack of adequate housing. The working classes lived in cramped and over-crowded conditions in poorly constructed buildings, starved of adequate light and air, and with little or no sanitation. Wealthier families moved out towards the edges of the growing city, but this choice was not available to all. Put simply, the solution to the problem of insufficient housing was to build more and at higher densities. Typical terraced streets had long been built by property speculators and building companies, generally repeating known patterns or variations from typical plans. Similarly, in the early days of building tenements and apartment blocks, architects were rarely involved. Land prices were high and for developers looking to make a good return on their investment, engaging an architect was costly – their designs,

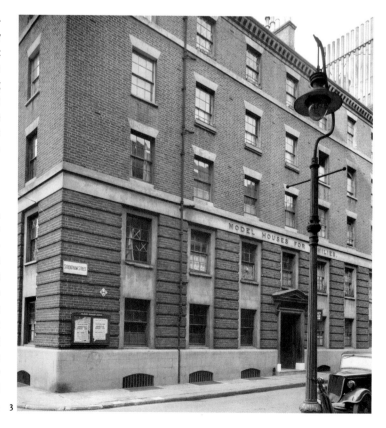

3

sash windows. The U-shaped plan follows the street edge and encloses a rear courtyard with a shared staircase and open-access balconies. Most importantly, these apartments were self-contained units and considered to be a great improvement on shared houses and many other schemes that provided only dormitories or single rooms. A range was fitted in the living-room hearth for cooking and each apartment had two bedrooms, a lavatory and a scullery.

Prince Albert supported the work of the Society and brought its ideas to a wider audience. Model dwellings were constructed for the Great Exhibition of 1851 that further developed the designs of the Streatham Street apartments. Each apartment is larger and includes a third bedroom to provide separate sleeping arrangements for children of different sexes. As well as ensuring that all rooms received adequate natural ventilation, an internal ventilation system was installed. Again, open stairs provided access, this time at the front of the buildings. Presented as a pair and only two storeys high, the model dwellings are sometimes described as cottages, but these were also seen as prototypes for multi-storey buildings.

From these earliest experiments in urban housing, two distinct urban design approaches were apparent. The work of Henry Roberts and the Society for Improving the Condition of the Labouring Classes developed

In France, likewise, affordable housing for the poor presented a problem, despite an already established pattern of living in apartment buildings and mixed-use buildings, although according to one observer: 'Problems of housing associated with congestion and centralizing populations didn't present the same pressing problems in large towns in France as in England.'[2] Also as in England, provision for this type of housing came via private and philanthropic efforts until the formation of the Société Française des Habitations à Bon Marché, following the Paris Exhibition of 1889. Its 23 detailed resolutions demonstrate a similar concern with the link between adequate housing and health and moral welfare. It included a minimum number of rooms to ensure separation of the sexes, and plans were designed so as 'to avoid the possibility of the families meeting'.[3] The construction regulations set out what still seem generous dimensions; for example for ground-floor ceiling heights a minimum of 2.8 metres (9 feet 2 inches) and, for the familiar French windows, a maximum of 30 centimetres (12 inches) from floor *and* ceiling. In Paris, Haussmann's restructuring (1853–82), which overlaid the existing street patterns with long, straight avenues and boulevards, meant that the elevations were the starting point. Behind these all-important façades, building plots were rigorously perpendicular to the street, resulting in trapezoid and triangular plots. Examples of

4–5 First class apartments for rent, 125 boulevard des Champs Elysèes, Paris, 1864, Paul-Frédéric Levicomte architecte.

Plan of upper floor (4), 1:500. Corridors are avoided and rooms interconnect in the typical French manner.

Plan of ground floor (5), 1:500. The concierge's lodge surveys the coachway and main entrance hall.

1. coachway
2. vestibules
3. main stair
4. concierge
5. main courtyard
6. lightwells
7. storage

8. stables
9. service stairs
10. petit salon
11. grand salon
12. dining room
13. bedroom
14. kitchen

complex schemes that combined internal plans to meet family living requirements with external plans that took into account the street and access arrangements. The designers of the Peabody Trust, a housing association founded in 1862 by American philanthropist George Peabody, adopted a more assertive and paternalistic position. Pre-existing street patterns were ignored, with buildings usually sitting in their own grounds, isolated from their surroundings, and enclosed by railings that were locked at night and supervised by resident superintendents or caretakers. Their tenements did not 'separate' the residents in self-contained flats, but, typically, had shared sculleries and lavatories so that they could more easily be kept clean and maintained in good order.

Despite different approaches, the shared intention was to embrace the nature of apartment living by demonstrating that it was possible for apartment buildings at high densities to be acceptable. Good design would provide improved accommodation that was well planned, adequately ventilated and sanitary. In contrast to the simultaneous development of architectural ideas for the suburbs, which were sowing the seeds of the Garden City Movement, these projects demonstrated a commitment to improving the urban environment. In an address to the Institute of British Architects in December 1866, Robert Kerr referred to 'suburban villages' as merely raising 'the question of ground rent versus railway fares'. He encouraged architects to take a more active role in urban housing design, despite the lack of financial incentive, because 'the public have a right to expect that even the most distinguished architects should give their best attention, for the general good, to a question of so much social importance.'[1]

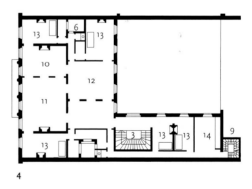

4

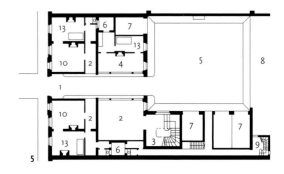

5

ideal plans, drawn up by César Daly[4], show the typical elements of French planning, particularly in their interconnected rooms.

On the other side of the Atlantic in the early nineteenth century, housing arrangements in New York were similar to other ports such as London or those in Holland. Artisans and small commercial concerns occupied individual buildings of a size that accommodated their business activities, housed their family, apprentices and servants. As areas became more densely populated, noisy and grimy, the wealthier aspired to building their own houses, separating work from their leisure and domestic environment. Decade by decade they moved further northwards, building on the empty lots away from the dock areas in the south of Manhattan island. The houses they abandoned were subdivided and let to poorer and new immigrants. Developers built row houses not unlike the terraces in London, which could be let to more than one family either as tenement buildings or lodging houses for the poorer classes. In Manhattan, particularly, the pressure of population growth and demand for land pushed up prices. For the emerging middle classes, who were not prepared to raise their families in the tenements but who could not afford row houses, the only option was to move out to the suburbs. The alternative was to be a new type of purpose-built apartment block.

Although wealthier families still aspired to live in a house, the typical New York row house was often not the most comfortable. Improving it and providing more living space was difficult within the confines of a typical building plot.[5] Social convention dictated that the ground floor be used for entertaining, but, with the parlour located next to the entrance hall, it was often very narrow. As with any row house, additional depth reduced the natural light, which came only the street front and from back yards and light wells. Servants who worked in the basement and lived in the attic already spent a great deal of time on staircases, so adding further storeys would just exacerbate this problem. Apartments seemed to be the answer. However, as tenements or houses in multiple occupation were associated with the poor, it was difficult to persuade the wealthier classes that apartments could be an acceptable option.

Architects and developers looked to France for inspiration. As well as a culture of living in apartment buildings, French cities – especially Paris – offered a model of city life that was dense and mixed. Richard Morris Hunt, the architect for what is generally considered to be New York's first apartment building aimed at the middle classes, had grown up in Paris and studied at the Ecole des Beaux-Arts. The apartment building he designed, the Stuyvesant on East 18th Street, was built in 1869. There were four apartments per floor,

6–7 The Stuyvesant, East 18th Street, New York, 1869 (demolished 1957), Richard Morris Hunt.

Plan of two flats (7), 1:500. Significant as New York's

first flats to be designed for wealthier residents, they include accommodation and separate circulation for servants.

1. main stair hall

2. back stair hall
3. private hall
4. parlour
5. dining room
6. chamber
7. servant's room
8. kitchen

8 Subsidized Housing, Marnixstraat, Amsterdam, 1877.

Plan of two pairs of flats, 1:200. Back-to-back dwellings with 'cupboard' beds were built until the housing act of 1902 raised standards for space and ventilation.

1. main stair
2. living space
3. cupboard bed
4. kitchen
5. WC

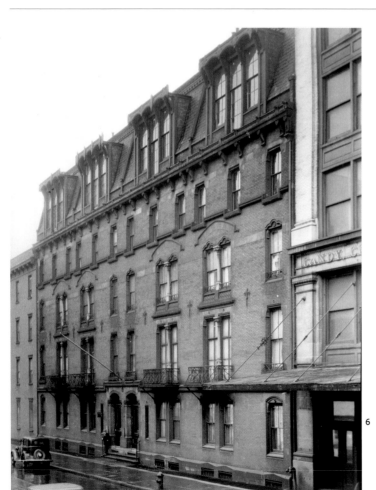

6

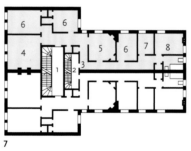

7

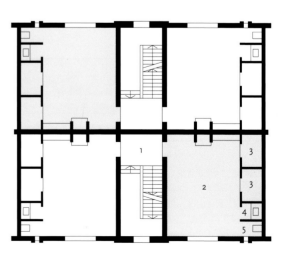

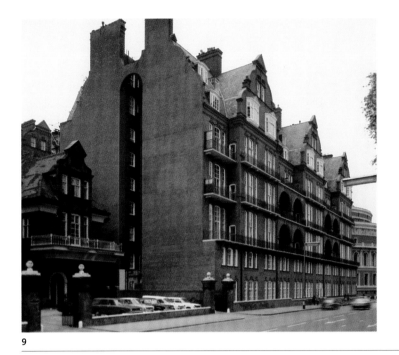

9

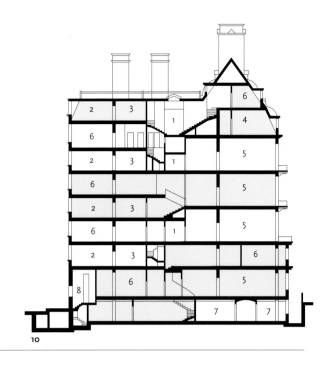

10

9–10 Albert Hall Mansions, Kensington Gore, London, 1879, Richard Norman Shaw.

Living rooms with higher ceilings overlook the street and the park opposite (9).

Split levels and lower ceilings increase the number of storeys at the back of the block.

Section looking west of block on Kensington Gore (10), 1:500.

1. entrance/passage
2. kitchen
3. pantry

4. sitting room
5. dining room
6. bedroom
7. spare room
8. porter

organized as two identical pairs around two entrances and light wells. Reports including the financial success of this and similar projects were regularly published in *Real Estate Record*. High return on investment meant that it was only a few years before developers were convinced that the apartment block was an acceptable model.

The new apartment buildings, established as a type in 1875[6], were referred to as 'French flats' to define their self-contained nature and to distinguish them from multi-family houses and tenements. Despite the enthusiasm of developers, the new models were not immediately acceptable to prospective tenants. Compared to the American way of life, the French way – involving sitting outside cafés – was much more public and under the watchful eyes of the concierge. In an apartment with all rooms on the same level, the separation of the private spaces of the bedrooms from the more public spaces where guests might be invited was more difficult to achieve. The distinctive French planning with rooms communicating directly with each other further offended American notions of privacy. There was also a resistance to living rooms overlooking anywhere but the street, and to 'living above the shop' that discouraged the inclusion of commercial and retail spaces at street level.

The early versions of 'French flats' were five or six storeys in height and followed the same single-plot dimensions as the row houses. Other than a few well-proportioned and well-lit public rooms on the street façade, they often had only small dark rooms deep into the plan, minimal dank light shafts and long, dingy corridors. As developers gained confidence, they saw the advantage of multiple lots and embarked on more ambitious schemes for ever-bigger apartment buildings. The Vancorlear on 7th Avenue,

designed by Henry Janeway Hardenbergh in 1880, was one of the earliest to occupy the whole block – a form that soon became common. In comparison to the drawbacks of row houses, in particular lack of adequate daylight, the new large apartment blocks with courtyards could offer wealthier tenants much more space and light, and as they were built higher, too, more spectacular views. The roof, initially just a place for water tanks and elevator motor rooms, in time became part of the sought-after penthouse apartment as a roof garden or terrace.

As a new building type, the apartment block had no stylistic or formal precedent. Functionally, the closest to it in type was the hotel building. In some of the new blocks the focus on creating well-designed public spaces, including entrance halls and dining rooms, suggest that hotels were used as models. 'Apartment hotels' were also developed as a type, specifically to cater for the increasing single-person household market. These 'kitchenette apartments', or 'condensed apartments', were popular for a period lasting into the 1920s. In the design of what were actually very small one- or two-roomed apartments, improved heating and ventilation, and efficient kitchen design, were important factors. Technology and gadgetry featured prominently, with new folding beds allowing the living area to be transformed into a sleeping space. Intricately designed kitchenettes included a range and an ice box, rubbish chutes that doubled as flues and ducted air systems that ventilated internal rooms. Hotel-like services were also on offer to residents, including the provision of meals and the collection and delivery of parcels, laundry and rubbish.

While developers and landlords were enthusiastic about this type of dwelling – more units on the same-sized plot brought in more rents – build-

ing authorities were less so. Legislation to distinguish between hotels and dwellings eventually restricted such developments. By the end of the nineteenth century in Manhattan, apartment buildings were the norm for all classes of occupant and were built to suit all budgets. Regulations, including those in 1884 to limit building height, only caused temporary pauses in development. Stylistically, there was a tendency to stick to Beaux-Arts French neoclassicism, as its highly organized repetitive planning, regular window layouts and hierarchy of levels seemed suited to the symmetrical arrangements.

In London, where the debate over 'gothic' and 'classical' architecture had continued for some time, the design of most early tenements was primarily influenced by Italianate classicism but, by the end of the nineteenth century, the influence of the Arts and Crafts movement was evident. Richard Norman Shaw, one of the best-known proponents of the Arts and Crafts style, was the first architect with a successful career in other building types to engage with housing design of the apartment block. Initially working on designs for semi-detached houses in an early garden suburb built speculatively at Bedford Park (1877), his first apartment block was the Albert Hall Mansions in Kensington – one of the earliest to be built for wealthier residents in London. At the time of its construction – the first phase on

Kensington Gore was completed in 1879 – there was considerable prejudice against apartments, or flats, which were seen as an economic way to house the poor.

The owners of the site, the 1851 commissioners, had designs drawn up but delayed decisions to build apartments on the site because of financial risk. Norman Shaw's redesign for the site followed his visits to Paris with his assistant Ernest Newton, particularly to look more closely at internal planning.[7] The new scheme incorporated two-storey apartments to appeal to tenants with an 'English' sense of what a house ought to be like, and also divided the scheme into separate blocks for phased construction to minimize the potential financial loss if apartments were left empty. Communal facilities that had been included in the original schemes – such as the dining rooms – were omitted.

The first phase of construction filled the gap overlooking the park and was designed in three identical pieces – a model that could possibly have continued as a terrace. The intelligent arrangement of split levels inside means that all the apartments have their principal living rooms overlooking the park. The large spaces that form the entrance halls on the street behind, to the south, are roofed over at ground level to continue as light wells on the upper floors. On the lower floors, apart from the main staircase, there is no

11 In *La Città Nuova*, 1914, Antonio Sant'Elia's visionary drawings describe a Futurist metropolis of high-rise buildings and multi-level transport systems.

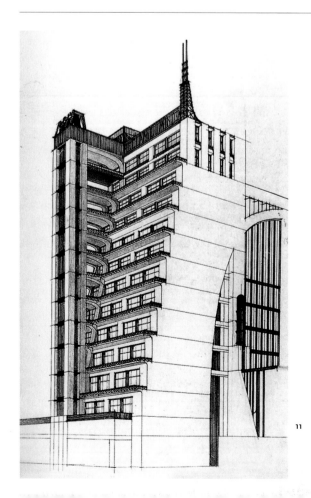

11

shared internal circulation until beyond the fourth floor, where corridors provide access to the smaller apartments. Lifts were installed but started only from the first floor, two storeys up.

The Arts and Crafts style became firmly associated with English domestic architecture and was also seen as a more appropriate alternative to some of the earlier blocks, which, although robust and economical to build, were often criticized for their dull monotony and barrack-like appearance. In London in particular, the setting up of the Housing of the Working Classes branch of the London County Council Architects Department produced, during the period 1893–1914, some of what are considered the finest built examples of Arts and Crafts architecture, and also established the importance of the role of architects at the centre of housing design.

Modernism and the twentieth century

Our external world has been enormously transformed in its outward appearance and in the use made of it, by reason of the machine. We have gained a new perspective and a new social life, but we have not yet adapted the house thereto.
Le Corbusier, *Towards a New Architecture*, 1927, p.21

With only a few exceptions, architects had generally not been much involved in housing design during the nineteenth century. However, in the early twentieth century, seemingly arbitrary stylistic and aesthetic debates shifted towards discussion of social and economic issues. For a new generation of architects, housing became a subject worthier of attention. With faith in progress based on the importance of advancing technology, the city was seen in a positive light as a product of industrialization and moderniza-

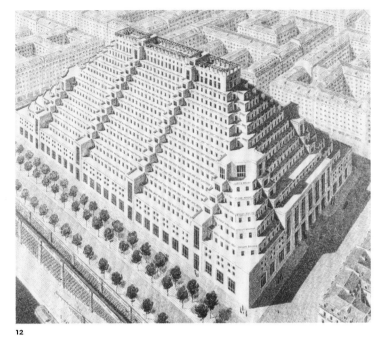

12

terrace and open up the streets to more light and better air circulation. The form could be developed at any size. The curved and faceted concrete surfaces of the façades were to be clad entirely in glazed ceramic tiles; used extensively in the Paris Metro, they were hygienic, robust and would not degrade. Two of Sauvage's designs for apartment blocks were built in Paris within existing street plans, and the spaces created inside the ziggurat, or pyramidal, forms are filled with workshops and cellars in the first version, in rue Vavin (1912). In the second, much larger block, in the rue des Admiraux (1922), a swimming pool occupies the cavernous space between the inclined façades.

In the same year (1922), Le Corbusier exhibited his Ville Contemporaine project at the Salon d'Automne, and in 1925 exhibited his plan for part of Paris as the Plan Voisin. This showed how vertical zoning could work with traffic flowing freely at ground level beneath a podium level of open space and housing concentrated in dense structures. These contemporary city designs included an *immeuble-villa*, an adaptation of the earlier Citrohan house that raised the house on *pilotis*, replaced load-bearing walls with a frame structure and windows with horizontal factory glazing. The units were stacked and lined up to form perimeter blocks around open courtyards for communal recreation. A prototype of an individual unit was exhibited at the

12 Design for the ziggurat-
shaped Giant Hotel, 1927,
Henry Sauvage.

13 Stepped apartment block,
rue des Amiraux, Paris,
1916–27, Henry Sauvage.

tion, and the most appropriate location for modern society. With the belief that a rational, logical and more objective approach to design and the application of modern technology must have the best results, design at the scale of the urban environment offered opportunity for experiments in the new modern architecture and planning, including housing design. Covered in detail in the CIAM (Congres Internationaux d'Architecture Moderne) documents, rationalization and standardization were to be the tools to revolutionize the construction industry. Attention to the question of minimum living standards (the *existenzminimum*) would engage consumers in the ambition to provide the maximum satisfaction for the needs of the greatest number.[8]

The drawings describing early twentieth-century proposals for a new kind of urbanism – high-rise buildings with high-speed transport systems – are now familiar illustrations to most architectural histories. The Italian Futurists, led by Antonio Sant'Elia, produced visionary drawings of factories and commercial buildings. In France, Toni Garnier's equally futuristic Cité Industrielle (1917) was a pioneering project planning all aspects of the ideal city, including the design of individual buildings. In Germany, Ludwig Hilberseimer's Hochhausstadt (1924) similarly proposed a version of vertical layering.

Finding built examples of ideal-city projects is more difficult. Henri Sauvage's rethinking of the city block was no less dramatic than other ideal-city proposals, but perhaps less disruptive. His proposals for 'apartements à gradin'[9] exploited the new aesthetic of reinforced concrete structures, proposing blocks with set backs at every level to provide each apartment with a

Exposition des Arts Décoratifs in Paris in 1925 as the Pavillon de l'Esprit Nouveau. It included furniture and home equipment to demonstrate a new kind of city living. Although never realized, projects such as these were influential in focusing attention on urban design issues. In particular, they proposed radical rethinking of the urban form, from the conventional plan of streets and façades to the 'wall-less' open city.

The architecture of the contemporary city had changed little, but a wide range of regulations, controlling building and all aspects of the infrastructure, were now put in place. For house builders, zoning regulations set out the types and density of different areas, and building regulations controlled the quality of construction. For architects, space standards were introduced, which were often linked to government funding mechanisms – subsidies were increasingly necessary in the urban environment. While these extensive regulatory frameworks raised standards to providing better housing, they could only set out design parameters and act as theoretical tools to solve what was still seen as a problem. The actual design and building offered a more tangible format for experimentation. Model-housing projects became the enduring testing ground for different ideas and forms of construction.

One of Modernism's best-known model-housing exhibitions is the Weissenhof Siedlung on the outskirts of Stuttgart. Open to the public from July to October in 1927, it reportedly attracted as many as 20,000 visitors per day.[10] Mies van der Rohe, at the invitation of the Deutscher Werkbund, planned the site. Rather than employ a geometric layout, he set out a less rigid plan that related to the terrain and the sequential relationship of the buildings. His approach was unique. 'The problem of the modern dwelling', he stated 'is primarily architectural, in spite of its technical and economic aspects. It is a complex problem of planning and can therefore only be solved by creative minds, not by calculation and organization ... I felt it imperative, in spite of current talk about Rationalization and Standardization, to keep the project at Stuttgart from being one-sided or doctrinaire. I have therefore invited leading representatives of the Modern Movement to make their contribution to the problems of the modern dwelling.'[11] As well as Berlin's best-known architects, including Walter Gropius, Hilberseimer, Bruno Taut, Hans Scharoun and Peter Behrens, he invited Le Corbusier, J.J.P. Oud, Mart Stam and Victor Bourgeois to contribute. The apartment block designed by Mies van der Rohe himself achieved the 'flexible plan' or a variety of different plan layouts that could be constructed behind uniform façades – an idea that had so far only been talked about was now a built reality.

14 Apartment building, Weissenhof Exhibition, Stuttgart, 1927, Ludwig Mies van der Rohe.

Part plan of an upper floor, 1:200. The frame structure and the kitchens and bathrooms grouped around stairs afford a variety of layouts internally for 1-, 2- and 3-bedroom flats.

1. main stairs
2. entrance hall
3. living room
4. bedroom
5. kitchen

15–16 Municipal Housing, Kiefhoek, Rotterdam, 1925–29, J.J.P. Oud.

Plans of ground (15) and first floor (16), 1:200. A forerunner of the terrace built at the Weissenhof exhibition, these houses are particularly small although intended for large families of up to six people.

1. entrance hall
2. living room
3. bedroom
4. kitchen
5. shower
6. coal storage

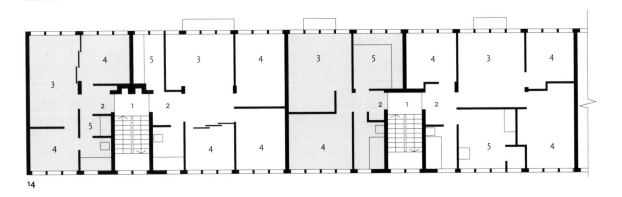

14

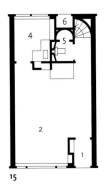

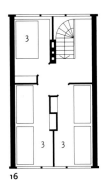

15

16

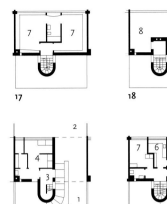

17 18

19 20

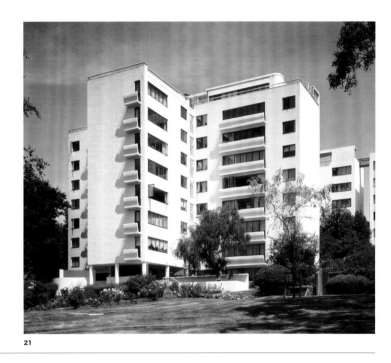

21

17–20 Terraced Houses, Werkbund Exhibition, Vienna, 1932, André Lurçat.

Plans 1:500. Three-storey houses with the main living space at first-floor level (20). A wide but very shallow plan has a private yard on the street that connects to the back

garden and rooms that occupy the full depth of the plan.

1. front yard
2. back garden
3. entrance hall

4. utility rooms/storage/washing
5. living/dining room
6. kitchen
7. bedrooms
8. roof terrace

21 Highpoint, London, 1933–35, Lubetkin and Tecton. The double cruciform plan has circulation including two service lifts at the intersections and means

that flats have extensive external wall area for natural light and ventilation.

Low-rise and terraced-housing schemes were also an important element of the project and included a version of Le Corbusier's Citrohan house and a terrace by Oud, which followed his recent work on the Kiefhok project in Rotterdam. One of the most significant changes in Dutch housing design was the shift away from traditional alcove or box beds, which remained common into the early twentieth century, to dedicated bedrooms used only for sleeping. The Werkbund exhibition of 1932 in Vienna featured another high-density terrace model. In contrast to the more usual narrow front and deep plan, André Lurçat's version has a small footprint, is wide, shallow from front to back, and is four storeys tall. The staircase is transferred from the middle of the plan to the edge, where it is enclosed by a curved wall visible on the façade.

Although not a model-housing project, Highpoint in London (1933–35) was the first building to demonstrate early Modernist ideals. It quickly became popular with architects and was included in all architectural histories for its formal qualities and close adherence to the tenets of the Modern movement. The scientific approach used by Berthold Lubetkin to analyze the clients' requirements, and look at systematic organization of circulation, services and structural arrangements, was demonstrated in a series of annotated sketch plans for the block. These were considered so significant that they were displayed in the entrance hall with the final layout, a double cruciform plan with two circulation cores. The building is significant in many ways but paramount, perhaps, are not its formal qualities, the composition of the façades nor the planning of its upper levels, but the ground-floor level: this achieves Modernism's 'spatial elasticity', which allows a dif-

ferent perception of the space as a part of the surrounding city – a contribution to the idea of the wall-less open city. Sited on the ground floor are the staff rooms – the porter's apartment and the maids' rooms – and communal facilities, including a tea room and the entrance hallway with access to the two lifts and stair wells. *Pilotis*, used to support the structure above, and a canopy visually extend the space of the ground floor. The enclosing walls, including the walls of the shared circulation spaces on upper-floor levels and those that define the edges of the plan, are curved and meandering. The impression is of a space that is unrestrained and free-flowing, distinct from the contained private volumes of the apartments above. Once inside the apartments, layouts are rectilinear. There is a small entrance hall beyond which the living area connects directly with the dining room, and a small lobby with doors to the bedrooms and bathrooms. With only eight apartments per floor, four per landing, six have external walls on three sides and all have cross ventilation, ample light and views in several directions.

Other housing paradigms in London with similarly simple white rectilinear forms include two much-praised projects by Wells Coates,[12] the Palace Gate Flats (1937–39) and the Lawn Road (Isokon) Flats (1932–34), both intended for wealthier residents. The Palace Gate Flats have a conventional programme but make use of an innovative split-level section. Across the depth of the block, the plans are organized with three storeys on one side – for bedrooms, kitchens and bathrooms – which have lower ceilings and take up the same overall height as two floors on the other side – for living rooms and dining rooms, which have higher ceilings. The Isokon block, one of the history of Modernism's popular icons that has recently enjoyed a revival,

has a programme similar to the apartment hotels, or kitchenette apartments, of early twentieth-century New York. Here the interpretation of the type is aimed at those who wished to pursue a professional life away from the constraints of family responsibilities and homemaking.

Ideas for hotel-like serviced apartments, or other forms of shared or communal-living arrangements, have continued to occur regularly throughout the history of housing design, but have never been developed to any great extent or become acceptable as an alternative to more usual family housing in either the United States or Western Europe. In Russia, however, such new forms of communal housing were considered to be a part of the reassessment of the traditional family that was seen as a necessary step in the transition to a more egalitarian society. Moisei Ginsburg's[13] Narkomfin apartment building (1930) in Moscow is the most often cited example; it organizes the apartments – double-height spaces with two bedrooms – into one block and all the communal facilities – kitchen, canteen, meeting rooms and kindergarten – into another. The communal spaces were to take the place of shared living rooms in dwellings where individual personal space was reduced to a minimum.

Few modern buildings were built in London, or anywhere in Britain, until after the Second World War, when extensive bomb damage meant that new building, especially housing, was urgently needed. Now the innovative ideas and adventurous schemes of the 1920 and 1930s could finally be put in place and at a significant urban scale. New construction technology and an established desire for modern equipment and services in buildings had a major impact on design. In London projects such as the Churchill Gardens Estate (1947) in Pimlico used the most up-to-date systems, including kitchens designed for optimum efficiency in terms of use and cost to build. For the first time, planning could make use of a concrete frame structure for the installation of central heating and dispense with the need to group rooms around fireplace flues.

In Chicago, Mies van der Rohe's 20-storey-high Promontory Apartments (1946), with reinforced concrete frame clearly expressed on the façade, were followed by the 26-storey-high Lake Shore Drive Apartments (1949–51), famous for their use of curtain walling. The internal layouts are similar to those designed for the Weissenhof Siedlung Housing Exhibition in Stuttgart 20 years earlier. Two lifts and staircases are located either side of a wide central corridor. Within the apartments, kitchens and bathrooms are adjacent to the corridor wall to leave the remaining area around the external façade as 'free space', which could be subdivided behind a continuous curtain wall of glazing.

22–25 Apartment Building, Palace Gate, London, 1937–39, Wells Coates.

Plans, 1:500. Lower level (22), middle (access) level (23), upper level (24). Living rooms with higher ceiling heights alternate in plan and section with other rooms with lower ceiling heights.

1. main stair and lifts
2. service gallery
3. access corridor
4. entrance hall
5. living room
6. kitchen
7. bedroom

8. bed/dressing room
9. service stair

Section, 1:500 (25). The split-level flats mean lift stops and access corridors are only at every third floor in the main block.

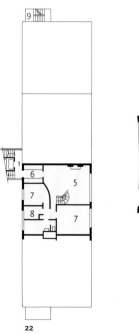

22

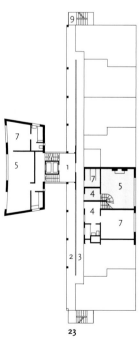

23

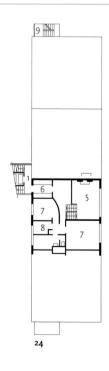

24

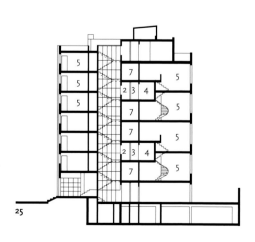

25

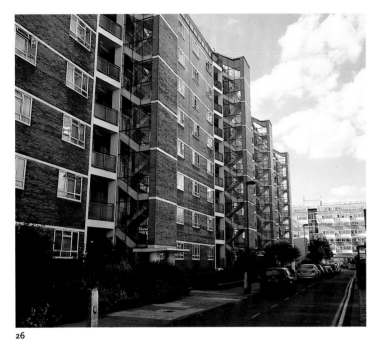

26

ceived in the terms of the technology of their time'.[14] In the early decades of the twentieth century, European Modernism had advocated mass production. This was not merely for its potential to speed up construction time but to alter perception of the building trade, which remained dependent on traditional methods based on the idiosyncratic craft skills of individuals. Proponents of Modernism believed that the application of industrial production methods that had revolutionized manufacturing in other areas, particularly the motor industry, was a necessary step towards the successful development of new forms of architecture. However, it was not until the post-war period of reconstruction, when demand for housing was urgent – in the 1940s and 1950s in Europe, and particularly in England – that prefabrication seemed the best means of providing housing quickly and cheaply.

Prefabrication of individual houses, primarily the timber-frame house, had been common in the United States since the mid-nineteenth century, and developments in industrialization and distribution networks by rail and road had contributed to improvements. The same technique – known as balloon framing – was introduced to Europe in the early part of the twentieth century. In Finland especially, where there was already a traditional reliance on timber as a building material, balloon framing gradually replaced traditional log construction. Architects were little involved in the design of such

26 Churchill Gardens, London, 1947, Powell and Moya. One of the blocks built to the original designs, with the distinctive glazed stair and lift towers serving just two flats per landing.

27 Lake Shore Drive Apartments, Chicago, 1949–51, Mies van der Rohe. Behind the glazed curtain wall, free space can be easily subdivided.

In France, Le Corbusier built the first Unité d'Habitation in Marseilles in 1952. It perfected the design of the earlier duplex apartment block by interlocking; apartments extended across the depth of the block and were accessed by internal 'streets' on alternate floors. An exercise area and paddling pool on the roof, shops and a kindergarten provided communal facilities, while the façade's composition clearly expresses the individual units.

The housing schemes briefly described here were well known in architectural circles when they were built and have remained so. Although very different formally and stylistically, they have in common Modernism's functional and analytical approach as well as an adherence to the use of contemporary construction technology as the basis for design. The development of a new aesthetic was largely based on the possibilities presented by reinforced concrete in all its forms – structural frames, poured in situ, and pre-cast panels and components.

Construction and the challenge of new technologies

Prefabrication in the truly industrialized sense, is a very special approach made possible now, for the first time when industry, research and material exist in the right relationship to one another, making possible an intelligent application of these resources to the needs of housing.
Arts and Architecture, Eames, Saarinen, Buckminster Fuller and Herbert Matter, July 1944

According to Alison and Peter Smithson, the success of the complete building systems of Mies van der Rohe and Le Corbusier is that they are 'con-

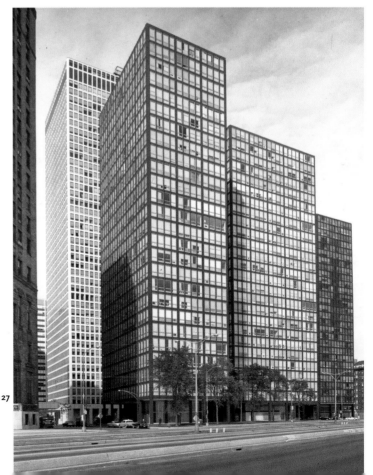

27

28

the factory-made Experimental Unit Development, designed by Raphael Soriano, which used tubular steel frames and steel decking. Later case studies 21 and 22, designed by Pierre Koenig in 1959 and 1960, used standard components.[18] The aesthetic developed in these projects and others – especially those by Charles and Ray Eames – became synonymous with 1950s style and provoked considerable interest from architects who continued to design one-off houses using steel fabricated construction. Despite this, none of the steel-frame models was ever developed for mass production.

While steel construction continued to be used in other building types, it is only recently with the introduction of computer modelling that steel fabrication with small-scale components is again being considered in the design of housing. Whether changes to production methods – of elements, assemblies or complete modules – will have a significant impact on design is not yet clear. Any positive effect on production costs would be sure to expand the market.

A recently completed second phase of housing, by Procter and Matthews Architects in Greenwich Millennium Village on the outskirts of London, claims to be the first large-scale housing scheme to make use of steel-frame construction, although its impact on the design is not immediately evident. The structural language is based on the building industry's substantial

housing, although for a short period in the 1920s, in an effort to improve design standards, the AIA (American Institute of Architects) endorsed the Architects' Small House Service Bureau, which offered a mail-order service of house plans and prefabricated buildings.[15]

In Britain in the 1940s the government supported experiments with new materials and construction methods. Prefabrication techniques had become vital to supply temporary housing for those made homeless by bomb damage, especially in and around London. New forms of construction were evaluated using the basic yardstick of a brick-built two-storey house. Steelwork was thought to be a likely alternative to brick, and the British Iron and Steel Federation provided sponsorship for an experimental house built in 1946, which was designed by Frederick Gibberd.[16] Designed as a permanent house, it made use of lightweight steel fabrication techniques intended for mass production. Compared to the standard brick house it had particular elements of modern design: an open plan at ground-floor level organized around a central brick chimney with fireplace and boiler, a steel staircase with open treads and mesh balustrade, and façades with large steel-framed windows, including French windows opening onto a terrace.

Steelwork was also the focus of more radical experiments carried out by the California-based *Arts and Architecture* magazine, which launched a Case Study House programme in January 1945.[17] The best known of the case-study houses is No. 8 (1949) at Pacific Palisades, designed by Charles and Ray Eames. It used standard steel sections – materials that were readily available but not yet used in domestic buildings. Other experiments include

experience of timber-frame construction, which was used for the first phase of the project but then adapted for steelwork. With computer models and one standard rolled-steel profile, a dedicated computer program cut pieces to size then coded them, including the positioning of mechanical fixings, ready for assembly. Storey-high frames were then assembled for mounting on concrete floor slabs.

At the other extreme of prefabrication methods – using modules or complete dwelling units fabricated off-site – the contribution to architectural form and expression is much more evident. The best-known example using a complete unit was designed by Kisho Kurokawa, a member of the metabolist group of architects, who proposed a hierarchical ordering system that separated the changing or 'growing' elements of the city from the more permanent elements of infrastructure. The Nagakin Capsule Tower in Tokyo (1972) uses a fixed concrete core to form a structural tower that is part of the permanent infrastructure of the city around which the factory-made minimal 'pods', or 'capsules', are clustered. Implicit in the idea is that the capsules are temporary and can be removed, altered, upgraded or replaced. This project and two similar ones are the only built versions using complete units, although other forms of prefabricated housing are common in Japan. Mostly it provides housing for the suburban market and, like much suburban housing elsewhere, conforms to a style that has little in common with any other contemporary design product. Much of the housing is produced by car companies, including internationally known names such as Toyota, Daiwa and Sekisui. With few exceptions neither the ideas nor the technical possibilities have been taken up significantly in Europe or North America.

In the early 1990s in *Building* magazine, Martin Pawley described the work of a British designer, John Prewer, who, convinced that Japanese housing manufacturers were ready to invade the British market, identified a gap in their product range – the single-person dwelling – and set about designing a 'microflat' for prefabrication. Based on one of his earlier designs for a modular lift shaft in steel sections, Prewer designed a 'microflat' that was similar in dimensions to a shipping container. It could be transported on trucks, then craned into position with the steel sections stacked one on top of the other.[19] Since 2003 Piercy Conner Architects have been pursuing a similar microflat project based on modules, and in Manchester the Krashpad company has proposed a 15-storey apartment building over a mere 30 square metres (322 square feet). Although there is some enthusiasm for such small apartments because they offer an affordable means of owning property, criticism of their size has included labelling them 'twenty-first century doss houses'.[20]

Whether microflats – modular or otherwise – will become common in Western cities raises questions about our priorities. We can imagine that they might work, like the capsules of the metabolists, either as parasites on existing structures or in purpose-made blocks, to provide basic accommodation to reinvigorate city centres. Like the 'apartment hotels' of the nine-

is clipped in place. These modules do not attempt to provide a complete dwelling but are grouped together in multiples to create a variety of plan arrangements. The housing modules were developed and completed in the factory and then brought to the site complete with wiring, plumbing, heating and even carpets.

Another version of the 'prefab' home is the pro/con housing project that uses commercially available shipping containers. Still only a project, it was shown at the *Live Dangerously* exhibition, held at UCLA in 2001, as one of a series of architectural research projects that set out to challenge the cosy notions of domestic architecture. Standard containers are used as building modules, allowing individuals to custom-stack their own homes, using the space inside and between them, and restacking them in a different configuration if they feel inclined. This project proposes an alternative to the idea of the permanence of home. It suggests that, by thinking of a house as an appliance, our relationship with it changes. This is summed up in the words of the design team: 'you don't get emotional attachment to a washer-dryer'.[21]

In a society where 'permanence' is still considered a necessary element of the idea of 'home', prefabrication and its association with transience has continued to affect its use. Whether the 'prefabs' of the 1950s that provided emergency housing in post-war London or their contemporary version, the

29 Nagakin Capsule Tower, Tokyo, 1972, Kisho Kurokawa. Interchangeable factory-made capsules are clustered around a central permanent structure.

teenth century they offer the opportunity to increase the numbers of tenants on any given site and thereby raise profits for developers. But can a microflat be a home? Affordable housing – or even housing that is not just for the wealthy – in almost any city in the world has long relied on government subsidy. Without such subsidy for land prices even a microflat is beyond the budget of most people. The design of small spaces is a fascinating exercise for architects. Most marvel at the ingenuity of the design of some boats and caravans, but it is doubtful whether living in such small spaces is desirable long term. In fact, the microflat contradicts the aim of architects to provide improved living conditions that give people more space. There is the likelihood, too, that the microflat will not be thought of as a home but as the latest must-have gadget. It could provide suitable student accommodation, particularly because of the temporary nature of student status. However, designed as a product – more or less independent of the infrastructure – it seems it would most likely be used as a *pied-à-terre* – a temporary space for the wealthy who work in town and live in the country.

Exploring the potential for modular construction also extends to more conventional housing projects. Recent experimental projects pioneering the use of modular prefabricated units have been built in London and York for the social landlord, the Peabody Trust. The first of these, Murray Grove (1999) by Cartright Pickard Architects, has been awarded design prizes by British and American institutions. It uses 3.2 x 5.15 x 3-metre (10 feet 6 inches x 17 x 10-feet) high modules in sheet steel, literally stacked one on top of the other. A lift and stair tower is added externally and connected to a self-supporting structure that forms gallery access at each floor level. Cladding **29**

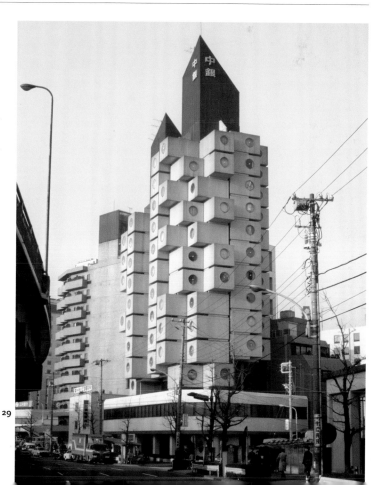

trailer park in the United States, or the new microflats, modular dwellings and prefabricated houses still carry with them a certain social stigma. From a construction perspective, prefabrication or off-site manufacturing techniques are part of a broader picture that includes a range of technical and financial issues generally relating to reducing construction time and regulating the detail design stages. However, it is evident that Modernist ideals – though supported by the designers of housing schemes that are now a familiar sight throughout Europe and the United States – have not yet been fully integrated into Western culture.

An important question raised by current renewed interest in off-site construction is that of permanence and change. Prefabrication, or industrial production, was part of Modernism's attempt to change the occupant's perception of a house from 'home', with its connotations of emotional attachment and belonging, to that of a piece of equipment – a change that signals a shift from an expectation of permanence to an acceptance of transience. This viewpoint is expressed by Lionel Esher in the conclusion to his 1981 survey of the state of housing provision in *A Broken Wave: the Rebuilding of England 1940–1980*. He suggests that a change of consciousness entails considering cities not as 'centres of power and architecture a statement of pride ... we no longer expect people to stand back like tourists and gape at our buildings, but simply to use them as they use a pub or a market'. The key to this change is for architects to accept a new role, one that he likens to being like a 'scene shifter in the urban drama'.[22] The often-aspired-to 'landmark' building implies high visibility and with that usually goes permanence. However, housing and particularly 'the home', forms part of a social structure within which change is implicit, creating a different relationship with the urban landscape.

The future

At the beginning of the twenty-first century, the city is a different place in comparison to previous centuries, but the housing problem remains. In cities worldwide there is still a pressing need for more housing to accommodate a growing population. Architects and designers are still looking for the best ways to provide better living space in the city. As Lord Rogers goes on to say: 'We must build cities for flexibility and openness, working with, and not against, the now inevitable process whereby cities are subject to constant change.'[23]

The high population density that continues to be the subject of much debate about city living throughout Europe and North America seems finally to be more acceptable to an urban society that no longer expects the

30 Murray Grove, London, 1999, Cartwright Pickard Architects. Experimental housing project using modular prefabricated units. The access balconies, diagonal bracing and cladding were all dry assembled on site.

luxury of living in individual houses. But when we look at the densities in cities being built in Asia, we might question the definitions of the problem. Statistics published in 2003[24] reveal a very different picture compared to Western ideas of acceptable density. In Europe, Paris still maintains the highest population densities at 7,793 people per square kilometre, around double that of London with 4,027 per square kilometre and New York with 4,432 per square kilometre. Tokyo may have a similar density to Paris at 9,660 per square kilometre, but it is only a fraction of the densities of other Asian cities, including Tapei at 18,732, Bangkok at 22,540 and Hong Kong topping the list with 95,560 – more than 20 times the density of New York or London. These vast urban populations in Asia have developed in the last 30 years, resulting in a very different urban environment to that of European cities. The towers that make up the urban skyline are not just the corporate headquarters now familiar in Western cities – the majority are residential. In the Far East, the scale of urban development far exceeds that in the West, with its much-lamented antiquated construction industry. Adopted following the first Modernist experiments and adapted for specific purposes, in the Far East a sophisticated construction industry uses system building, factory-production methods and off-site construction. The best of English town planning has also been employed for the New Town programmes in Singapore and Hong Kong. These are based on the principles of the New Towns built during the 1950s in England, but at ultra-high-density with mixed-use tower blocks. Anthony Ng's award-winning Tung Chung Crescent at the centre of Tung Chung New Town, developed alongside Hong Kong's Chek Lap Kok airport, seems closely related to the utopian

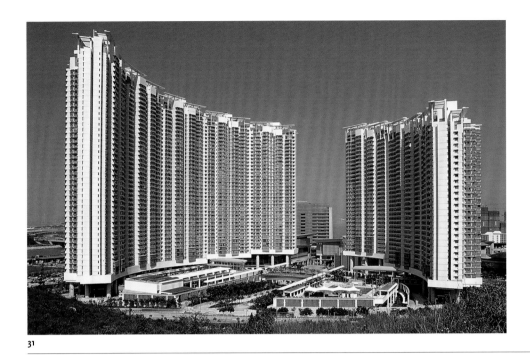

31

31 Tung Chung Crescent, Hong Kong, 1999, Anthony Ng. The high-density mixed-use towers in Tung Chung New Town were based on the New Town planning principles of 1950s England.

visions of Garnier and Le Corbusier. Eight linked tower blocks, arranged in a semicircle, rise from 29 to 45 storeys tall. Cruciform in plan to maximize external wall surface and natural ventilation, they provide more than 2,500 dwellings.[25]

Architectural histories provide no concensus on the appropriate context for a critical discussion of housing design. 'Housing', as the definition of a 'functional' typology, is only useful as a very broad definition. It includes the ultra-high-density towers of Anthony Ng, Modernist row houses of the 1920s by J.J.P. Oud and model dwellings of the 1840s and 1850s by Henry Roberts. In addition, because of the complex nature of the architecture of mass housing, stylistic comparisons beyond the most simplistic have aroused little interest. Funding regimes and related changing space requirements, and their connection with planning legislation and political imperatives, have been used to focus attention on particular aspects of housing provision. However, from a design perspective, although the influence of such legislative frameworks and funding mechanisms is of vital importance at the design and construction stages, these factors rarely remain in place long enough to make their comprehension legible. Plan typologies – which can be developed independently of location and urban planning – have therefore often provided the focus for detailed study, but are often seen as leading to a sterile and formulaic approach.

In the chapters that follow, the particular focus is on the relationship of the individual dwelling to the whole, and the relationship with the immediate urban environment that sees the architecture of housing as fundamental to the matrix of the urban landscape. As Aldo Rossi states, observably:

'The city has always been characterized largely by the individual dwelling. It can be said that cities in which the residential aspect was not present do not exist or have not existed'[26]. The loose classification used here is based on the plan arrangements at the urban scale, the method Rossi calls 'descriptive, geometric or topographic'[27]. Four types divide urban housing schemes into 'terraces and row houses', 'quadrangles and courtyards', 'city blocks and infill' and 'towers and slab blocks'. Each chapter that follows includes a series of examples of housing schemes from around the world built recently, which demonstrate a contribution to new thinking or an innovative architectural approach to the reinterpretation of different aspects of housing design.

Chapter 1

Terraces and Row Houses

1 A terrace in Amsterdam; a
Dutch version of a common
northern European form.

*Eighteenth- to mid-nineteenth-century terraced houses – as well as many early versions of 'semi-detached'
and 'detached' houses – were high and rambling, the backs often chaotic. There was mostly no garden, front
or back. The master of the house and his family lived 'stuck up', literally and socially, above the ground, sepa-
rated from the street by a gap, the 'area'; to get to the back of the house was quite complicated and there was
usually nothing worth getting to. For later small houses, too, the back was not meant to be pleasant but only
practical and salubrious. In this lack of emphasis on contact with the ground, the better houses can at least
superficially be compared with the common continental system of flats with a bel étage.*
Stefan Muthesius, *The English Terraced House*, p. 145

Without the problems associated with housing servants and having a separate, servants' entrance, the
twentieth-century terraced house became a very different place, further enhanced by improvements in
plumbing and drainage installations for wealthier and poorer classes alike. The back of the house –
once a place for servants, kitchen and laundry work, and privies – became the back garden, a private
place of leisure. The street had also changed, with front gardens now the norm. The notional territory of
the house often extends beyond the confines of the area to the car-parking space on the street.

In stylistic terms, the influence of the Arts and Crafts architects has persisted in what is now considered to be a traditional Victorian terrace – red brickwork, Dutch gables, decorative barge boards, multi-pane windows and an emphasis on the opportunity for individual expression. For Modernism, the terrace as a type was an opportunity to consider the overall composition. Attention to this consideration is often used to differentiate the terrace from the row house, as in Taut and Wagner's well-known Berlin Britz housing scheme (1925–27), in which each house is recognizably part of the composition of the whole. The renewed interest in the terraced house, as an alternative form of high-density development to the growing numbers of slab blocks and high-rise apartments in the early 1960s, produced two very widely published schemes – the Halen housing near Bern by Atelier 5 (1955–61) and the Fleet Road scheme in London by Neave Brown (1967). Both demonstrated the advantages of the type, particularly with regard to issues of privacy and the importance of the relationship with external space. At a time when hostility towards high-rise and other more 'urban' forms of multi-unit blocks has diminished, the terrace nevertheless continues to be investigated as a type, as the examples included here demonstrate. Some of the projects illustrated in this chapter should only loosely be termed terraced housing but, each is based on the terrace plan – open at both ends

2

2 Britz housing, Berlin, Taut and Wagner, 1925–27. Each house forms part of the composition of the whole terrace.

3 A typical terrace in Melbourne, Australia, has a raised ground floor and a verandah on the street.

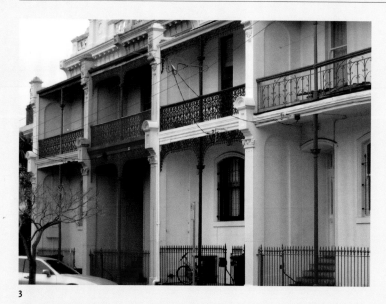

3

and contained between parallel, blank party walls – and is included for some aspect of design and construction that informs this idea.

At the end of a pedestrian route, the scheme in Graz, by Szyszkowitz. Kowalski, closes a vista. Two storeys high at the ends and rising to three in the middle, its formal symmetrical composition forms a boundary to the site and halts the vista against the backdrop of the wooded parkland beyond. Taking advantage of a steeply sloped site, the section is cut into the

ground to form paved terraces outside different floor levels, and a series of external staircases climb up the slope to delineate the different units. A shared basement under the whole terrace is given over to car parking accessible from the street.

Like the scheme in Graz, the Léon Wohlhage Wernik Architekten scheme in South Biesdorf relegates car parking to the perimeter roads. It is laid out in what at first looks like a conventional plan but, in fact, all the terraces are orientated in the same direction. The streets are pedestrian and, although they are wide enough for occasional access, there is no provision for parking within the scheme. Internally, these houses are all identical with very little opportunity for variation within the individual dwellings. Externally, the architects have differentiated between dwellings by varying entrances with steps in the façade, and by different treatments of the third storey that can be either attached to the house, or accessed independently as a room for a student, lodger or elderly relative.

The Nieuw Terbregge scheme in Rotterdam, by Mecanoo, also separates pedestrians from traffic, but with a vertical solution that maintains the integrity of the individual houses. What the architects call a 'double-decker house' has an entrance on two levels. Cars arrive at lower-ground-floor level, where each house has an integral garage, while the storey above – an open timber deck – provides pedestrian access. This arrangement, by providing a car-free, safe street environment, is intended to encourage social interaction between neighbours and create a sense of community.

In Ljubljana, the main intention behind Ofis architekti's 68 x 16-metre (223 x 52-feet) plan was flexibility to avoid the repetition so often associated

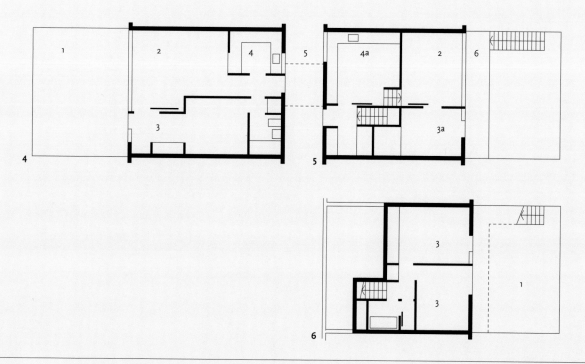

25

4–6 Fleet Road, London, 1967, Neave Brown.

Plans, 1:200, of four-person maisonette, lower level (6) and upper level (5), opposite a two-person flat with bedroom at the front (4). A modern version of the traditional terrace with

70 dwellings in six parallel rows, two- and three-storey dwellings with back alleys and a central pedestrian street.

1. garden

2. living room
3. bedroom
3a. bedroom/study
4. kitchen
4a. kitchen/dining room
5. alley
6. terrace

5 Halen housing near Bern, Switzerland, Atelier 5, 1955–61.

On a steeply sloping site, a stepped section means the flat roofs of the terraces at the lower levels provide the gardens for the houses above.

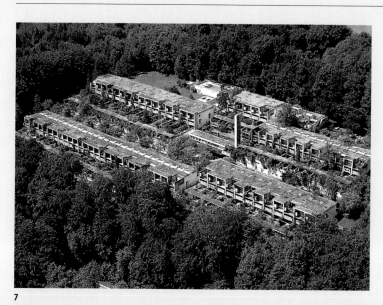

7

with terraced houses. Not conforming strictly to the formal definition the scheme is, however, based on a deep double-aspect plan, with a series of different internal layouts. The original plans that could provide variation to suit different occupants were, unfortunately, not realized, and the built version now includes single-aspect apartments.

According to Stefan Muthesius, three is the minimum number required to form a terrace, although creating a symmetrical composition is difficult

to achieve unless the houses are double fronted. The three houses that make up Whatcott's Yard, London, designed by Riches, Ullmayer and Gariboldo, are identical in footprint and overall volume, but each has a different internal arrangement. The terrace is organized with entrances along one side and a private garden on the opposite side; it is not accessible from the street but from a shared yard.

In Tilburg the façades of the terraced houses and adjacent block of apartments, designed by Erick van Egeraat, have a role to play in framing the open space the scheme has created. Semi-private space is a key part of the plans, structured to provide a progression from the public space of the street through to the private space of the dwellings.

A pair of case-study houses in Houston, Texas are included here as prototypes, built by Wittenberg Oberholzer as part of an experimental housing project. The Yoakum Street Town Houses are a reinterpretation of the town house – a model that embraces car parking by incorporating it into the building envelope and raising the living space to the upper floors. This scheme includes space for six cars, either in garages or carports, and explores a rethinking of the associated off-street areas of 'yard', 'driveway' and 'garden'.

Similarly, the terraces, designed by Neutelings Riedijk, that line the shore of Lake Gooi in the Netherlands raise the living space to first- and second-floor levels to provide a covered area for parking at street level. This project also breaks the rules of terraced-house design by extending the living rooms sideways – breaking away from the constraints of the party walls by stepping across them – to occupy the full width of two houses.

This scheme was commissioned by a cooperative to provide affordable family housing. The overall site was planned by Heiner Heirzegger but, to achieve some diversity, other architects were invited to design different elements within an overall framework. For Szyszkowitz. Kowalski, this included both designing a housing scheme and contributing to the landscape design. On a long, roughly rectangular sloping site, running east to west, the buildings are organized as a series of linear blocks, or terraces, running parallel and perpendicular to the slope of the site and the perimeter streets. A single main pathway that meanders in a gentle curve through the site is used as the main organizational device.

At the highest point, bordering the eastern edge of the site, the curving pathway arrives in front of the crescent-like, curved terrace of glass-tower houses designed by Szyszkowitz.Kowalski. Behind the terrace the tall trees of wooded parkland form a dark-green backdrop and, in front, an open, grassed area, intended as recreation space, works as a type of forecourt in front of the terrace. Crossing the grass, the concrete pathway divides into two branches and includes flights of steps up to the terrace that follow the slope of the site and the embankment. A spring, discovered during the

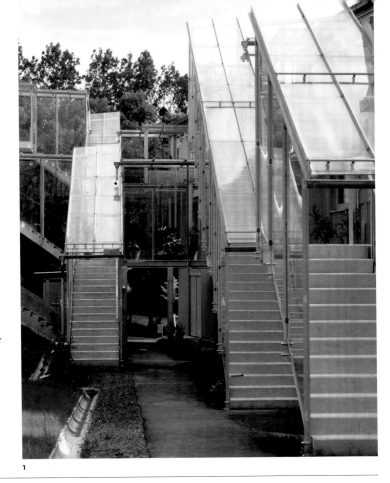

1

Schießstätte Housing Complex

Graz, Austria
Szyszkowitz.Kowalski
1999

1 Glass canopies over the stairs break up the continuity of the façade and allow views through to the backdrop of trees behind.
2 In the centre of the symmetrical terrace the buildings reach three storeys.
3 Site plan, 1:2,500. The terrace is at the end of the pedestrian pathway.
4 High levels of transparency and proximity to neighbours mean that the activities of the inhabitants are clearly visible on the various terraces, stairs and sloped planting spaces directly in front of the houses.

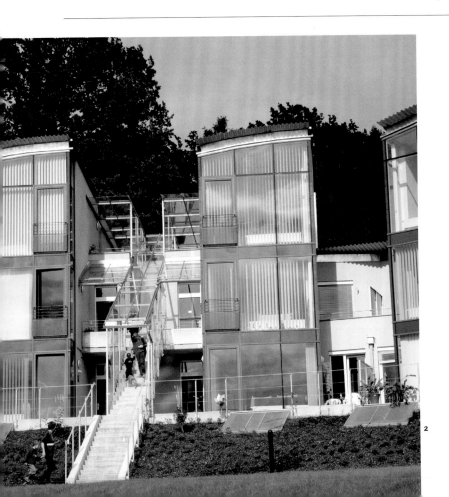

2

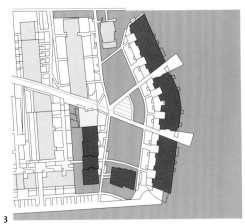

3

4

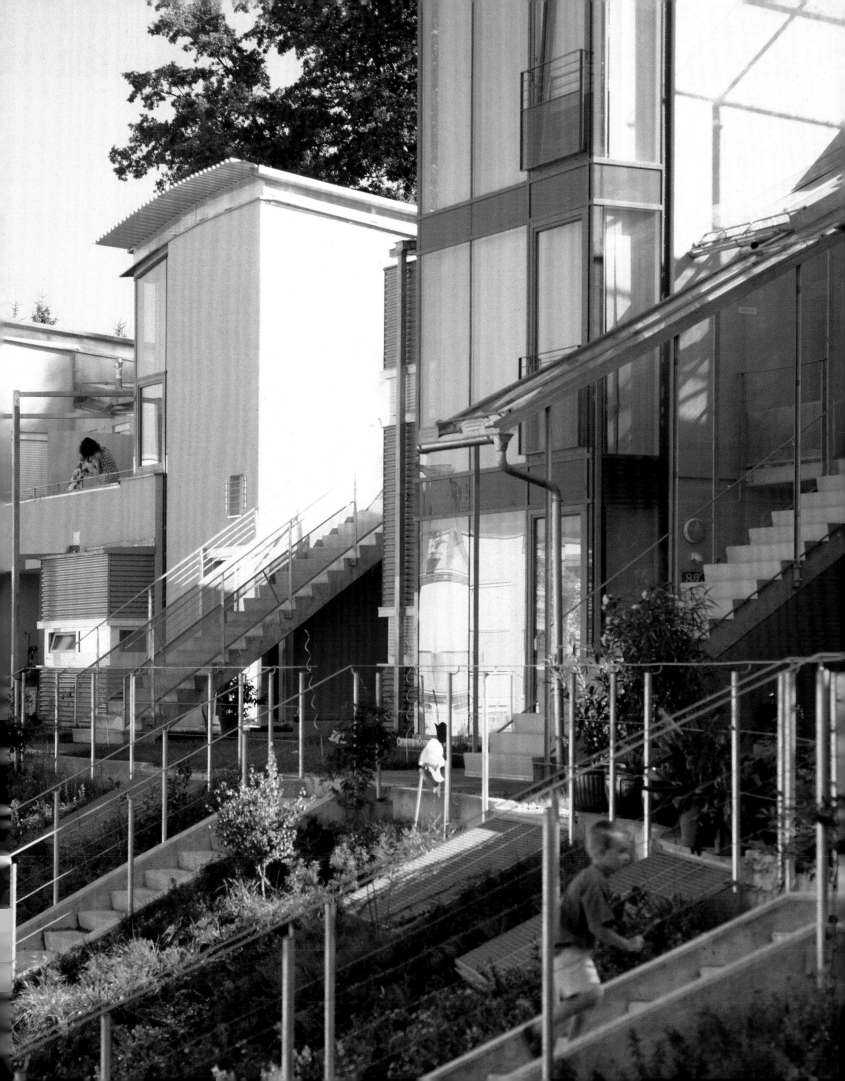

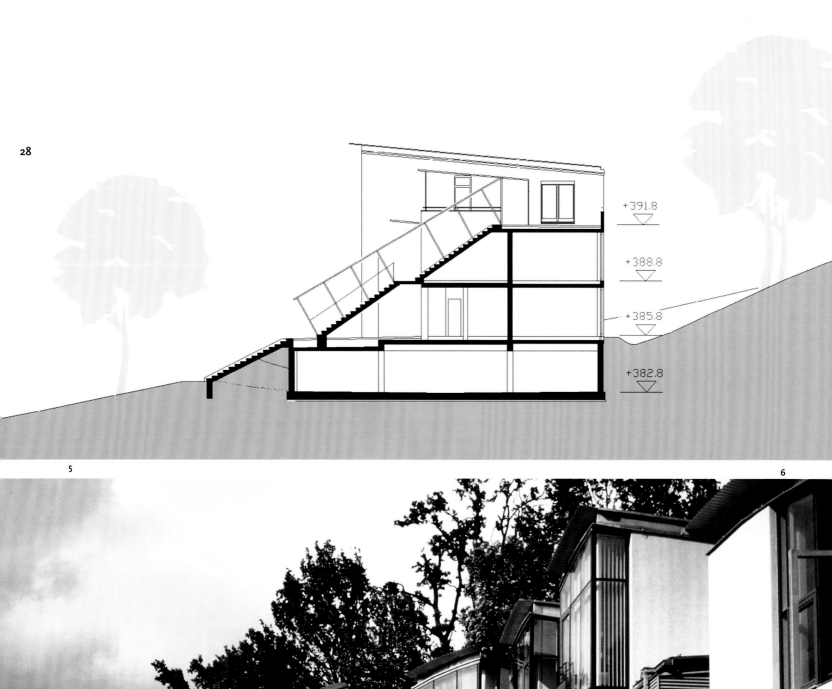

+391.8

+388.8

+385.8

+382.8

5

6

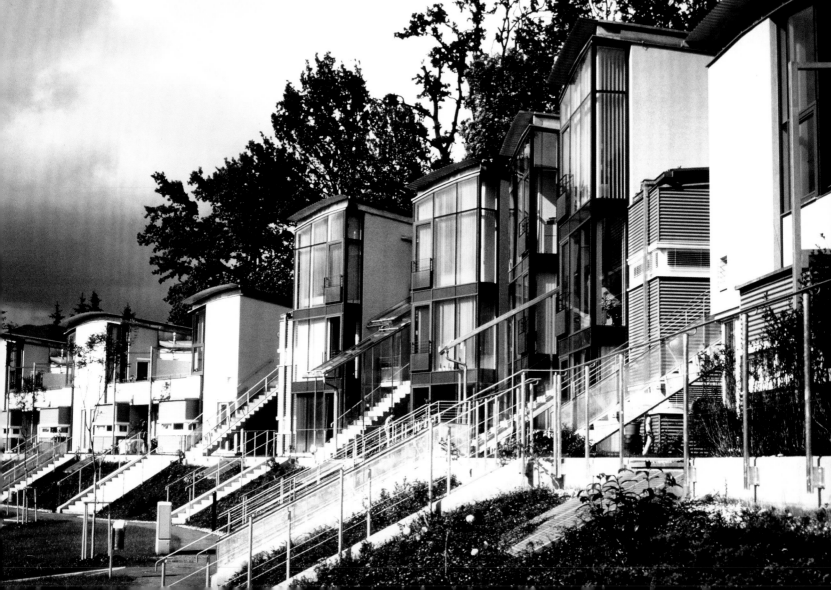

building work and incorporated into the landscaping, appears where the path forks and continues as a constantly flowing rivulet following the pathway in ornamental concrete troughs. The two branches of the pathway continue beyond the terrace into the woods, where they terminate in small, secluded terraces intended for social gatherings.

Access to the dwellings is via external staircases that rise first to the level above the green, then a series of smaller staircases climb up between the glass towers. The façade is a symmetrical composition, with the two-storey houses making up the two ends of the terrace either side of the central,

three-storey section. The dwellings vary in layout and in size from 40 to 90 square metres (430 to 970 square feet). Kitchens and living spaces are generally located at the front, overlooking the front gardens on the raised embankment, and the bedrooms are on the quieter side next to the woods. An underground parking area is cut into the slope of the site and is accessed via the perimeter road, to keep cars away from the dwellings.

The external stairs and landings, embellished with balustrading and glazed enclosures, are an integral part of the façade, which has a strong visual impact. Rather than being an impenetrable surface, it has a high degree of transparency.

The façade allows glimpses into the buildings through glass and to the woods beyond through breaks in the terrace. This contributes to an overall impression of depth, the framework perforated to give views beyond the surface. The notion of 'openness' extends to the high levels of visibility between the external spaces, encouraging communication between private spaces and shared open spaces, such as the forecourt, or the terraces and pathways that lead to the woods.

5 Section, 1:200. The stepped section follows the slope of the site.
6 Concrete steps follow the slope of the embankment.
7 Part plan, 1:200. Entrances and open-plan living spaces are at the front and bedrooms, which are accessible from separate lobbies, overlook the embankment and parkland at the back.

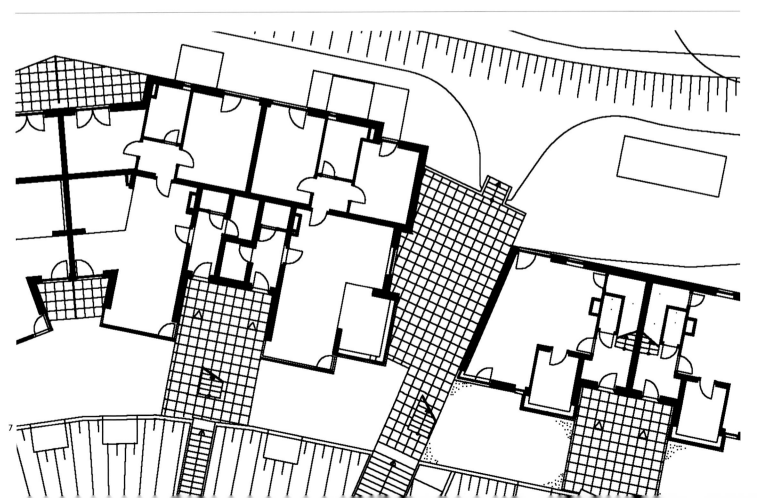

7

In the design of public-sector housing, the provision of any opportunities for individuality or difference is considered a bonus. In the private house-building market, however, in which developers are keen to feed consumer demand, multiple-house types, the incorporation of distinguishing features and the opportunity for customization are high on the list of priorities. With this in mind, Léon Wohlhage Wernik Architekten have approached the design of a scheme of terraced housing in South Biesdorf, Berlin, with the concept of differentiation and the potential for future change.

In place of the uniformity and repetition associated with row houses, or terraces, this project uses one basic house type singly or in pairs, organized in much more loosely structured rows. Different building heights and staggered plans result in an irregular roofline and, at ground-floor level, a variety of different entrance conditions. On a roughly rectangular site, the 64 'houses' are arranged in five terraces all orientated the same way apart from the final row, which faces the street. Breaks, including the footpaths, in the continuity of the terraces contribute to the less rigid appearance and windows, arranged in relation to the internal spaces, add to an overall, more haphazard impression than terraced housing usually conveys.

Coherence is brought to the scheme through the consistent detailing and the use of red render throughout. The cubic, unadorned forms, the uninterrupted flat planes of the façades and the flat roofs show a direct relationship to the housing schemes of the early Modernists in 1930s Germany.

Private gardens, rather than roadways, separate the terraces within the site boundaries and gravel driveways, designed for access only, lead to the front of each house. There are off-street parking spaces in front of the end terraces, but otherwise parking is relegated to a row of carports on the southern edge of the site. A network of pathways leads across the site and

gives pedestrian access to sheds equipped with bicycle racks and bin stores. The individual private gardens provided for each house are accessible from either the driveways or pathways.

The houses all occupy plots of identical size. At 11 metres (36 feet) deep, the staircase and service ducts are located in the centre of the plan, furthest from any natural light. A 6-metre (20-foot) width allows for circulation on both sides of the central core. This layout accommodates open-plan living space and kitchen on the ground floor, and conventional subdivisions form three bedrooms and a bathroom on the first floor. The basic two-storey units can then

Condensed Housing Development

South Biesdorf, Berlin, Germany
Léon Wohlhage Wernik Architekten
1999

1 Site plan, 1:2,500. Unusually, the terraces are orientated in the same direction.

2 Interior view of an end-of-terrace house with additional windows in the flank wall and a sliding partition to divide bedrooms.

3 A three-storey double unit. A staircase between the houses separates the front doors and leads to a pair of self-contained flats at second-floor level.

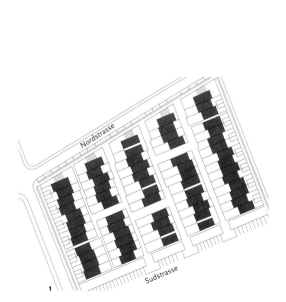

1

2

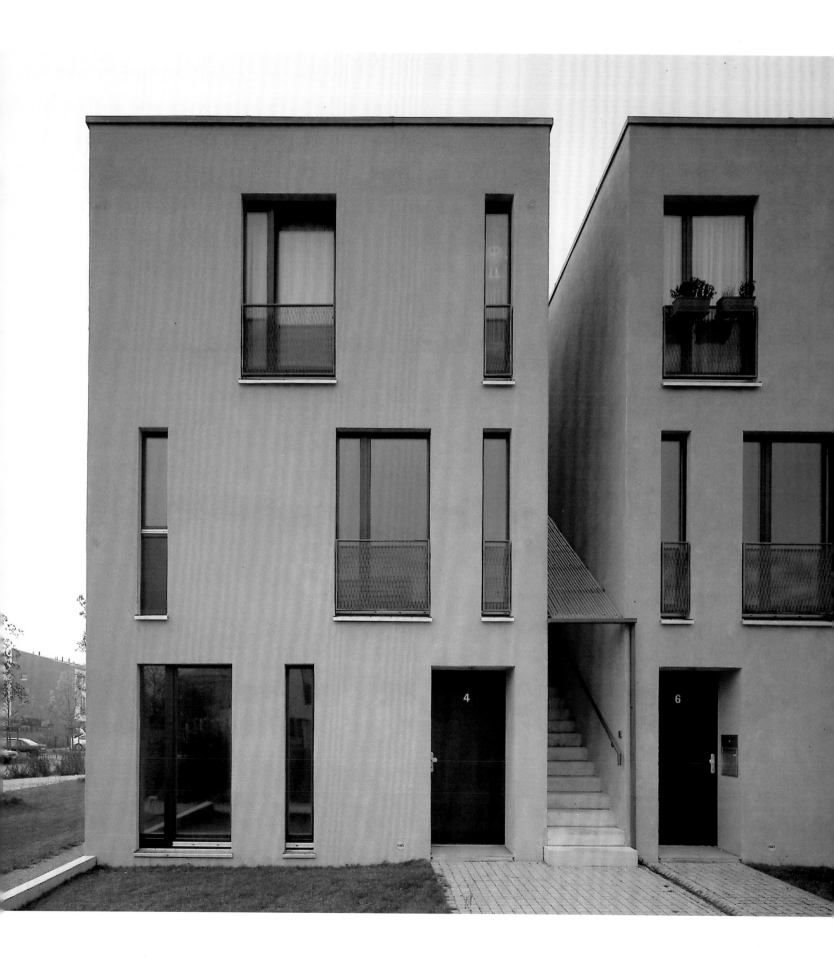

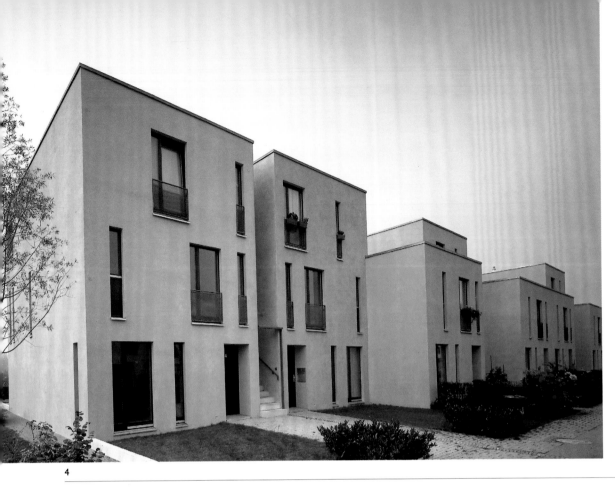

be developed to form a three-storey unit in one of two ways. In a single unit, the staircase continues internally up to the second floor, which has a full-width room and a terrace. The terrace is intended to provide the potential for later expansion. In paired units, the stair is placed externally between the two houses, giving independent access to the second floor and additional space for a lodger or a nanny.

4

4 Windows are full-height with widths and positions to suit internal layouts. The units are staggered in plan to create variety.

5–7 Plans, 1:200. Double house type: ground floor (5), first floor (6), second floor (7). Both house types can be either two or three storeys high.

8 A rear view (first phase construction) showing the four different variations.

9–11 Plans, 1:200. Single house type: ground floor (9), first floor (10), second floor (11).

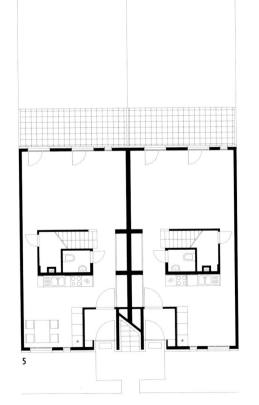

5

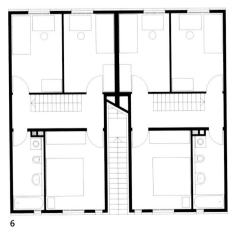

6

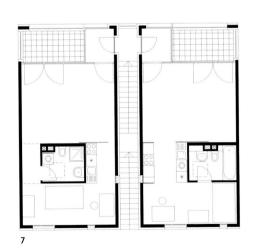

7

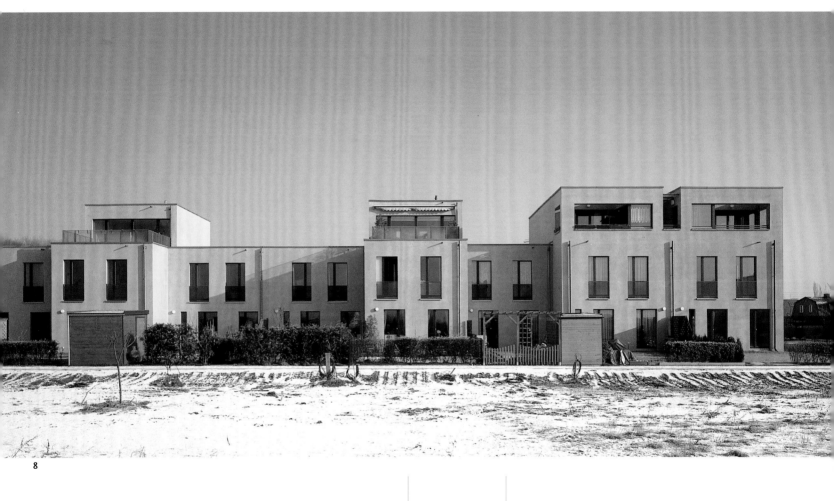

8

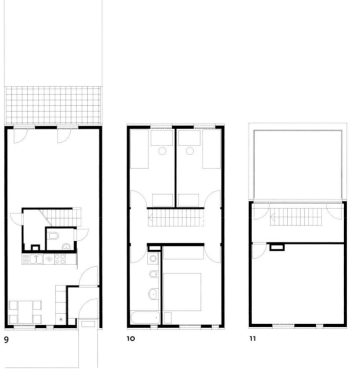

9　　　　　　　　10　　　　　　　　11

The Nieuw Terbregge project has won awards for the quality of its design, and particularly for the innovative design of the areas outside the dwellings. The houses are aligned in parallel rows oriented north–south, divided by fingers of water chanelled from the adjacent canal. To separate car traffic from pedestrians, the architects have invented a two-storey or 'double-decker' street. Cars circulate at lower-ground level, where each house has a garage, and one storey higher a timber deck spans the space between the houses to form a pedestrian street. Open stairs connect the two 'streets' and the open-timber boarding of the deck construction allows sunlight to filter through to the lower level. The space of the upper level is animated with trees planted at the lower level, emerging through openings cut into the deck.

The architects describe their scheme as an attempt to recreate the unconstrained atmosphere of a holiday camp and as a 'protest against the tidiness of neighbouring schemes which lack any adventure'. We can imagine easily the quiet and car-free pedestrian deck level directly outside the houses being used for social exchange and as the focus for social events. For children particularly, the interconnected street levels and the jungle bridges that connect the islands are reminiscent of holiday adventure and carefree play.

The internal arrangement is relatively straightforward. At the lower-ground level are the garage, a small lobby and a cloakroom. At the upper-ground-floor level are the kitchen and living room, with the bedrooms and bathrooms on the upper floors. The idea of the holiday atmosphere, or less constrained living, has also influenced the internal planning of the living spaces. The kitchen is designed as a very public part of the house, with the front door opening directly onto it and no hallway or entrance lobby. Instead of a front garden, or similar space, to distance the interior and its occupants from the public space of the street and the prying eyes of passers by, there are full-height, glazed panels that can be opened, seeming to invite social interaction. The kitchen functions as the semi-private space through which family and visitors necessarily pass to get to the rest of the house, reaching the upper floors via the corner staircase, or going down the steps that lead directly to the living room.

In the living space, the change of level creates extra ceiling height and adds to the sense of openness. The depth extends visually beyond the volume of the house with long views out through the glazed façade to a series of patios, lawns and planting areas that step down gradually towards the water.

Nieuw Terbregge
Rotterdam, The Netherlands
Mecanoo
2001

1 Site plan, 1:2,500. The parallel terraces are separated by fingers of water.

2 Front doors opening directly off the upper deck level and full-height glazing to the kitchens are intended to encourage contact and neighbourliness.

3–6 Plans of a typical house, 1:200. Lower ground floor (3), upper ground floor or deck level (4), first floor (5), second floor (6).

1. entrance hall
2. garage
3. living room
4. kitchen
5. garden
6. roof terrace
7. bedroom

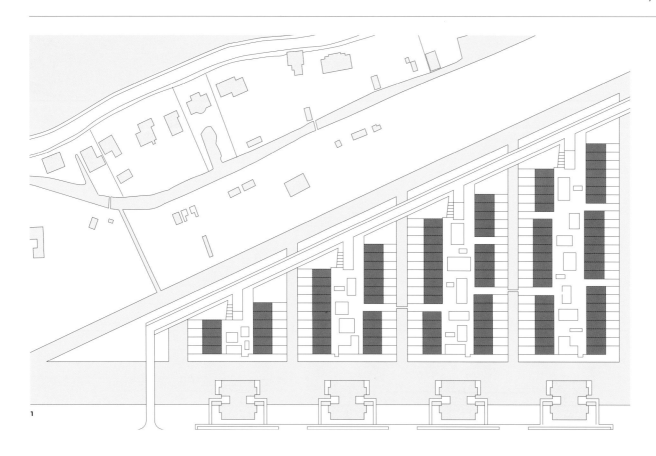

1

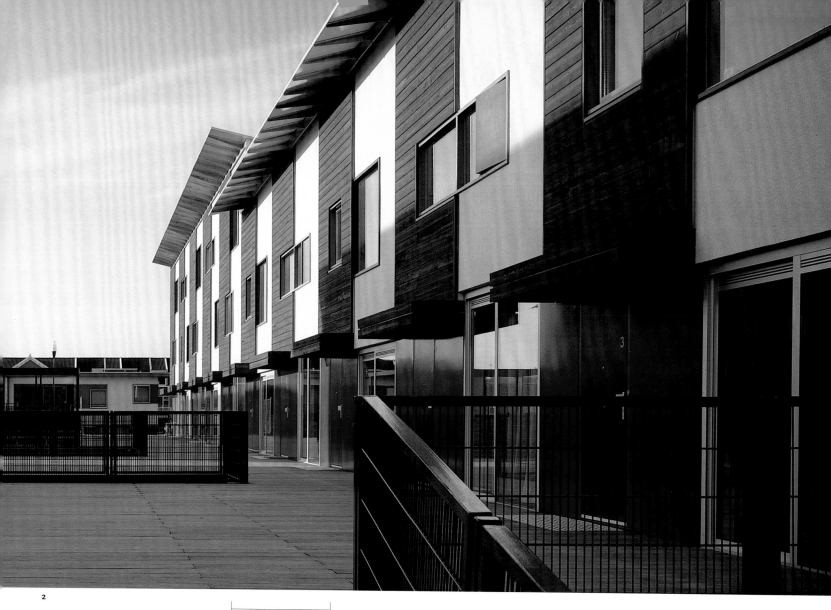

2

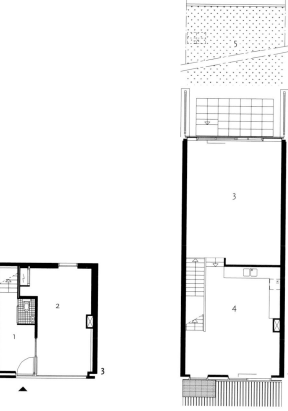

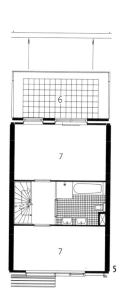

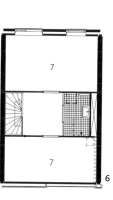

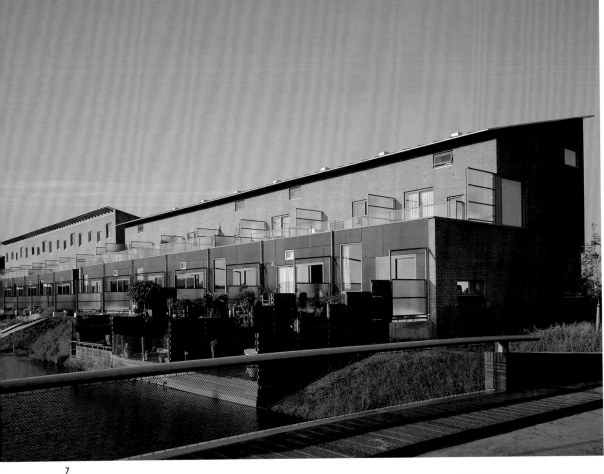

Roof terraces at first-floor level, garden patios and level changes down to the water, with the 'double-decker' interconnected levels on the 'street' side, provide a confident manipulation of the horizontal landscape. There is a rich diversity of external living spaces from which the islands of terraces rise up. In addition, the mono-pitch roof planes are inclined in different directions to break up the continuity of the terrace in a conscious effort to avoid the repetition for which terraces are sometimes criticized. The surfaces are a combination of white-painted render, orange masonry and natural larch panelling.

7

7 At the back the houses have roof terraces at first-floor level and back gardens that stretch down to the water's edge.

8 Section, 1:200. The roofs are sloped in different directions to animate the façades and break up the continuity of the terraces.

9 The lower ground floor has access for cars and parking spaces. As planting matures it is intended to grow up through the openings in the timber deck above.

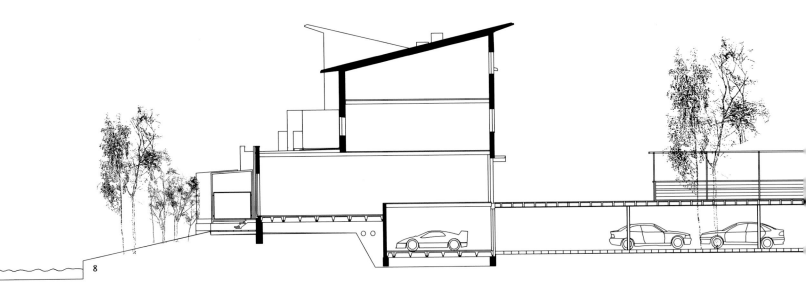

8

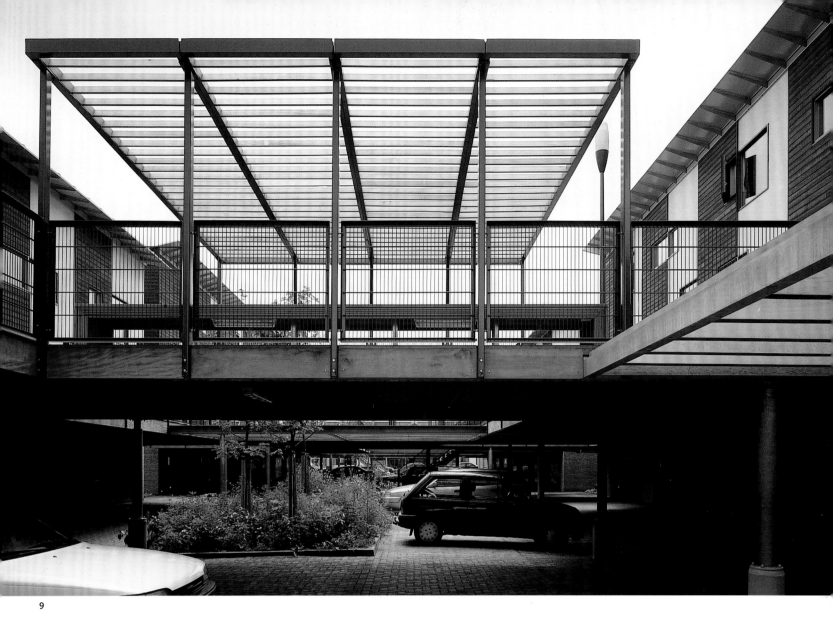

9

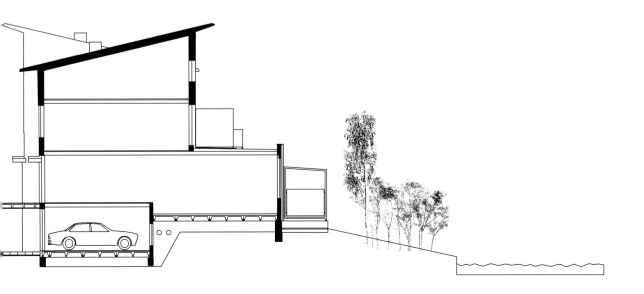

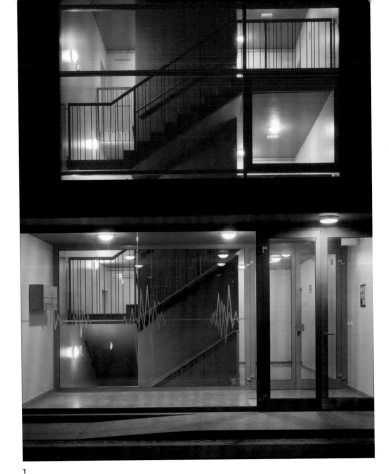

Ofis architects, Rok Oman and Spela Videcnik, have been awarded several prizes for their housing designs. They won the Piranesi award, a prestigious award for Eastern European Architecture, in 2000 and were the recipients of the UK Young Architect of the Year award in 2001. In the same year they won the Europan 6 (for new ideas in housing design). Their first housing project to be built – on a site in a redundant industrial area of Ljubljana, overlooking a lake and woodlands – was the result of winning a competition in 1997.

Their scheme comprises three terraces: each measures 68 x 16 metres (223 x 52 feet), is three storeys high and has ten

apartments per floor. A basement level has storage areas and parking space. Vertical circulation shafts are enclosed within the overall volume, while two or three dwellings share each landing. Externally, glazing identifies the entrances and circulation shafts, and breaks up the otherwise continuous line of the façade.

The plans as built are very different to the original designs. A change in client and a revised brief after construction had already started required the architects to reduce costs considerably. Alternative apartment layouts had to be devised based on foundations that were already in place, and the specification of materials for

1

Housing Block 16X68
Ljubljana, Slovenia
Ofis architekti
2001

1 Detail of glazed entrance façade.

2 Site plan, 1:2,500.

3 Part ground-floor plan, 1:200, as built, showing three units. Studio apartments are located behind staircases.

4 Loggias and winter gardens alternate along the length of the rear façade. The ground-floor units have private back gardens.

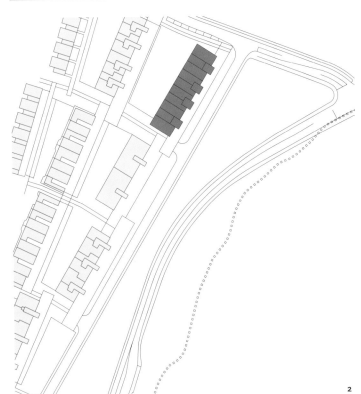

2

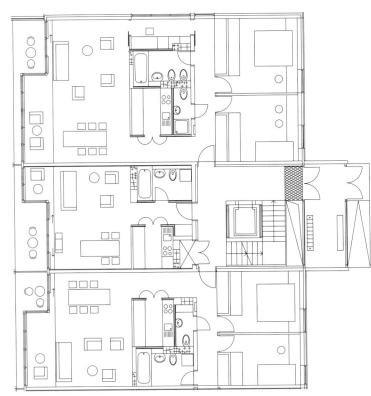

3

cladding, fittings and finishes was reduced. PVC replaced timber window frames, render replaced granite facing panels and off-the-shelf industrial components were specified in place of the purpose-made balustrades and *brises soleil*. Most importantly, the apartments had to be reduced in size to provide ten on each floor instead of the original eight. The overall dimensions of the block remained unchanged, which meant that apartments had to be narrower. This required the architects to more or less abandon their original design intention to provide maximum flexibility that had won them the competition for design innovation.

The original layout follows a modified terraced principle in which the habitable space extends full depth from front to back between solid flank walls. It is then divided into three strips: living space, bedrooms and a service zone. The service zone includes the kitchen and bathroom, and is set in the centre of the plan furthest from any daylight. The bedrooms are on the east side, with windows cut into the solid façade, and the living spaces are all on the west side to take advantage of the winter sun and views across the lake. The façade here is fully glazed and zigzags at different intervals to enclose winter gardens and frame balconies of different sizes.

Intended to provide maximum flexibility, the plans were devised to accommodate different partition layouts within the standard envelope. The entrance in the middle of the plan and a width of 7.5 metres (25 feet), allows for the service spaces to be configured in several different ways, and for a corridor on both sides to allow cross ventilation and daylight deep into the building.

As built, the plans of the larger apartments have retained the same zoning across the depth of the block and kept the generously sized strip for loggias and balconies on the lakeside façades. The apartments at either end of the block are the same width as

originally planned, but the others are much narrower, with one central corridor and fixed room layouts that give little or no opportunity for future alteration. Single-aspect studio apartments have been included behind the staircases. Despite the obvious compromise in the internal layout, the overall composition, the form and scale, and the material quality of the terraces, has been successfully retained.

4

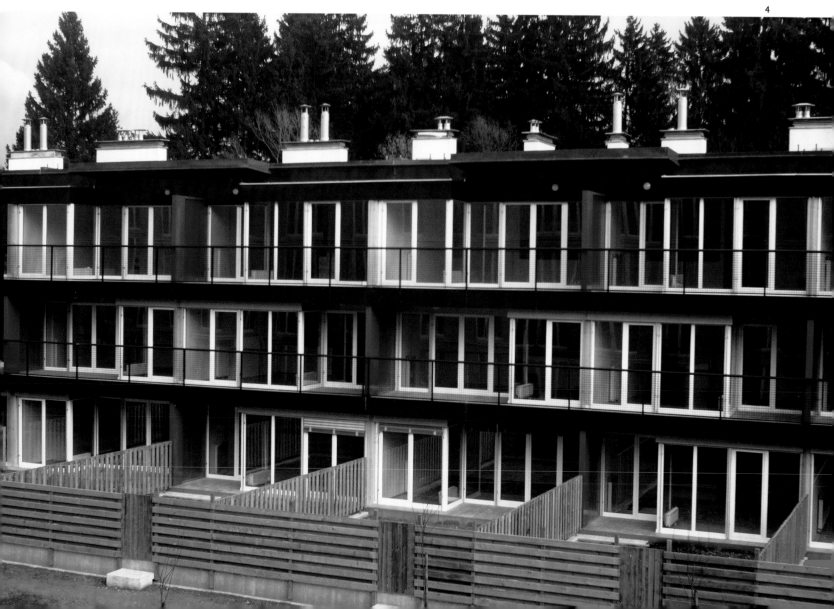

The 'in-between' terrace is located on the site of a redundant warehouse in a yard behind the rows of nineteenth-century terraced houses that are commonplace in Hackney, north-east London. Industrial activity is no longer acceptable on sites this close to residential areas, but Whatcott's Yard was ideal for a residential development. The three terraced houses that make up the scheme were not built speculatively. Two architects, Annalie Riches and Silvia Ullmayer and a designer, Barti Gariboldo, designed and built the In-between Terrace to live in themselves. The site layout, the overall form and construction were developed in collaboration to arrive at three houses of identical footprint, which were then designed individually.

The overall form of the terrace evolved in relation to the constraints of the site. As a starting point, a narrow pathway is located along the northern edge of the site leading to the entrance to each house, and a shared garden takes up the south side. The south-facing façade is fully glazed and is inclined perpendicular to the gently sloping roof. The north façade, with access pathway, is more solid, with window openings positioned in relation to the interior spaces.

A timber-framed construction is used, with beams that span the full width between the party walls, avoiding the need for any internal load-bearing structure and leaving all options open for positioning the internal partitions. The footprint of each house is an identical, roughly square plan of about 47 square metres (506 square feet). Each has at least one upper storey and a combination of other partial floors or mezzanines. These are wider than average for terraced houses, and therefore avoid the problem of insufficient daylight in the centre of the plan associated with excessive depth from front to back.

The interiors are all very different. Such diversity would be much less likely in a speculative development for which a certain amount of repetition is required to keep costs down and profit margins up. One interior was designed as two self-contained flats, whereas the others are two-bedroom houses. The design of the interiors demonstrates a shared preference for certain materials and finishes. All three, while tailored to suit different requirements, employ a similar spatial language. Steps in floor level are used to demarcate different areas and the simple stacking of floors arranged one above the other is eschewed in favour of interconnecting levels, double-height spaces and mezzanines. Roof lights are used to bring daylight into enclosed rooms.

In-between Terrace, Whatcott's Yard
London, UK
Annalie Riches, Silvia Ullmayer, Barti Gariboldo
2002

1 Garden space on the southern side. Bedrooms are located at lower levels, where the foliage affords a greater degree of privacy.

2 Site plan, 1:2,500. The terrace is located in a yard between rows of nineteenth-century terraced houses.

3 Kitchens and living spaces occupy the upper floor levels behind the inclined, glazed façade.

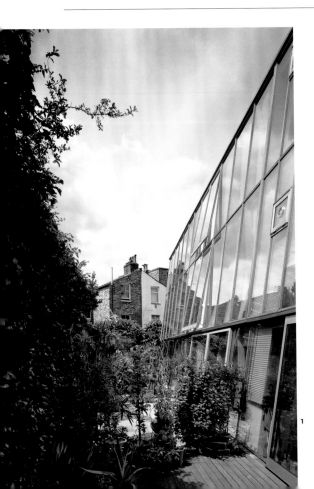

1

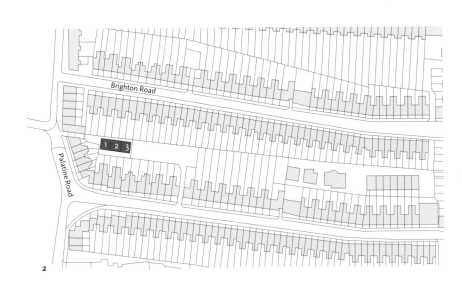

2

3

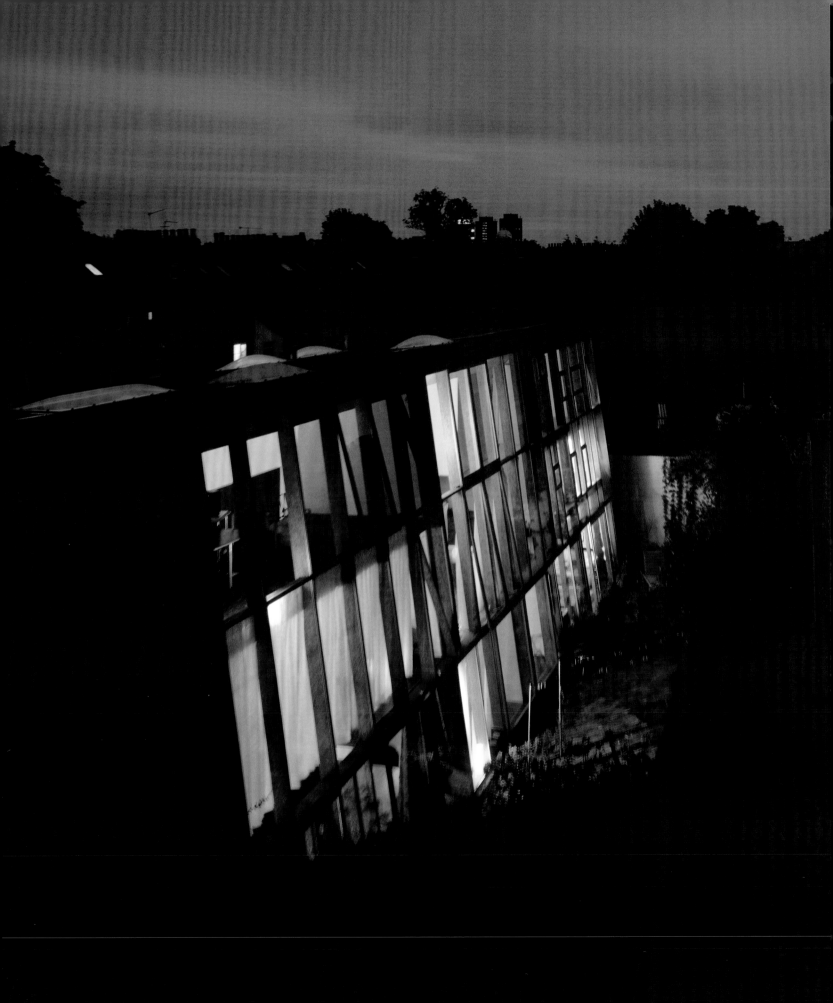

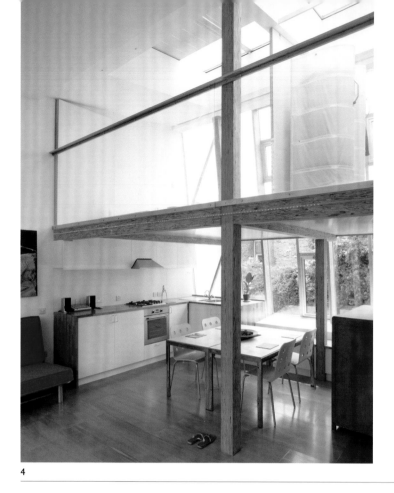

4

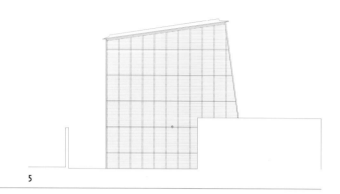

5

4 Interior of House 3. Sleeping space on the mezzanine above the first-floor open living space. The ground floor of this house was designed as a self-contained unit.

5 West elevation, 1:200.
6 House 2. A bedroom is enclosed within the volume of the first-floor, double-height living space.

7 House 2. The kitchen at first-floor level is set back from the fully glazed façade and overlooks the full-height void.

8 House 1. Ground floor with bedrooms and open stair hall.

9–11 Plans, 1:200. Ground floor (11), first floor (10), mezzanine (9). House 1: Annalie Riches, House 2: Silvia Ullmayer and House 3: Barti Gariboldo (designed as two self-contained units).

12 The first floor of House 1 has a change of level between living and dining spaces.

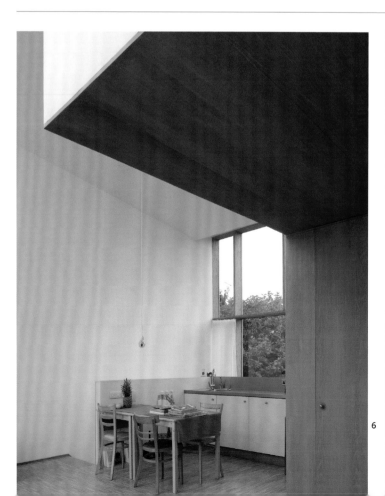

6

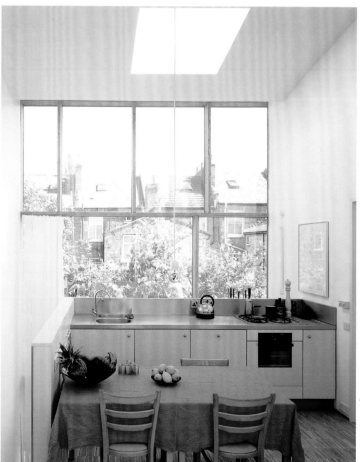

7

8

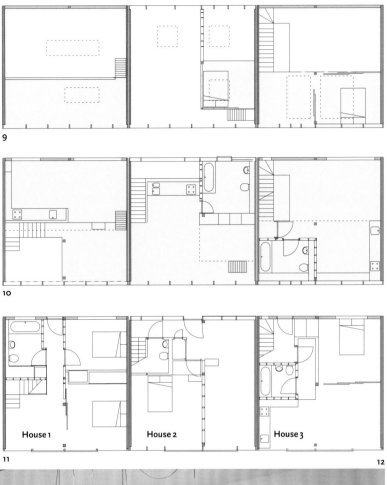

9

10

House 1 House 2 House 3

11 12

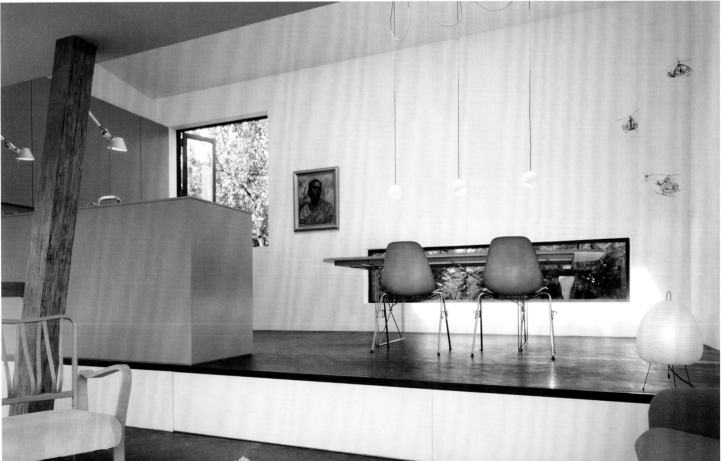

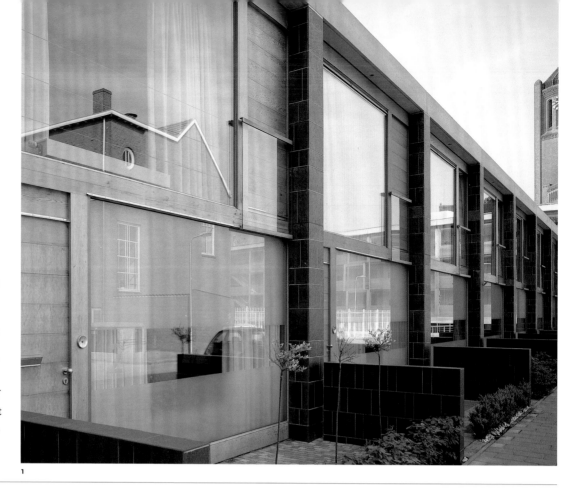

The client, a Dutch housing association, Wonen Midden-Brabant, stipulated two main requirements in their brief: housing, some of which was to be for rent and some for owner occupation, and a robust urban intervention that would help to structure and define the site and its surroundings. Erick van Egeraat responded with a deft plan comprising two linear blocks set at right angles to each other to define an open square. One is a terrace of nine two-storey houses for owner occupation and the other a block of three storeys plus a semi-basement that contains 26 rental apartments. The same palette of natural materials and finishes, and

1

Stuivesantplein Housing
Tilburg, The Netherlands
Erick van Egeraat
1999

1 The terraced houses are set back from the street with small gardens in front of the fully glazed façades. The party walls extend beyond the line of the façade to clearly identify each house.

2 Site plan, 1:2,500. At right angles to the terrace is the three-storey block of rental apartments.

3–4 Plans, 1:200. Ground (3) and first (4) floors. The kitchen, bathroom and circulation spaces are located in the central, darkest part of the plan.

5 Together the terrace and block form a public square.

2

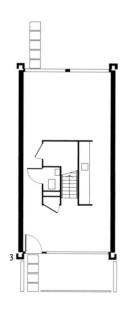

3

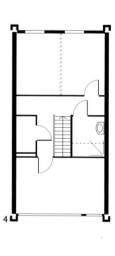

4

similarities in formal composition, link the two elements spatially and visually.

The composition of the whole is an important factor in the design of the façades facing the square. A heavy concrete frame contains the block and the individual apartments are barely visible behind the glazing that encloses the access corridors. Two staircases, clearly visible at either end, reinforce the symmetry of the composition. The terraced houses present a similarly restrained façade. The ends of the party walls that protrude between the glazed elevations are clad in slate as are the flank elevations, demarcating the individual dwellings.

The positioning of the two elements is also important for orientation and daylighting. Access to all the dwellings is from the north side facing the square. Living spaces in the terraced houses are then orientated southeast on the opposite side, where each has a private garden. In the apartments, the living spaces face southwest; all have covered balconies within the overall building envelope, which has views onto a nineteenth-century church – an important local landmark. Internally, staircases are positioned centrally in the terraced houses. Here also, in the darkest part of the plan, are the services, kitchens and bathrooms. On the ground floor, circulation space on

both sides connects the living room at the back with the dining room at the front.

The terraced houses each have a front garden, or yard, distancing the front doors from the public domain to provide an adequate sense of privacy. In the apartment block the access corridors are wide and, although shared with several neighbours, fulfil the same function of providing a sort of buffer zone between the private space of the dwelling and the public space of the street. The consideration for potential problems caused by too-close proximity between public and private spaces continues in the interior layouts. Immediately inside the apartments there is a very large

hall with an unspecified use. It is easy to imagine how this, too, might serve as an additional buffer zone, whether used for the type of activities house dwellers carry out in their porches, lofts or garden sheds, or simply as a means to separate the more private areas of the apartment. Similarly, the terraced houses have a space designated as a dining room at ground-floor level, next to the front door, which might equally be considered a less private element of the home. Increasingly, such spaces have become multi-functional, perhaps used as home offices or children's playrooms.

5

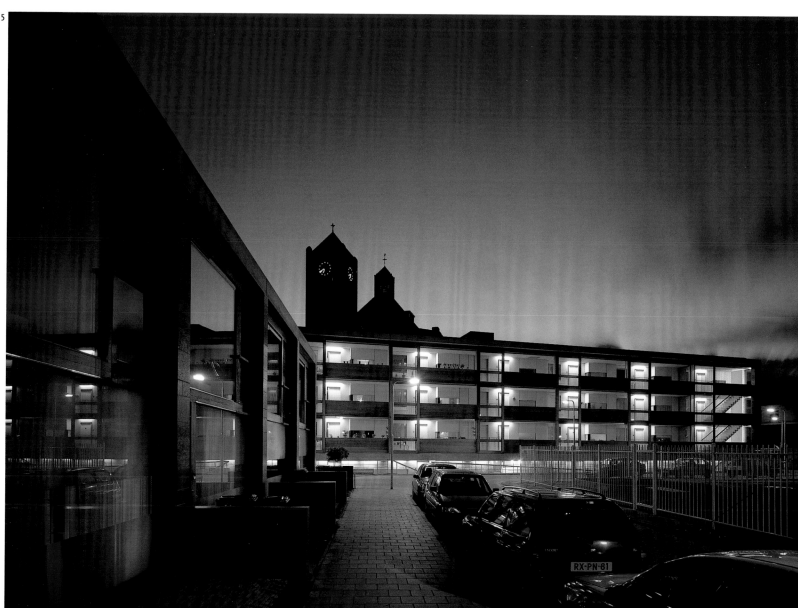

The term 'town house' usually refers to a type of terraced house that includes a garage for a car at street level and these houses, in the densely populated and congested area of the downtown Museum district in Houston, Texas, include spaces for several cars. Three storeys high, the building gives most of the ground-floor level over to carparking in garages and covered carports. Kitchens and living rooms are situated on the first floor, with bedrooms and study rooms on the top floor. The pair of houses were planned to interlock and form an L shape, one side of which faces the street; the other faces onto an open space that is both the driveway and the back

yard. From the street, access to the rear house is reached by going through the front house, between the entrance and the garage space.

The Yoakum Street Town Houses are prototype dwellings. They were designed by Wittenberg Oberholzer as part of an experimental project, based on the idea of the *Arts and Architecture Magazine* case-study houses built in the 1940s to test different designs and construction methods, and inspired particularly by the well-known Eames case-study house in California. The design aims to minimize construction time and costs by using the minimum number of materials and processes. It also explores the use of components

and materials more familiar in industrial buildings, such as painted steel frames and metal sheeting, and exploits materials such as exposed cast concrete and granite pavings in their natural or simplest state. The basic construction is a simple exposed steel frame, 5.66 metres (18 feet 7 inches) across, which is repeated every 2.85 metres (9 feet 4 inches).

Internally, partitioning is minimal. Stairs rise up from the large open-plan living spaces that also contain the kitchen units and work surfaces. The notional party wall, which is continuous along the north side, has been designed as a service space concealing the pipework and equipment, and a

storage zone. Full-height, hinged wall panels open up to reveal storage space behind. The south- and west-facing 'rear' façades are fully glazed to continue the notion of the uninterrupted interior spaces by making a visual connection to the external space. A two-storey-high garden room, or conservatory, at the upper level adds to the sense of light and space. The 'yard' itself is a paved area, contained by the perpendicular wings of the L shape. It also connects the front and back, and is used by cars – a hybrid space that means assumptions about front and back must be put aside.

Yoakum Street Town Houses
Houston, Texas, USA
Wittenberg Oberholzer Architects
2004

1 Site plan, 1:2,500. The open space between the two wings of the 'L' shape is both the driveway and back yard shared by the two houses.

2 The staircase in the middle of Townhouse 1 leads down to the entrance and the courtyard with its pool and parking area.

3 At first-floor level a double-height 'garden room' extends into the courtyard space.

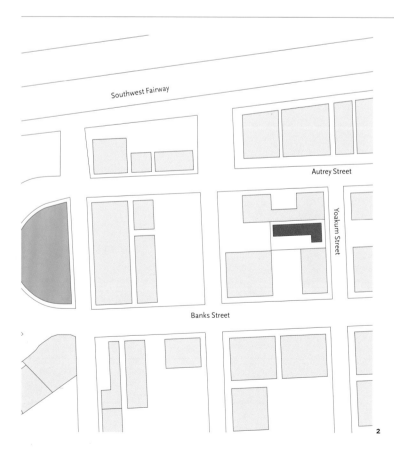

Southwest Fairway

Autrey Street

Yoakum Street

Banks Street

2

2

3

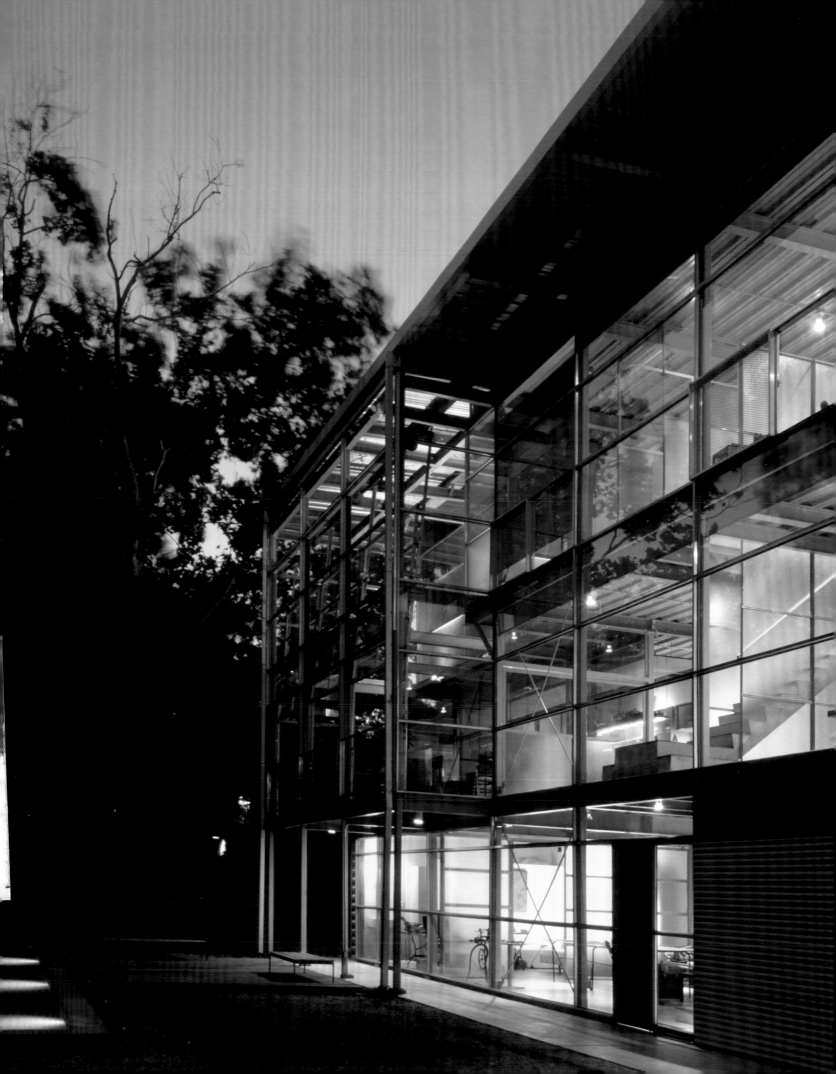

4

5

4 From the rear courtyard a pathway leads between the two houses to the street. There is covered parking at ground-floor level in Townhouse 1.

5 The steel-frame structure and corrugated decking is exposed throughout.

6–7 Full-height hinged wall panels along the length of the solid 'party' wall open up to reveal storage space.

8–10 Plans, 1:500. Ground floor (8), first floor (9), second floor (10).

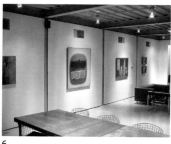

6

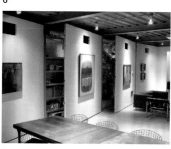

7

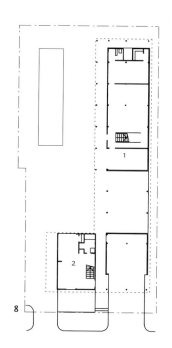

8

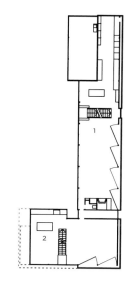

9

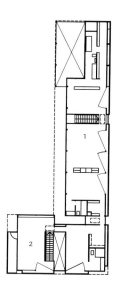

10

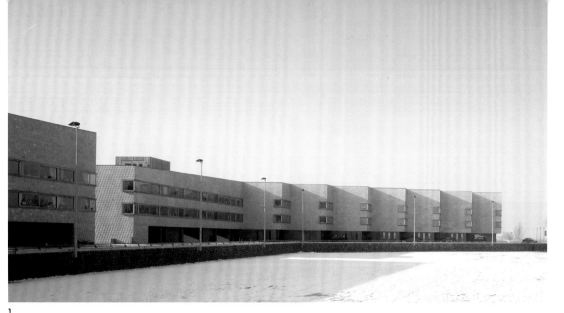

1

daylight levels and spectacular views across the lake. The sloped roof has sun decks cut into it as it rises upwards to the north away from the lakeshore, and the flank elevations are angled to minimize the possibility of being overlooked and to give the best views out.

The plan arrangement of the sphinx and the terraced housing along the length of the esplanade has much in common with semi-detached housing plans. The terraced houses, arranged in pairs, are three storeys high and line the esplanade in rows of between six and 16 houses with breaks between terraces that correspond to, and provide access to, the buildings behind. The party walls are based

The shore of Lake Gooi in Huizen provides a dramatic setting for a housing development, and it has been fully exploited by Neutelings Reidijk's powerful scheme. Built in several phases, it has two separate and distinct elements on either side of a roadway, or esplanade, that follows the edge of the lake. On the lake side, five buildings sit in reed beds on the water joined to the land by narrow jetties; on the other, three-storey terraced houses line the street. The lake-side buildings, or sphines, as they have come to be known, rise under continuously sloping roofs from one to five storeys high. Each contains 14 flats organized symmetrically either side of a spine wall interrupted only in the centre of each block by the lift and stair. The kitchens and bathrooms, cupboards and services are arranged along the central wall. All the living spaces are sited along the external walls, where they benefit from good

Housing on the Shore of Lake Gooi

Huizen, The Netherlands
Neutelings Riedijk
1996

1 Terraces of two house types, single and paired, line the edge of the lake.
2 Site plan, 1:2,500. The esplanade along the lake edge is the main organizational device for the scheme. A further phase for the scheme – the five 'sphinxes' – are built in the reed beds on the lake's edge.
3 Paired houses with the staggered terrace of single houses beyond. The living-room windows have an almost continuous strip along the façade.
4 In contrast to the front elevation, dark brickwork is used on the rear, garden elevations.

2

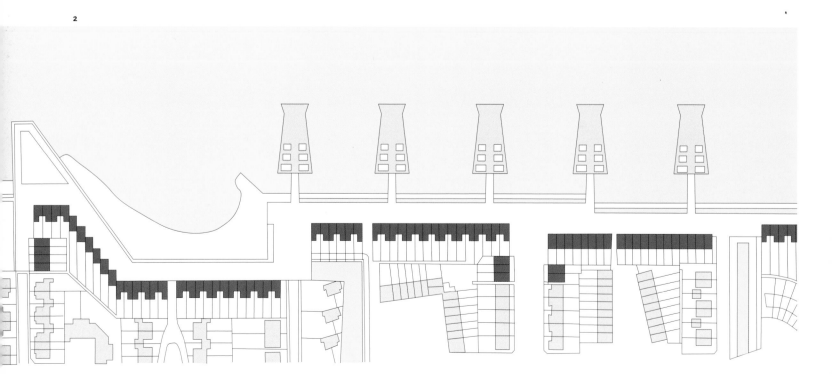

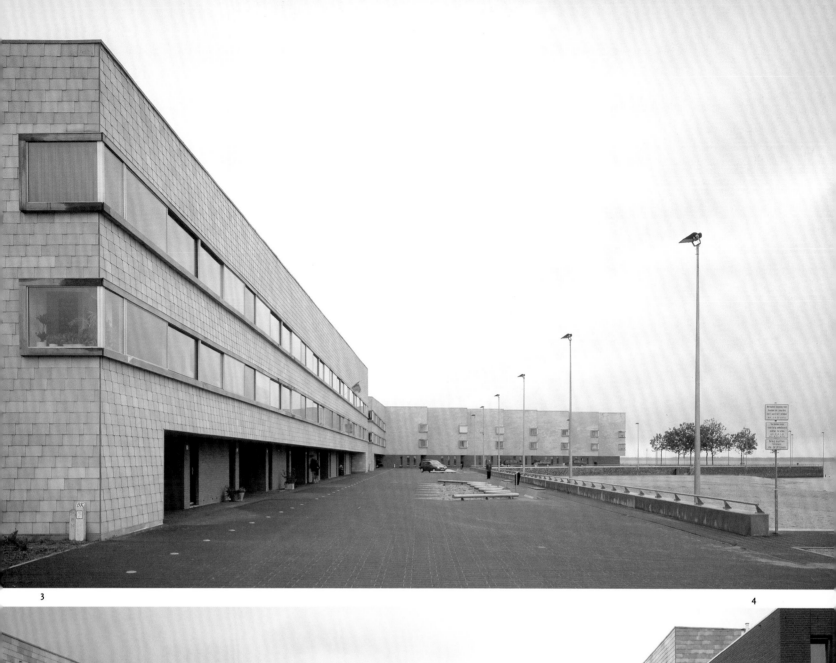

3

4

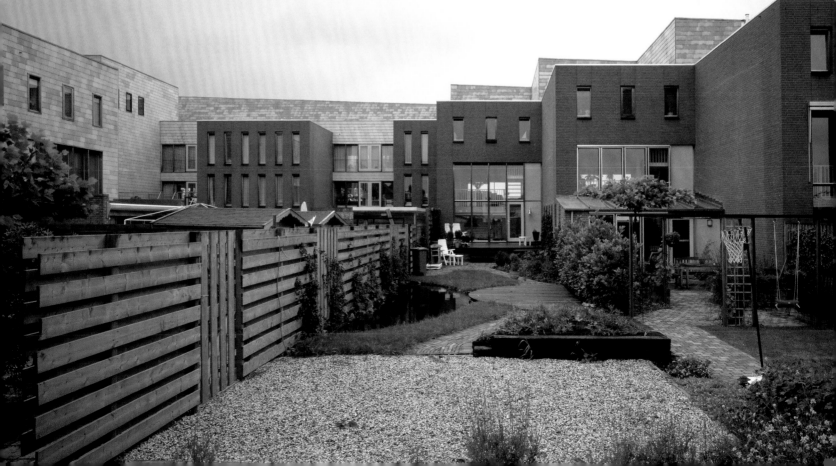

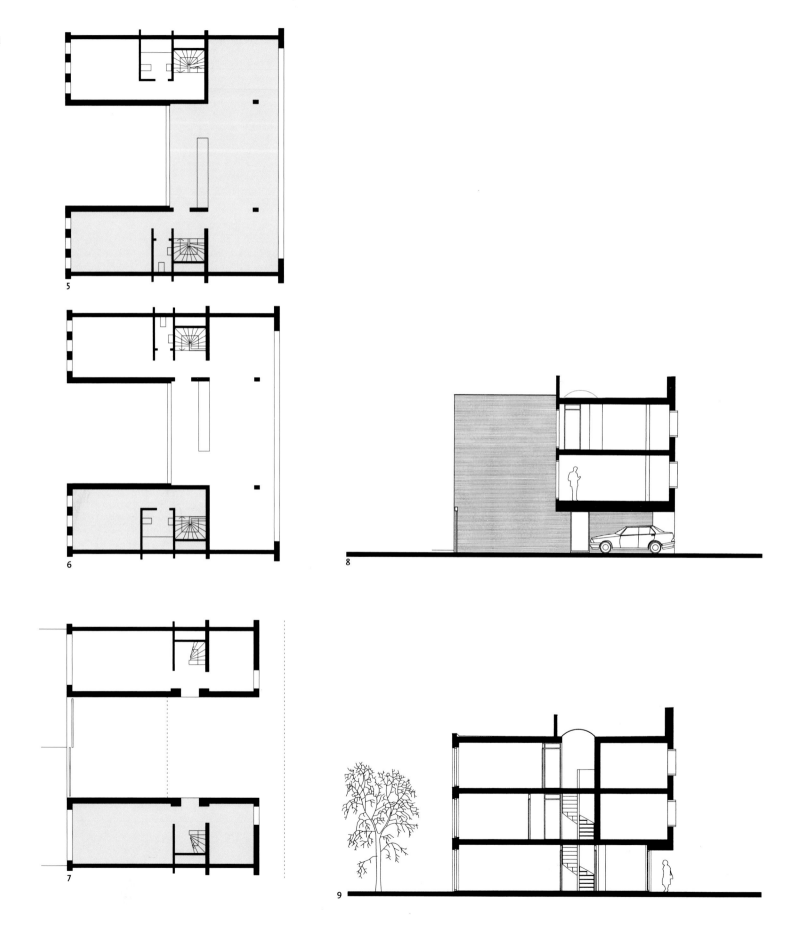

5

6

7

8

9

on houses of 6 metres (20 feet) wide but, rather than restrict the space occupied by each house to the width between the party walls, they are conceived as pairs with interlocking plans. At the upper levels, the living spaces on alternate floors overlap each other to extend the full 12-metre (39-foot) width of two houses. At ground level, each pair has entrances either side of the covered parking space with direct access to a back garden. Inside at ground level there is, with the entrance hall, storage space and a garden room. The kitchen is located next to the living space at either first- or second-floor level, between the wings where the bedrooms are situated, and has

full-height glazing overlooking the garden. The symmetrical arrangement is more clearly visible at the back, where the bedrooms above the garden rooms are paired either side of the gap behind the living spaces. The designers also envisaged the option of adding an external terrace.

The scheme includes a second type of terraced house with the same 6-metre (20-foot) width that conforms to the conventional constraint of the party walls. Again, the desire to create the largest possible living room, which inspired the double-width houses, has resulted in an unconventional design. An open-plan staircase, located in the corner of the plan,

frees up the entire first-floor area for a living room. The sense of light and space is further enhanced by a double-height void at the back, which connects to the kitchen on the ground floor and has full-height glazing overlooking the south-facing back garden. The top floor has a conventional layout with three bedrooms and a bathroom.

Externally, the same materials and textures are used for both types of terraced houses. At the back, overlooking the private gardens, the bedroom windows are narrow, vertical slots. On the front, horizontal glazing bands stretch the full width of the living rooms. Where the esplanade curves around and the plans are staggered

to remain orientated towards the lake, the horizontal windows continue around the exposed corners of the party walls. The scheme uses two contrasting cladding materials: natural-coloured, fibre-cement panels and reddish-orange brick. The internal finishes are render and ceramic tile flooring. The esplanade is an integral part of the scheme conceived as if a journey interrupted by events along its length. A fishing jetty, a square, a wind balcony, a surf beach and a look-out are all provided to act as a prompt for activities that will contribute to a sense of community.

5–7 Paired house floor plans, 1:200. At ground level (7) entrances face each other across the parking space. On first (6) and second floors (5) a full-width living space extends on both levels across the width of the two houses.

8 Paired house section, 1:200, through the car port in the central space.

9 Paired house section, 1:200, through the staircase.

10 The lakeside 'sphinx' buildings. Terraces are cut into the continuously sloping roofs as they rise upwards away from the lake shore.

10

Chapter 2

Quadrangles and Courtyards

1 The private central courtyard space of London's Dolphin Square, built in 1937.

The bungalow court appeared in Los Angeles about 1910 as a new form of low-cost or moderate-cost housing, consisting of a number of small attached houses or separate bungalows grouped around a central garden.
Dolores Hayden, *Grand Domestic Revolution*, 1981

By the end of the nineteenth century, designers of apartment blocks in New York had discovered the quadrangle, or courtyard block, as a new model. In earlier designs, as in the European models, the courtyard was a secondary space seen only as a service area or light well. Graham Court (1901) on West 79th Street, built for for the Astor family, is generally considered to be the first block that uses a courtyard as a significant space. It was followed by many others, notably the Belnord (1907), by Hobart Weekes, on West 86th Street, which occupied the whole city block and enclosed a courtyard of vast dimensions, 28.6 x 70.4 metres (994 x 231 feet). Such courtyards were designed as enclosed, impressive gardens, often with fountains and lawns. Semi-public spaces, they were yet separate from the public realm of the street. Dolphin Square (1937) in London is a rectangular block of high, dense and uniform façades that encloses an entirely private space. This introverted form is reflected in a programme that provided for all the tenants' needs, including parking, a gymnasium, restaurant and shops. In a densely populated city, a courtyard provides shared external space much larger than any attached to an individual dwelling, affording respite from the noise and clamour of the urban environment.

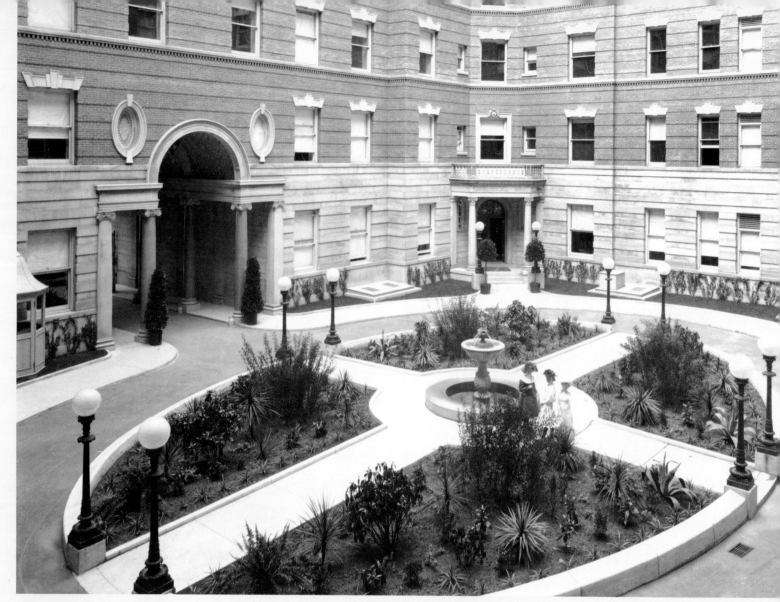

3

At the scale of the individual dwelling, Rudolf Schindler's name is synonymous with the patio, or courtyard, house (1922) that he designed for himself and Clyde Chase in Hollywood at a time when bungalow courts were the popular model in California. Schindler's El Pueblo Ribera Court (1923) in La Jolla uses the same ideas – outdoor living on patios and trellised verandahs – in a multi-unit scheme that, although suburban, is relatively high density, with 50 per cent ground occupation. Similarly, The Ryde housing scheme, in Hatfield, England (1964) by Phippen Randall and Parkes (PRP), although single-storey, is notable for its high density. In this more urban location, the patio is included as an outdoor room that brings light and natural ventilation into the centre of very deep terraced-house plans.

In the examples included here, architects have introduced the use of the void spaces – courtyards, patios and quadrangles – as a key organizational or structuring device in the scheme. Following in the tradition of college quadrangles and monastery cloisters, the new accommodation at Queen Mary College in London's East End uses a courtyard model for several of the student residences. These are not fully enclosed but form a U-shaped court with the intention of providing a sense of identity, community and belonging. The court also provides the benefits of some semi-private, sheltered open space.

In the Maquinista scheme, a housing project in Barcelona by Josep Lluís Mateo, the void in the centre has become the organizational device for the site. Tall blocks line the edges, with smaller-scale buildings within the space, which is landscaped with lawns, trees and pools. This is a busy space with access points to the different buildings all round.

Walter Menteth's sheltered-housing scheme for Ujima Housing Association, High Cross Road, London, is much smaller in scale, but again uses the courtyard as an organizational device. It creates order in an area where there is otherwise only a chaotic mix of piecemeal development and the remnants of earlier town-planning schemes long since abandoned and carved up by traffic planners. In this scheme the courtyard is accessible only by the residents, and it is a calm and intensely private space removed from a sometimes hostile neighbourhood.

In Leipzig, HPP Hentrich-Petschnigg & Partner's courtyard scheme was built as starter homes intended for young people. Behind the row of buildings that continue the street façade, the courtyard is similar to a row of English suburban semi-detached houses with the fences taken down so that the back gardens form one big, shared garden. Although a private space, this courtyard and the activities that take place within it are highly visible. Other dwellings overlook the courtyard and, from the street, it can be

5

2–3 Graham Court, Seventh Avenue, New York, 1901, Clinton and Russell. The central landscaped courtyard overlooked by the apartments.

3 Typical floor plan, 1:500. One of the earliest blocks with living spaces overlooking a central courtyard space. Vertical circulation is organized in four corners with six

secondary service stairs and lifts for the twelve apartments per floor.

1. lobby
2. foyer
3. parlour

4. dining room
5. chamber
6. bathroom
7. kitchen
8. pantry
9. servants
10. servants' stairs

4 The Belnord Apartment Building, 1907, Hobart Weekes, was one of Manhattan's earliest apartment buildings to occupy the whole city block.

4

glimpsed through the spaces between the buildings. Delugan_Meissl envisaged their mixed-use scheme in Vienna as a natural, undulating landscape, continuing from the rear courtyard under the building and rising upwards on the street façade. The sloping grass roofs of the 'fingers' of offices are overlooked by the apartments but are not accessible. Between them the long narrow courtyards provide ventilation, daylight and open space for the office workers who inhabit the lower levels.

In Sydney, Australia, the climate – the heat and low rainfall – and the culture of living outdoors means that the inclusion of external spaces, either within individual dwellings or at a larger scale, is much more common. In the Mondrian Apartments by Stanisic Associates, each of the four blocks is reached via a private, planted courtyard accessible only to residents but adjoining a public footpath that crosses the middle of the site. The decision to arrange the buildings on the site with a series of courtyard spaces was a key part of the architect's strategy to achieve high levels of sustainability – using natural ventilation, avoiding solar gain and reducing energy consumption – the success of which has resulted in several awards.

Similarly, meck architekten's scheme in Ingolstadt links a series of more private courtyards with pedestrian paths criss-crossing the existing city block. Here the open spaces are developed to work in conjunction with other semi-public spaces, verandahs, common rooms and access walkways. There is also a strong social agenda in designing these semi-private spaces in such a way as to encourage different social groups to mix through a variety of activities. There are raised planting beds close to the housing for the elderly and infirm, sand pits and playgrounds close to the larger family housing, and sitting-out space for students and the elderly.

The Harold Way development in Hollywood, California, has two interconnected courtyards. Four-storey blocks that contain the larger family dwellings are arranged on the perimeter of the site, forming a rectangular enclosure with lower, single-person units grouped in the middle. The different elements within the courtyard spaces – the elevator tower, external stairs and access galleries – break away from the rigid geometry and, with benches, planters and play spaces, loosely arranged, form a richly varied animated environment.

Peter Barber's scheme, Donnybrook Quarter, in London's East End, might easily be included in a discussion on terraced housing. The plan of pedestrian streets, every dwelling with its own front door onto the street, was a key design concept. The scheme is included here because its innovative plan includes a patio for each dwelling. A two-storey apartment and a flat are interlocked to form three-storey units repeated across the site.

5 El Pueblo Ribera Court, La Jolla, 1923, Rudolf Schindler. Different configurations of the interlocking U-shaped plan covers the site at almost 50 per cent, enclosing private courtyards for every dwelling and flat roofs furnished with a timber trellis for sleeping outdoors in the summer.

5

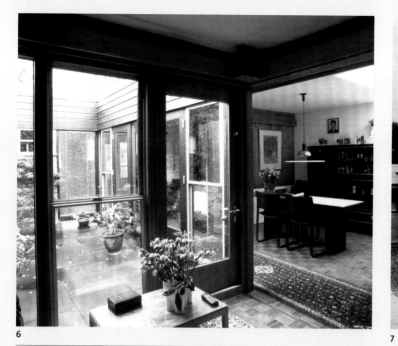

6

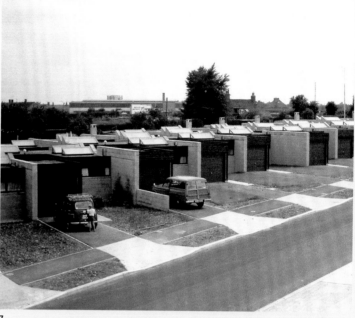

7

6–8 The Ryde, Hatfield, UK, 1964, Phippen Randall and Parkes. Terrace of 28 single-storey patio houses. A sense of space is created with simple planning and the use of natural light with floor-to-ceiling glazing, skylights and the centrally positioned patio.

7 Two-, three- and four-bedroom houses form a staggered terrace set back from the road.

8 Plan of a four-bedroom house, 1:200. Sliding doors and folding partitions contribute to the sense of space.

1. bedroom
2. living room
3. patio
4. dining room
5. kitchen
6. garage

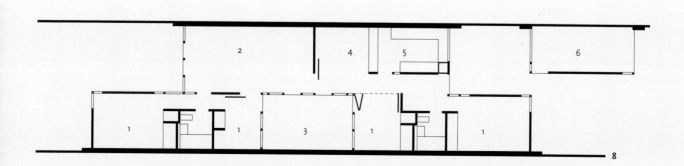

8

In a period in which we are increasingly questioning the need for distinctions, or separations, between residential space, office or working space, and leisure space, student accommodation continues, as it always has done, to combine all three. As well as the dwelling space itself, a student campus – like a microcosm of the city – blurs all these distinctions and brings people into close proximity with one another.

The Westfield Student Village in East London, the recent addition to university accommodation for Queen Mary College, occupies land that was formerly a railway gravel yard, bounded on the east side by the Regent's Canal and to the north by the elevated main railway lines. The accommodation, for almost 1,000 students, is arranged in eight buildings that, in the words of the architect, aim to provide 'spaces with distinct character and levels of privacy'.

A pedestrian street running north–south links the different elements of the site. At the north end it arrives via a wide lawn that stretches the full width of the site, in front of the eight-storey building that forms the boundary with the railway. Another eight-storey block forms the boundary on the east, canal side, this time perforated to allow views to the canal and the park on the opposite bank. This block includes social spaces, bars

1

Westfield Student Village, Queen Mary College
London, UK
Feilden Clegg Bradley Architects
2004

1 A pedestrian street runs north–south between the brick quadrangles and the canalside block.
2 A lawn stretches full width in front of the eight-storey block on the northern edge of the site. Pathways connecting the different buildings cross the open courtyards.
3 Site plan, 1:2,500. Three quadrangles sit within the area defined by taller blocks and the railway viaduct.
4 Looking south along the pedestrian street; the canalside block is on the left and the brick quadrangles on the right.

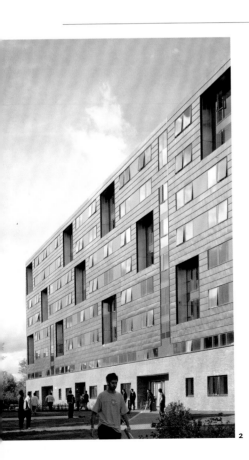

2

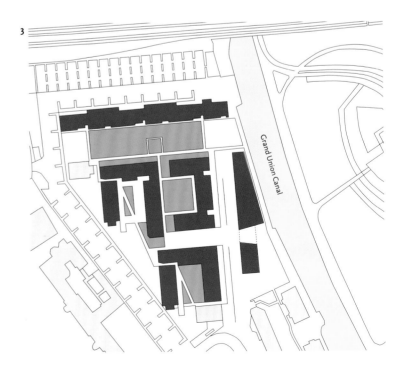

3

Grand Union Canal

4

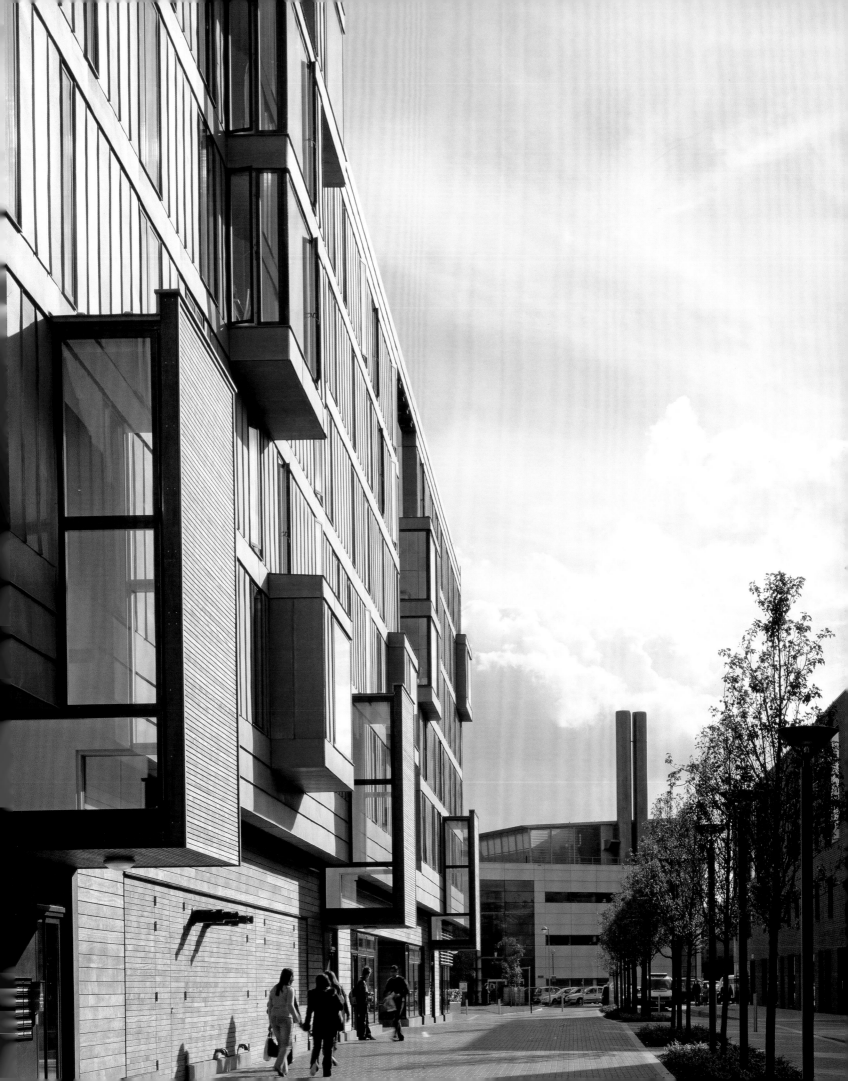

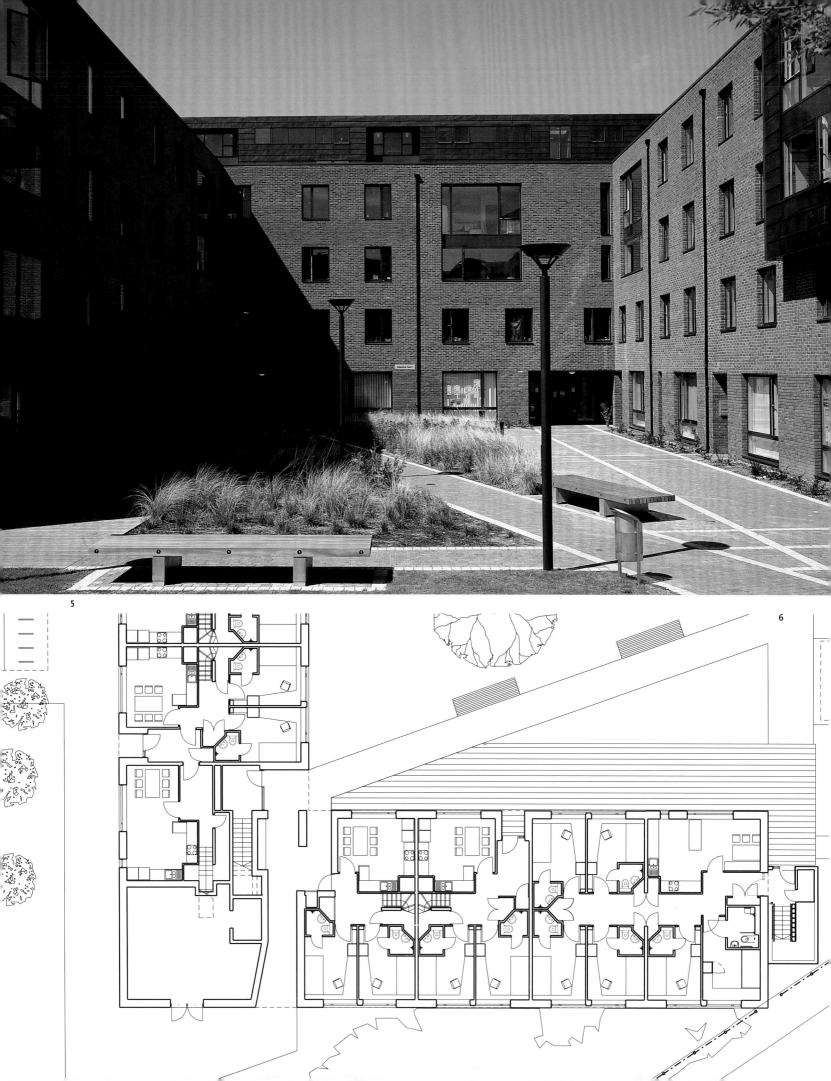

5

6

and shops at the ground level. Within the enclosed space of the site are three smaller, entirely residential buildings, designed as partially enclosed quadrangles, open on one side.

The distinct character of the different buildings is intended 'to avoid an all-too-frequent tendency for student housing to be cellular and repetitive'. The tall buildings that form dense boundaries have a strong visual identity. Highly visible from outside the site, they are clad in copper and have distinctive angled windows. Quite different are the more intimate, introverted spaces of the brick-clad courtyard buildings. These U-shaped, open spaces are crossed by diagonal

pathways, making them part of the network of public routes and connecting them with each other. They provide groups of students with more secluded, shared outdoor areas. One is densely planted with silver birch trees, to further differentiate the buildings, while the others – intended for gatherings and socializing – are open.

Internally, there are 17 variations on the basic student room. The students occupy study-bedrooms – prefabricated en suite showers or bathrooms are standard. Groups of six or seven students share kitchens that have full-height glazing overlooking the courtyards or the pedestrian street.

The scheme has a strong visual presence and the local council must be optimistic that residential accommodation at such a scale will make a significant contribution to the reinvigoration and social regeneration of the area.

5 Pathways connect the different buildings across the open quadrangles.

6 Part ground-floor plan, 1:200, of a quadrangle building. Students are housed in flats and maisonettes with six study-bedrooms and a shared kitchen and dining area.

7 The eight-storey building with its distinctive façade extends to the canalside, enclosing the northern boundary of the site.

7

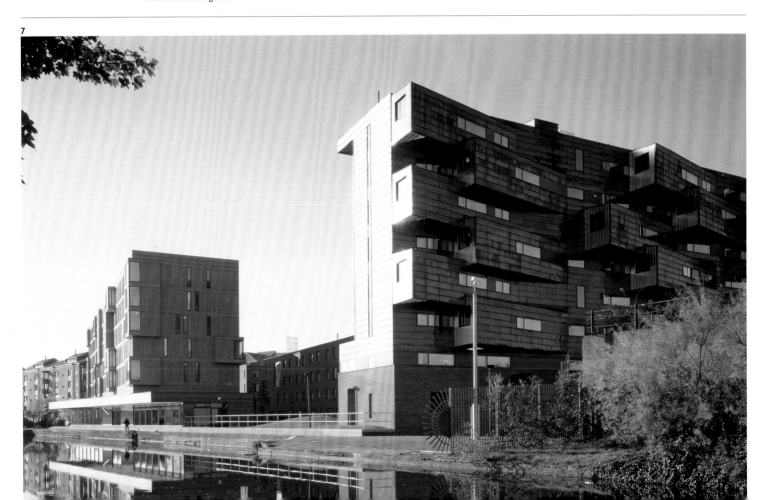

The architects won the project for 500 dwellings in the Maquinista residential area of Barcelona in a limited competition in 1998, and it was completed in phases between 2000 and 2002. The general site arrangement, with taller continuous perimeter blocks and smaller buildings in the centre, was predetermined to an extent by the local urban-planning requirements. From this starting point the approach of the architects to the scheme is based on three key elements: the void, volume and the use of conventional materials.

The perimeter blocks are of two types: on the north and south sides of the site, blocks are of fairly conventional form, approximately 12 metres (39 feet) deep with dual-aspect apartments; on the west and east sides of the site they are double layered, with two parallel blocks separated by a void of approximately 8 metres (26 feet) wide. Designed as a garden, the central void forms the structuring device of the scheme. The architect conceived it as a horizontal plane that continues underneath the inner layer of the perimeter block, which is raised on *pilotis* and rises upwards – a vertical reinterpretation of the patio.

The voids – the central courtyard and the vertical patio – are not passive spaces but describe the access routes. Within the courtyard, entrances to shared lift

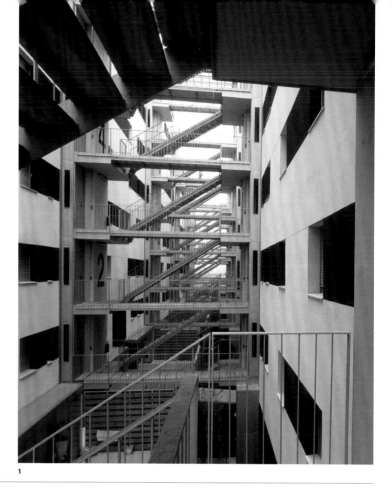

1

La Maquinista
Barcelona, Spain
Josep Lluís Mateo – MAP Arquitectos
2002

1 The 'vertical patio', with bridges and staircases, connects the blocks at every floor level.

2 Site plan, 1:2,500.

3 Part section, 1:500. The lower-level buildings occupy the central part of the courtyard.

4 The central courtyard with lawn, planting and pools.

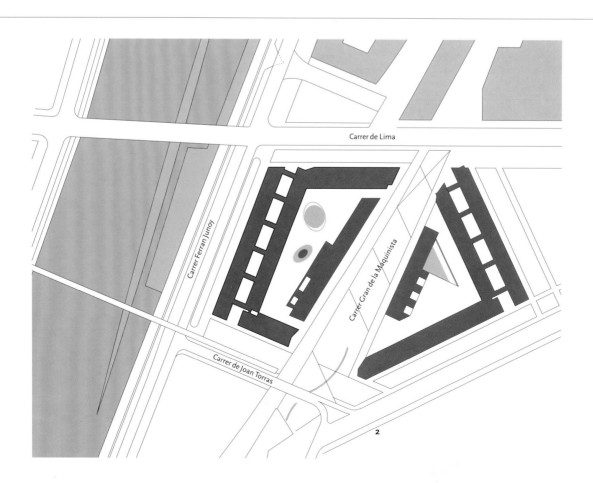

Carrer de Lima

Carrer Ferran Junoy

Carrer Gran de la Maquinista

Carrer de Joan Torras

2

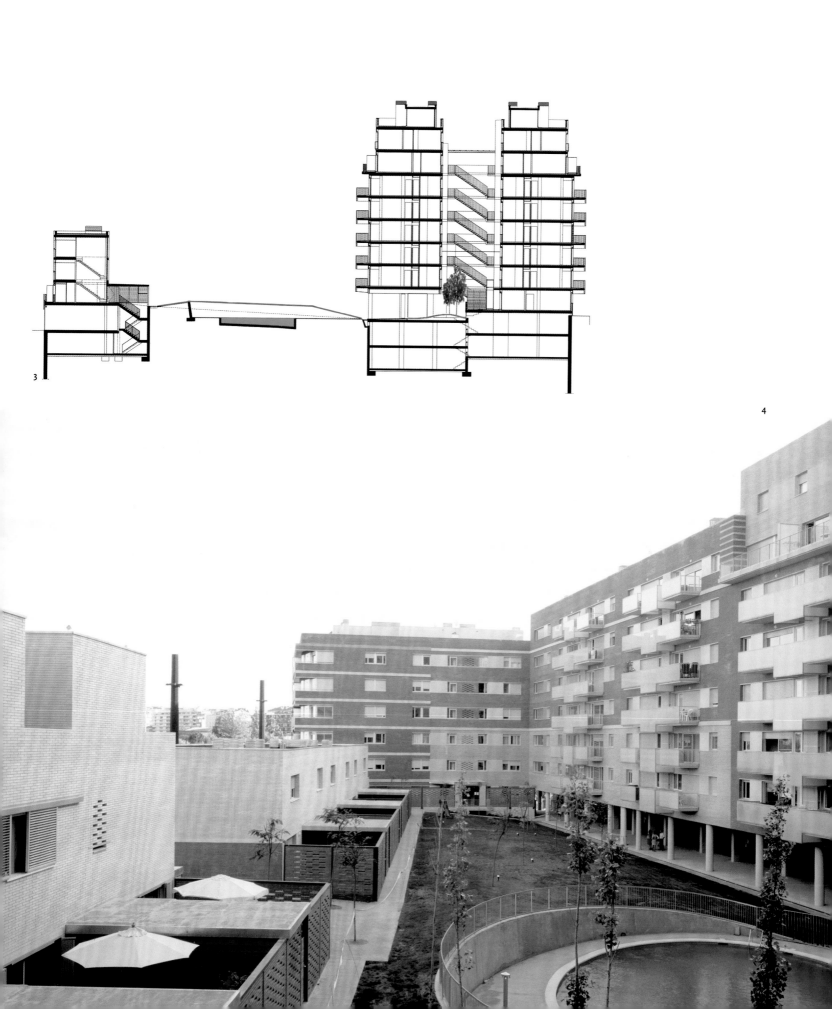

3

4

5

5 The entrance to the upper floors is underneath the inner leaf of the double-layer block, via the central courtyard.

6 Plan of a typical floor level of a double-layer perimeter block, 1:200.

7 The street façades are predominantly brick.

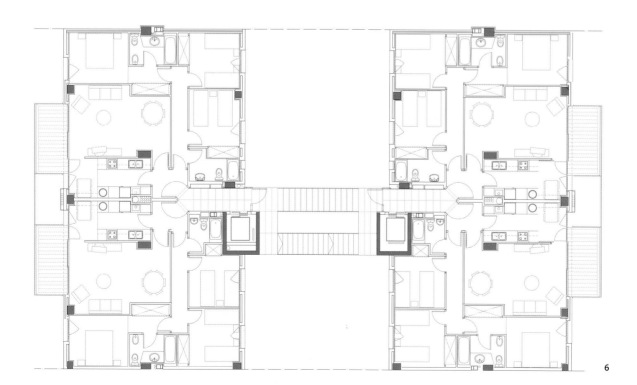

6

lobbies are set out along the perimeter blocks, one for every two apartments. At the upper levels, bridges linked by stairs cross the void at every floor level and connect to each lift tower. By keeping the numbers of dwellings that share landings to a minimum, the architects have achieved a good level of privacy. The vertical patio between the blocks brings advantages of cross ventilation and improved daylight levels, as well as a sense of enclosure to the upper levels.

The standard floor plans are identical on both layers of the perimeter blocks, despite the different orientation, and they vary little until the upper storeys, where set backs are used to modify the volume. Typically, a lift lobby leads to two apartments. From the outside, the entrance doors at the ends of the corridors and the 45-degree angles suggest that space planning will be less than generous. However, despite the small surface area, the apartments are efficiently planned to include three bedrooms, two bathrooms and built-in storage. An entrance hall has doors to the living room and kitchen and to a separate corridor that leads to the more private spaces of the bedrooms and bathrooms. The kitchen is a minimal working area connected to the living space via a small dining area that also has access to the balcony.

7

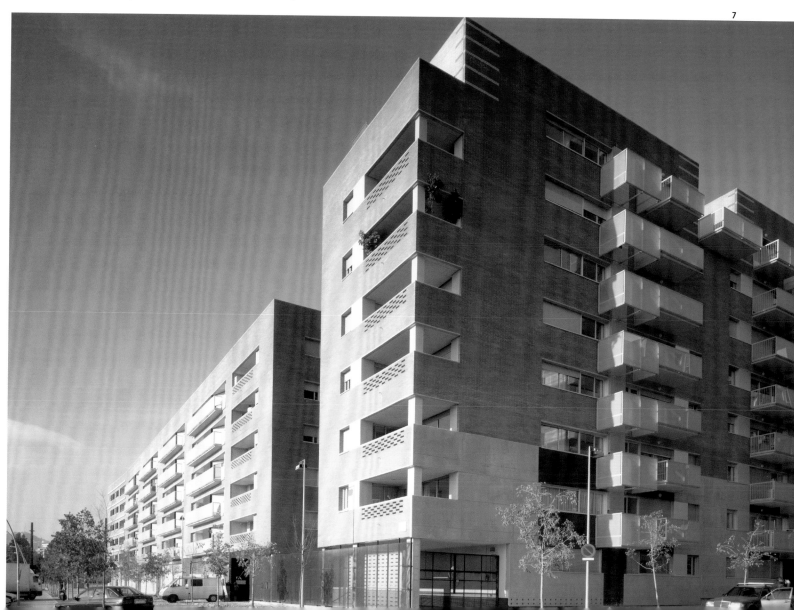

1

From the motorway or dual carriageway, an embankment roughly planted with gorse and ferns is a common sight, where the man-made, smooth surface of the road cuts through the natural landscape. In Haringey in north London, the steep embankment to Monument Way is not such a cutting but reveals itself nevertheless to be a man-made earthwork. The scheme, designed by Walter Menteth Architects, was built for a mental-health housing association, Ujima. All the accommodation is designed for single people with different degrees of dependency.

The embankment, or bund, forms one side of a courtyard roughly square in plan with housing blocks making up its other three sides. On the east and south sides are two-storey terraced houses; on the west side, a taller block is visible above the bund. The terraced houses for single occupation are small – 47.5 square metres (511 square feet) – with an open-plan living room and kitchen on the ground floor, and a single bedroom and bathroom on the first floor. On the ground floor enclosed porches are added at the front that extend the floor area and improve privacy by locating the doors at 90 degrees between the porches. At the back, glazed doors open onto the shared courtyard.

The taller block houses the residential care home and has a

High Cross Road
London, UK
Walter Menteth Architects
2001

1 The stair towers, painted orange, signal the presence of the building behind the protective bund.
2 Site plan, 1:2,500. The bund wraps around the site to enclose the courtyard.

3 One of the rows of terraced houses lines the street.
4 The red brickwork continues, at ground level, to the entrance area of the main block.

5 Ground-floor plan, 1:500. The ground floor of the terraced houses and the communal rooms open onto the courtyard.

2

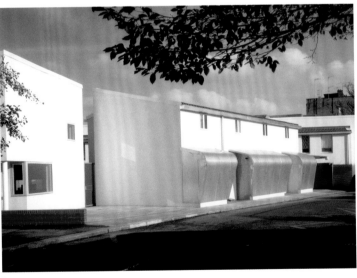

3

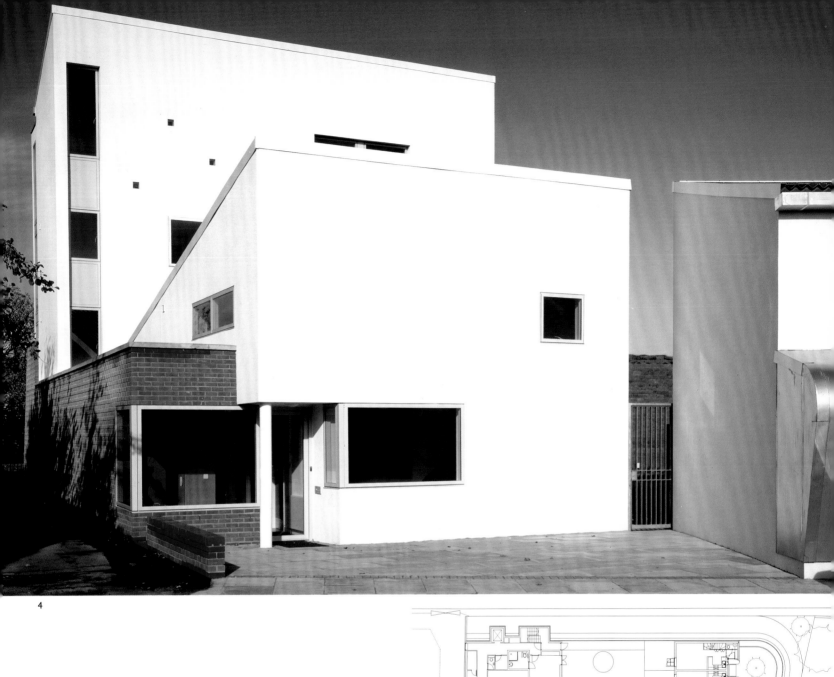

4

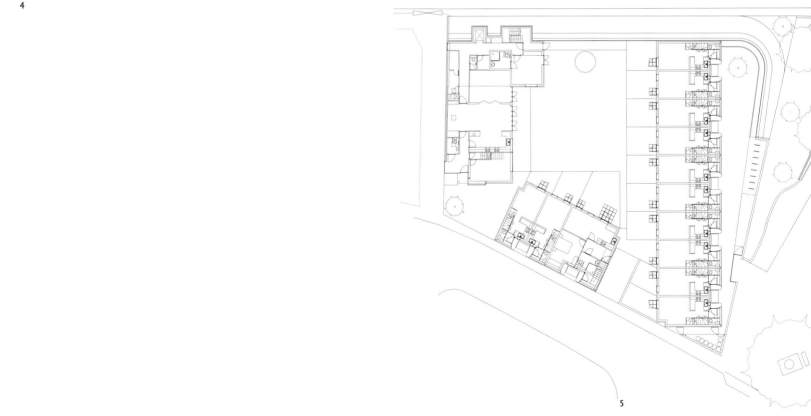

5

series of individual private rooms, each with en suite bathrooms. There are also therapy rooms at the upper levels and administrative offices for the staff at ground-floor level, along with the shared kitchen, dining and living rooms.

From the outside the bund is visibly a protective element: three metres (ten feet) thick at the base and two storeys high, it presents an uninterrupted mass that shelters the dwellings from the noise of the traffic. Continuing the line of the bund, red-brick walls enclose the entrance court to the terraces and the ground-floor level of the block, which, together with the stainless-steel cladding to the entrance porches, form a robust and graffiti-resistant façade. Above the ground-floor level – which has been described as a modern interpretation of a rusticated base – the separate rectilinear forms and simple outlines of the buildings are finished in smooth white render. The courtyard is directly accessible from all sides – from the individual houses and the common rooms in the block. The elevations facing it follow a rigid, regular layout to form a restrained backdrop appropriate to the tranquillity that the courtyard is intended to provide in such an introverted space.

The bund was built using the rubble and spoil excavated during the construction phase, which has been tied together with polypropylene matting and covered with textile bags of soil. The hairy surface of rough planting is expected to grow unchecked. It is retained by a dry-jointed blockwork wall on the courtyard side, which in time, too, will be covered with climbing plants. The bund is successful as an architectural device both in terms of design and function. It visually separates the housing from the dual carriageway and the surrounding area, which is dotted with redundant structures and an incoherent mix of nineteenth- and twentieth-century housing projects. As the key organizational device in the plan, the bund encloses the courtyard and structures the arrangement of the buildings. It is also highly effective as an acoustic damper, isolating the courtyard from the rest of the neighbourhood, and creating an extraordinarily quiet and peaceful space seemingly cut off from the rest of the world.

As a form of housing for people who require more care than most, the architecture makes a bold statement about shelter. The enclosure lends itself to the calm of a monastic cloister while, at the same time, asserting its presence with highly visible circulation towers. These are painted a striking, bright orange to stand out on the dual carriageway, rising up from the wild and hairy bund.

6 Terraced house section, 1:200, showing the additional 'porch' space at the entrance and the mono-pitched roof line.

7–8 Single-person terraced house plans, 1:200, with living room on the ground floor (8) and bedroom on the first floor (7).

9 The simple and restrained façade of the courtyard: the planting is just visible above the retaining wall.

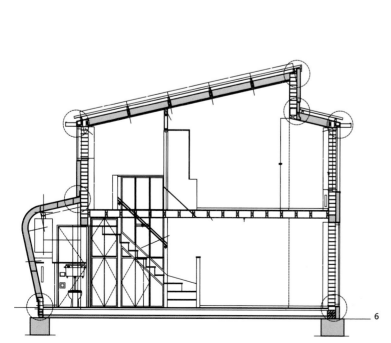

6

7

8

9

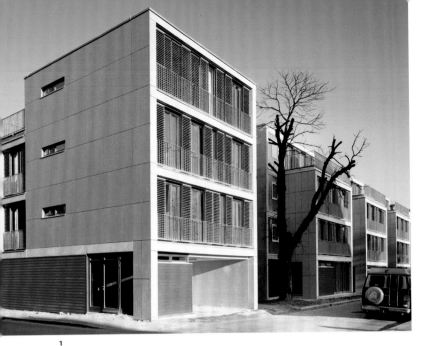

1

The brief for the competition organized by the city of Leipzig was to provide much-needed starter homes for young families. HPP Hentrich-Petschnigg & Partner won the competition with a scheme that combines a coherent, yet curious, interpretation of urban living with a design for individual units that offers the opportunity for differentiation. Flexibility and sustainability were high on the architects' list of priorities and are evident in the designs, both in the assumptions made about patterns of occupation and in constructional and technical aspects.

Located on a corner site, the plan continues the line of buildings along the main Pfeffingerstrasse and around the corner to Biedermannstrasse, enclosing the courtyard. Then, rather than create a continuous façade enclosing a private, inaccessible space behind, the accommodation is organized into six separate blocks with gaps between that allow direct access from the street into the courtyard. The blocks are arranged in pairs that share a vertical circulation tower set back from the street frontage and connected by bridges at upper levels.

The blocks are designed as simple rectilinear forms with structural concrete flank walls and floors. The front and back façades are fully glazed, divided into 12 full-height panels of equal width, approximately 60 centimetres (two feet), and incorporate four pairs of French windows. In front are sliding timber slatted screens for use as *brises soleil*. Fibre-cement panels are used for external cladding and simple steelwork balustrades cross the façades and continue across the bridges. The circulation towers are fully glazed above ground-floor level, and a translucent, structural glazing system that glows with coloured lighting is used on the stairs.

Dwellings for Young People
Leipzig, Germany
HPP Hentrich-Petschnigg & Partner
2000

1 The row of identical blocks mimics a row of detached houses.

2 Site plan, 1:2,500.

3 The shared courtyard space is accessible from the street and overlooked by all the dwellings. Covered parking spaces are located at both ends.

4 Façade of a typical 'block': the sliding shutters screen the apartments from excessive solar gain.

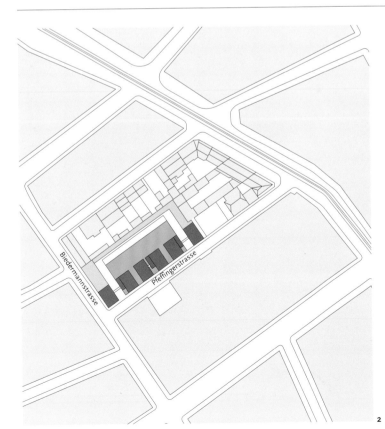

2

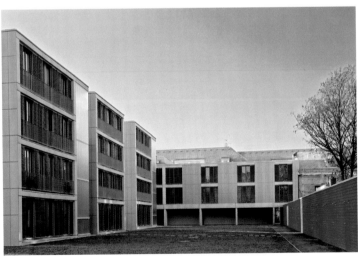

3

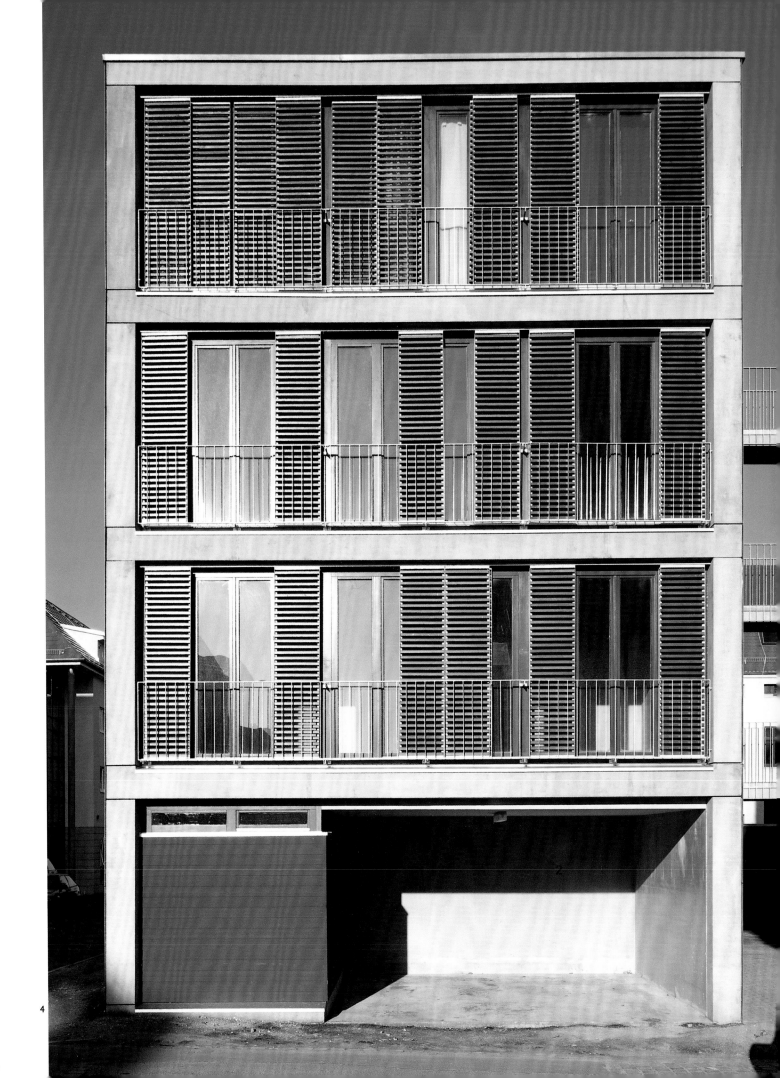

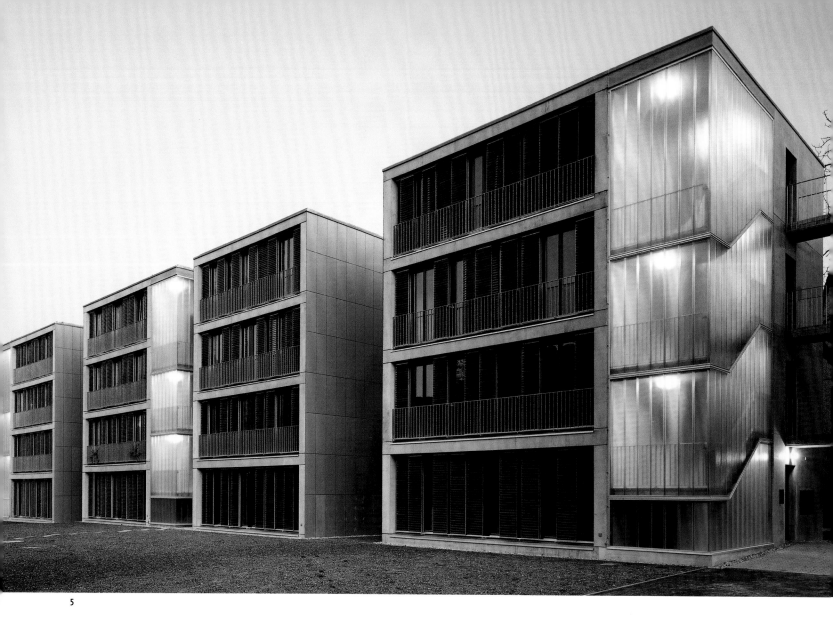

5

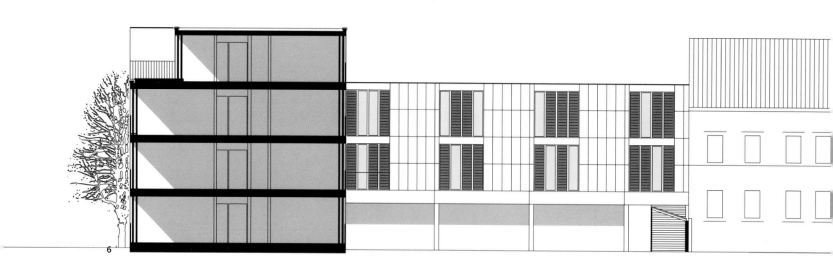

6

In scale each of the blocks is more like a four-storey house with one apartment per floor of approximately 85 square metres (915 square feet), and a smaller apartment on the top floor where there are set backs to form terraces. The absence of any internal structural elements, and the modular arrangement of the façade, is part of the strategy to allow for different internal partition configurations. The entrance hall in the middle of the plan, and the bathroom and WC on the opposite wall, are the only fixed elements within the apartment, and the overall width of more than seven metres (26 feet) means that the circulation space between them is wide enough to be divided centrally. The architects envisaged several different ways in which the apartments might be occupied with different layouts, using non-load-bearing partitions that can easily be altered in the future to suit changing requirements.

Consideration for energy efficiency in buildings is now a requirement of most current construction legislation, and in addition to this the scheme includes further energy-saving elements. The full-height openable windows at both ends of the plan allow cross ventilation through the 12-metre (39-foot) depth from front to back. In addition, the configuration of several smaller blocks allows for windows on the flank elevations that bring natural light and ventilation to all the bathrooms, reducing the need for mechanical ventilation. Solar panels are incorporated to boost the hot-water supply, and there is a rainwater collection and recirculation system for flushing and for watering the garden.

The glazed façades, the bridges between the blocks and the direct views into the courtyard suggest that the inhabitants will be highly visible. Moreover, the coloured lighting of the stairwell and the direct access through to the courtyard draws yet more attention to the buildings and the occupants. The courtyard is the visual focus for the entire scheme, overlooked by all the apartments and surrounded by the covered parking spaces and sheds that line the other boundaries of the site. This suggests the courtyard as the central focus for social activities, part of a scheme that refuses the conventions of privacy in favour of the promotion of a collective approach.

75

5 Open bridges at upper floor levels span the gaps and connect the blocks in pairs.

6 Section, 1:200. The fixed elements, the bathrooms and the storage spaces are located in the centre of the very deep plan.

7 Typical plan, 1:200. The spacing of the glazing on the façades allows partitions to be organized in a variety of different layouts.

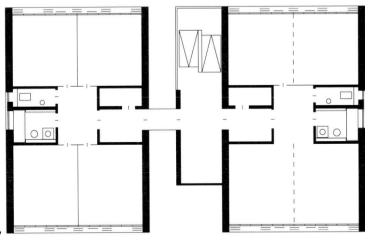

7

1

Delugan_Meissl use landscape design terminology to describe their work, and their recently published book of theory and projects lists 'landscape', 'paths', 'cityscape', 'networks', 'thresholds' and 'façades' as the themes to organize a discussion of their work. To apply their ideas to an urban setting, they start with the topography of a site in its broadest sense. Their designs blur boundaries between the usual distinctions of building and site, of inside and outside, and of constructed and natural. In this way, spatial and formal categories are combined to produce new landscapes.

In the Wimbergergasse scheme in a dense, urban district of Vienna,

Town House, Wimbergergasse
Vienna, Austria
Delugan_Meissl Associated Architects
2001

1 The residents look out over the green, grassy sloped roofs of the office buildings.

2 Site plan, 1:2,500.

3 Section, 1:500. Parking and storage space for both residential and office use extends across the whole site.

4 Long, narrow courtyards provide open space and natural light for the offices underneath the sloped roofs.

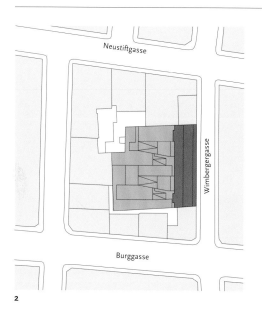

2

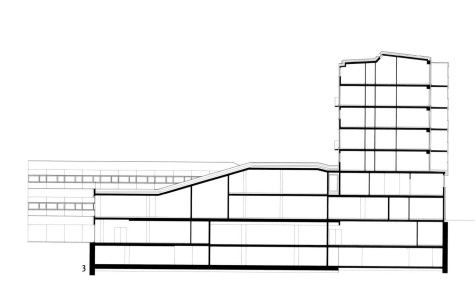

3

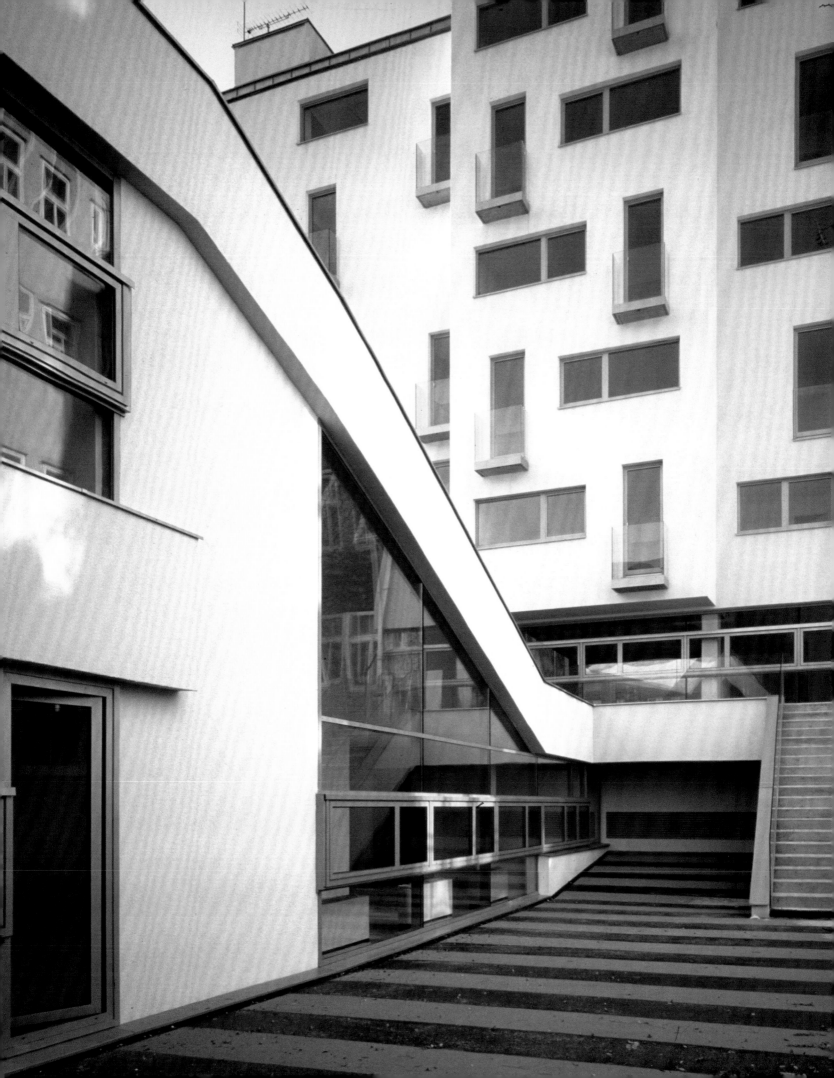

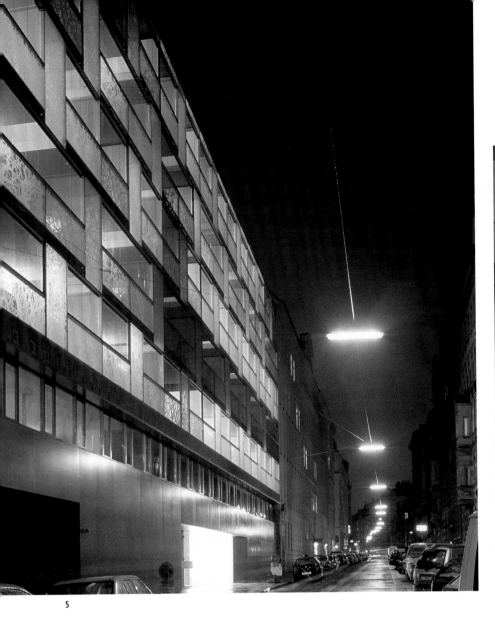

5

6

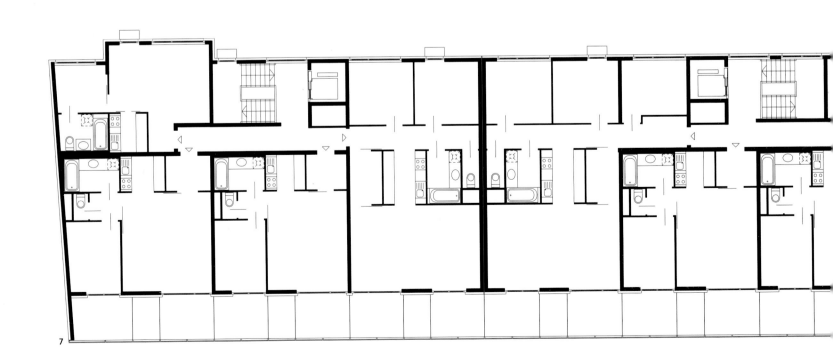

7

a mix of offices and apartments conforms to the familiar European tradition of an urban matrix with commercial spaces close to residential spaces. The scheme has two distinct elements that share an entrance and foyer on the street. Above the foyer, on the street edge, a seven-storey-high residential block fills the gap between two existing buildings and a two-and-a-half-storey-high office building fills the courtyard space behind. Two basement levels extend under the whole area with parking on two levels, cellars and storage spaces for residential and commercial occupants.

Part of the residential block is for social housing and contains a variety of apartment sizes on a relatively simple plan. Two circulation cores, each serving four or five apartments per floor, are located at the back of the block with a shared central corridor leading to the apartments. Apart from a one-bedroom apartment at either end, all have living spaces overlooking the street. Minimal space is allocated to kitchens and bathrooms, which are arranged in a strip along the centre of the plan without any natural light. Although this is not ideal, it is offset by the generous size of the living spaces and the addition of a winter garden 2 metres (6 ½ feet) in depth.

The offices at the rear jut out like fingers with courtyards in between. These long, narrow courtyards bring daylight into the offices and provide some external space for the workers. The roofs, at different levels, are sloped away from the main block and planted with sedge to give a view of greenery to the residents, who would otherwise see only rooftops. The planting was originally intended to be more vigorous and continue – conceptually, as the landscape – under the residential block to reappear as a planting of bamboo on the balconies, growing up the façade.

The architecture incorporates the work of several fine artists who worked in collaboration with the architects to contribute to the ordinary aspects of space and surface. Most prominent is the etched pattern on the glazing on the street façade to the winter gardens by Herwig Kempinger. This abstraction of the growing plants originally intended for the project is reminiscent of the abstract plant forms of secessionist Vienna and an expression of historical continuity. The parking spaces have large-scale graphic work by Susanne Korab and the foyer has neon work by Leo Zogmayer. A red carpet acts as the conceptual threshold to both the residential block and the offices.

5 The Wimbergergasse façade, with its continuous lines of winter gardens (verandahs).

6 Etched glass forms the balustrades that enclose the winter gardens.

7 Part plan of a typical floor, 1:200. Apartments include deep winter gardens across the full width of the building.

8 The apartments and the offices share a common foyer space at ground-floor level.

8

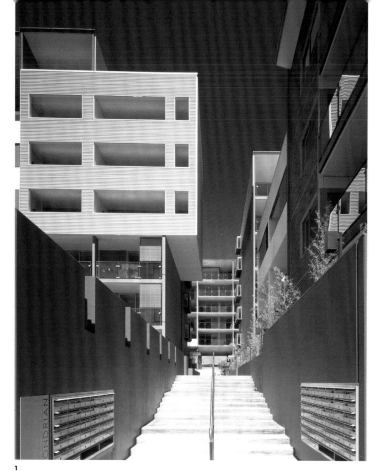

1

The arrangement and orientation of the buildings, with long, narrow courtyards between them, is a key element of this scheme. The architects' starting point for the design of a block was to create 'a perforated wall – permeable, transparent and operable'. These 'walls' are arranged as three parallel blocks across the site orientated east–west with courtyards between. This starting point is part of the architects' commitment to current thinking on issues of social and technological sustainability, which has influenced much of the decision-making on all aspects of the scheme.

A pedestrian pathway across the site connects Powell Street on the north side to Short Street on the south, linking the courtyards and providing access to the apartment blocks. The courtyards themselves are enclosed but visible from the upper levels. Their presence, with dense, lush planting and the single lap pool in the centre, is a direct contrast to the hot, dry surroundings, providing the sense of a cool oasis and a welcome relief from Sydney's hot sun.

The rise in the height of the blocks from four storeys on the north side to seven on the south, and the height of the Australian sun, means the blocks can be close together without excessive overshadowing. All orientated the same way, the blocks have single-

Mondrian Apartments
Sydney, Australia
Stanisic Associates Architects
2002

1 From the Powell Street entrance, steps lead up to the raised ground-floor level.

2 Site plan, 1:2,500. A pedestrian street connects Powell Street with Short Street and links the entrances to the buildings.

3 Sliding *brises soleil* allow residents to control sunlight.

4 Sun shading is a key element of the scheme, which includes oversailing roofs, deep reveals and *brises soleil*.

3

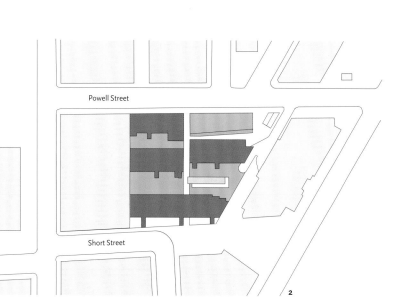

Powell Street

Short Street

2

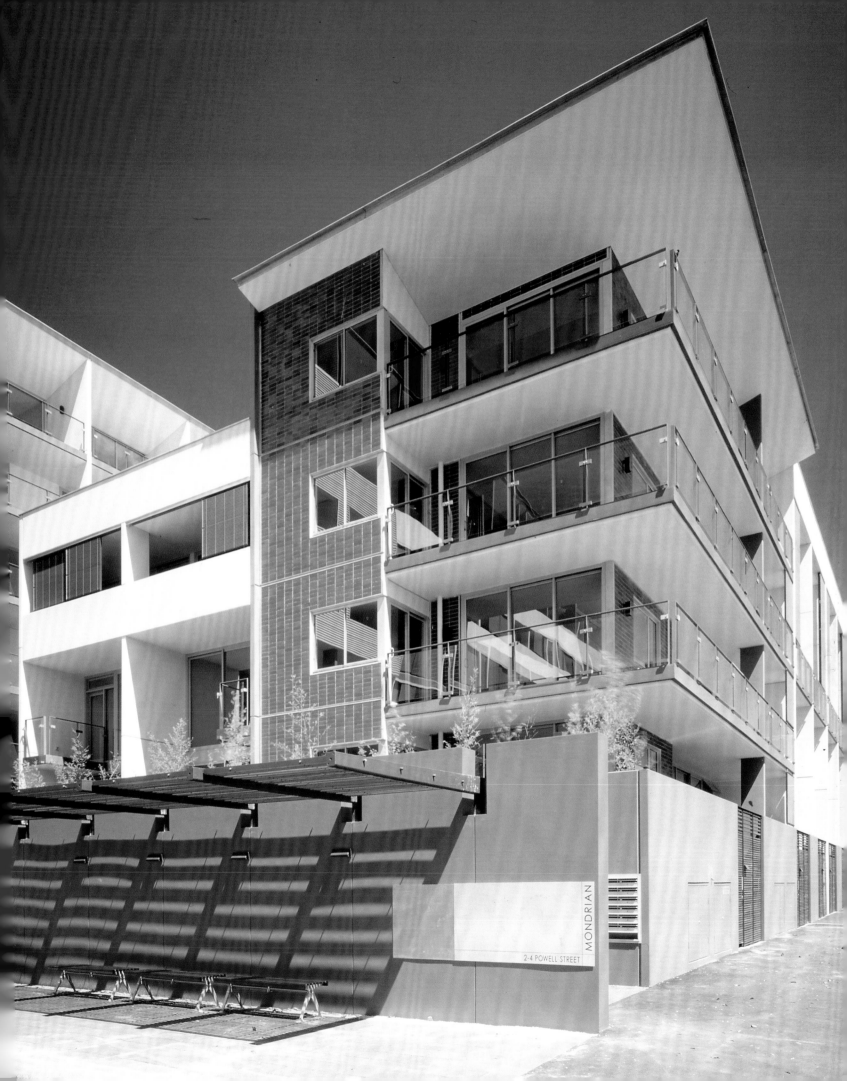

loaded, glazed access corridors along the south side. The lifts and stairs are separated from the main volumes and are glazed, making them highly visible at night. Shared circulation space is minimized due to a high proportion – 30 per cent – of two-storey apartments. There is a mixture of one-, two- and three-bedroom apartments, many of which extend the full depth of the block for improved natural ventilation.

Internally, all but three of the 132 apartments have north-facing living spaces. The façades form a linear and planar composition carefully designed to control the penetration of sun, and reduce solar gain and thereby the need for air conditioning. Glazing is generally recessed and shading is provided largely by the concrete planes of walls and floors that extend beyond the enclosure. In the two-storey units a balcony at the upper level extends into the double-height balconies of the lower level. There are many variations in the plans, and sliding partitions in some apartments mean that the layouts can be further varied to suit the occupants. Standard in all the apartments, usually located close to the entrance, are spaces designated as studies, or media alcoves, specifically designed for 'home office' use.

The architects' desire to include eco-friendly or sustainable ideas extends to other areas of the site. The trees, ferns and shrubs of the external planting are all Australian 'natives', intended to minimize maintenance and the need for watering, and encourage birds. Waste collection is centralized and bicyce racks are located at the entrance to encourage bicycle use. Pre-cast concrete panels and concrete slabs and walls were used in preference to brickwork because of concrete's much lower embodied energy content.

5 Apartments overlook the courtyard with native Australian planting and a lap pool.

6 In the lower block on Powell Street the maisonettes are clearly identifiable, set back in deep concrete reveals with balconies at upper floor levels.

6

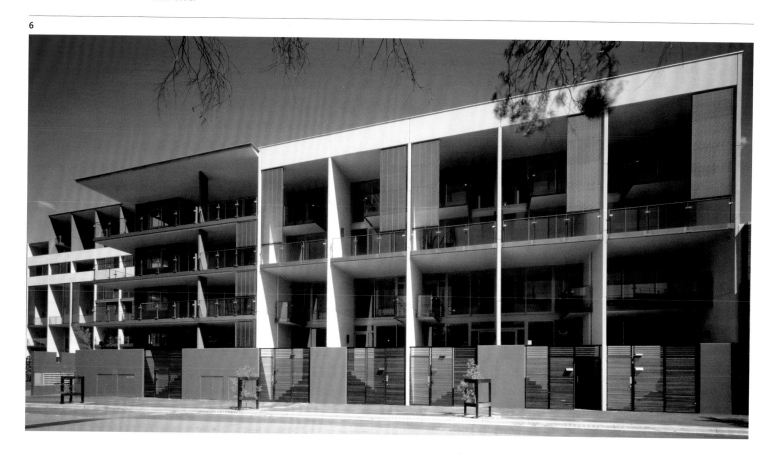

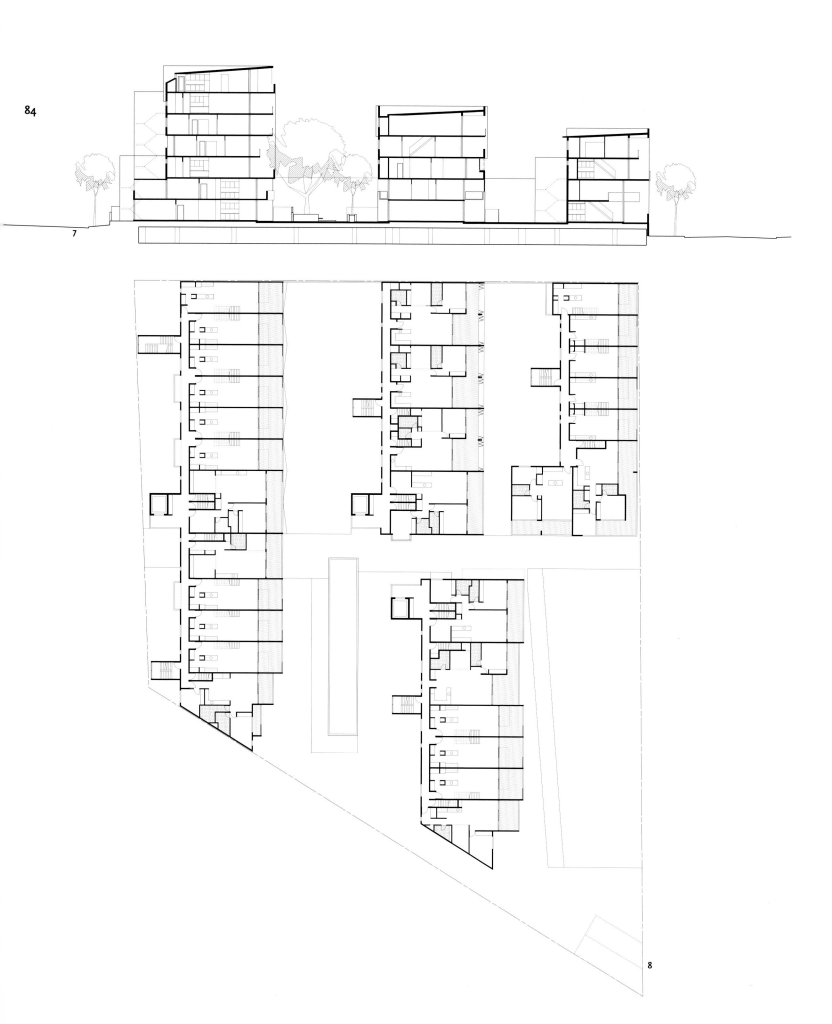

9

10

7 Section, 1:500. The blocks are lower on the north side to allow sunlight into the lower levels of the blocks behind.

8 Plan of level two, 1:500. Access stairs and corridors are on the south-facing façades. The apartment plans are generally deep and narrow on either one or two levels.

9 View of an upper-level balcony set within the double-height 'loggia'.

10 Full-height glazed sliding doors open onto the balconies, which are recessed within the concrete walls.

11 The apartments are open-plan, with kitchens in the main living space.

11

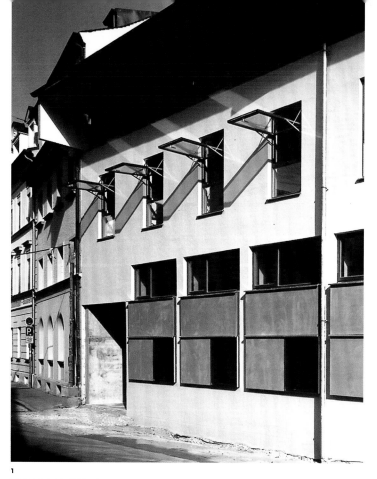

1

Integrated Housing
Ingolstadt, Germany
meck architekten
1999

Behind continuous street façades, the area zoned for redevelopment between Sebastianstrasse and Kellerstrasse comprises a series of open courtyards. Small blocks across the site maintain the scale of the surroundings and a similar ratio of open space to building. Footpaths across the site in both directions provide direct pedestrian routes to the city centre, leading to the different buildings and connecting the open spaces.

As a state-subsidized project, the programme is complex, intended to demonstrate by example the value of maintaining mixed social groups in close proximity. The scheme organizes the different accommodation in three distinct but interconnected elements – family houses, student rooms and assisted housing for the elderly or infirm. Courtyards, gardens and balconies form a network of open spaces, the 'glue' that binds the whole together.

The terraces of family housing and the student block are continuous with the street façades enclosing the area. At the northern edge of the site, the family houses are shallow from front to back, with wide frontages and a staircase that rises up in a single flight in the centre. A second row of terraced houses, parallel to the street, faces a shared garden space behind. At the other end of the site on Sebastianstrasse, a four-storey

1 Student housing forms the boundary on the southern edge of the site on Sebastianstrasse. A two-storey-high opening leads to the courtyards behind.

2 Site plan, 1:2,500.

3 Walkways connect the upper levels of the accommodation.

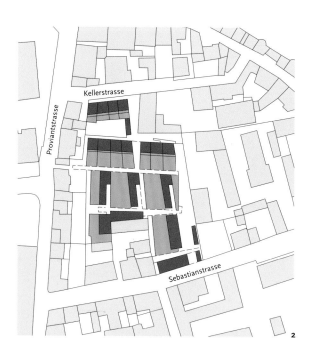

2

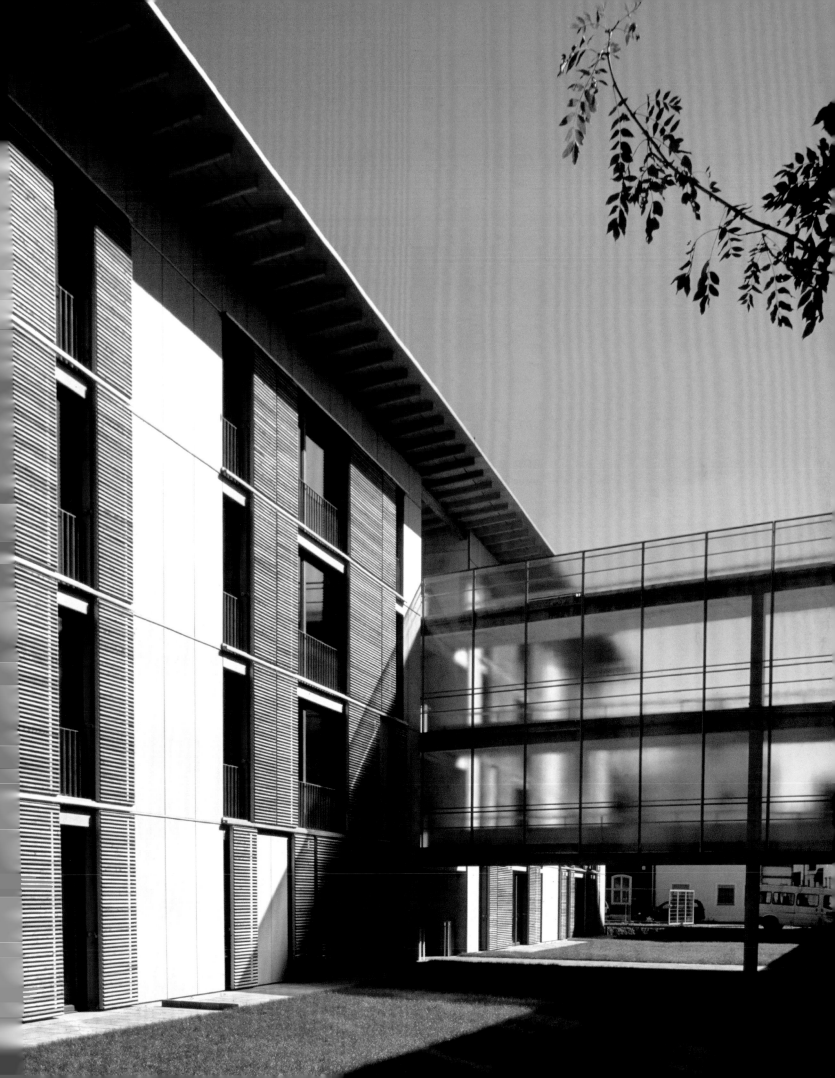

block of student accommodation contains very small, single-person, one-room dwellings. The two lower levels have double-height units with mezzanines, while the two upper floors contain 'studios'. Above the top floor, there are additional skylit roof spaces. A double-height volume is included again as part of the circulation space, where it is enclosed and contains the balcony access to the upper-level studios.

In the central part of the scheme are three linear blocks orientated north–south, perpendicular to the blocks on the perimeter streets with courtyards in between. These blocks contain a series of apartments designed for the elderly or infirm, and include some assisted-living accommodation. The apartments are small, mostly one- or two-person units, with minimal living spaces but with a variety of different layouts to suit the particular requirements of the occupants.

Communal facilities are included in a central block with common rooms and a café. The apartments have semi-private open spaces, such as the access balconies and verandahs at the upper-floor levels, designed to provide extra space outside the dwellings. The courtyards accessible from the pathways across the site are designed to be used, as well as providing necessary daylight and space to the dwellings. There are embankments and raised planting beds for the elderly unable to stoop to tend to plants, seating areas and children's playgrounds; one walkway even incorporates a slide that descends to the children's sand pit below. The scheme brings together a range of social groups – students, families and the elderly – with specifically designed accommodation that promotes further interaction through the proximity and careful juxtaposition of shared external spaces.

4 Looking down the staircase in a student apartment towards the windows overlooking the street.

5 Immediately inside the entrance door is a minimal kitchen and the door to the bathroom.

4

5

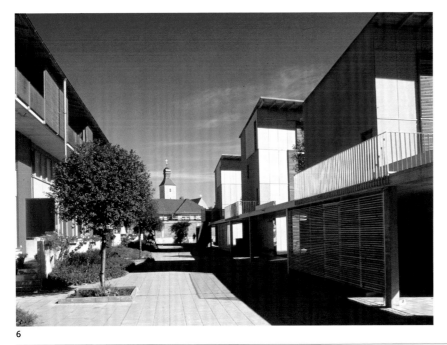

6

7

6 View along Quartiersplatz with the elderly people's accommodation on the right and the terraced family housing on the left.

7 Staircase to the upper levels. The different elements of the scheme have a shared material language; fair-faced concrete, full-height glazing, simple geometric shapes and overhanging eaves.

8–9 Plans of student housing, 1:200. Ground floor (8) and mezzanine (9).

10–12 Plans of housing for the elderly, 1:200. A variety of different plan layouts can accommodate elderly residents with different needs.

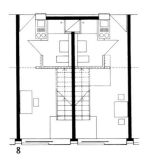

8

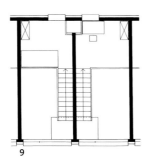

9

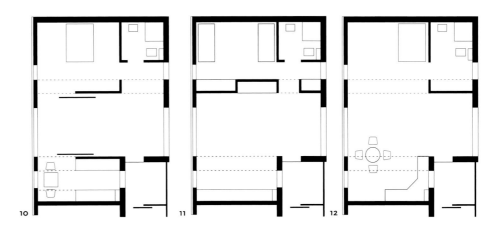

10 11 12

1

The Harold Way Apartments for the Hollywood Community Housing Corporation have won several design awards including a citation from the American Institute of Architects in Los Angeles. The judges were impressed with the way the architects used the constraints of budget and site-planning difficulties – 25 per cent open space, building set backs from the property line and increased road margins on Western Avenue – in a positive fashion.

The arrangement of the buildings, in three roughly parallel rows running north–south, concentrates the highest density of accommodation on the edges of the site. On the east side – Western Avenue – there are four storeys of two-bedroom apartments; on the other, two levels of two-storey maisonettes. The void created between these two parallel blocks forms two interconnected courtyards either side of three lower blocks, which contain the single-person units. The scheme has 51 apartments, 17 one-bedroom units, 19 two-bedroom units and 15 three-bedroom maisonettes. There is a community space, computer room, laundry and storage facilities, and a basement with one parking space for each unit.

This courtyard is a busy place, combining the characteristics of a pedestrian street, a communal front porch and a children's play area. As one of the competition judges put it: 'There's energy in it. It's very urban.' The lift shaft appears as a distinct elements as does the open stair leading to the access balconies; planters and seats occupy every corner. With a very limited budget and therefore no air-conditioning, the design of the courtyard space and external access arrangements means all apartments have cross ventilation. The courtyard also brings light into the centre of the scheme and, simply by reducing the extent of the parking area at basement level, a

Harold Way Apartments
Hollywood, California, USA
KoningEizenbergArchitecture
2003

1 On Harold Way the central block rises to four storeys to complete the elevation and enclose the courtyard behind.

2 In the courtyard, bridges lead from the access balconies to the entrances to the flats.

3 Site plan, 1:2,500. Three-bedroom maisonettes are on the west side, two-bedroom flats on the east and one-person flats in the centre of the courtyard.

4 The courtyard is animated with sitting spaces, children's play and the main stair rising up to the high-level access corridor.

2

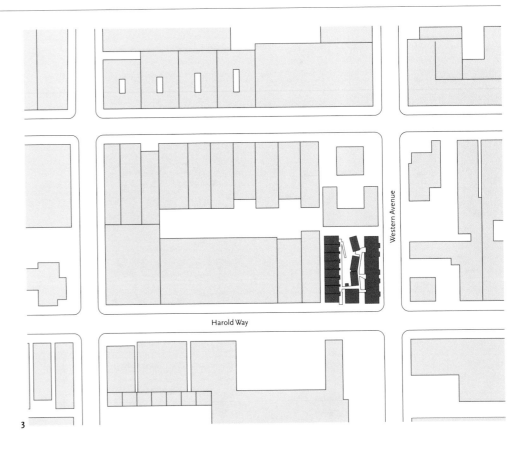

Western Avenue

Harold Way

3

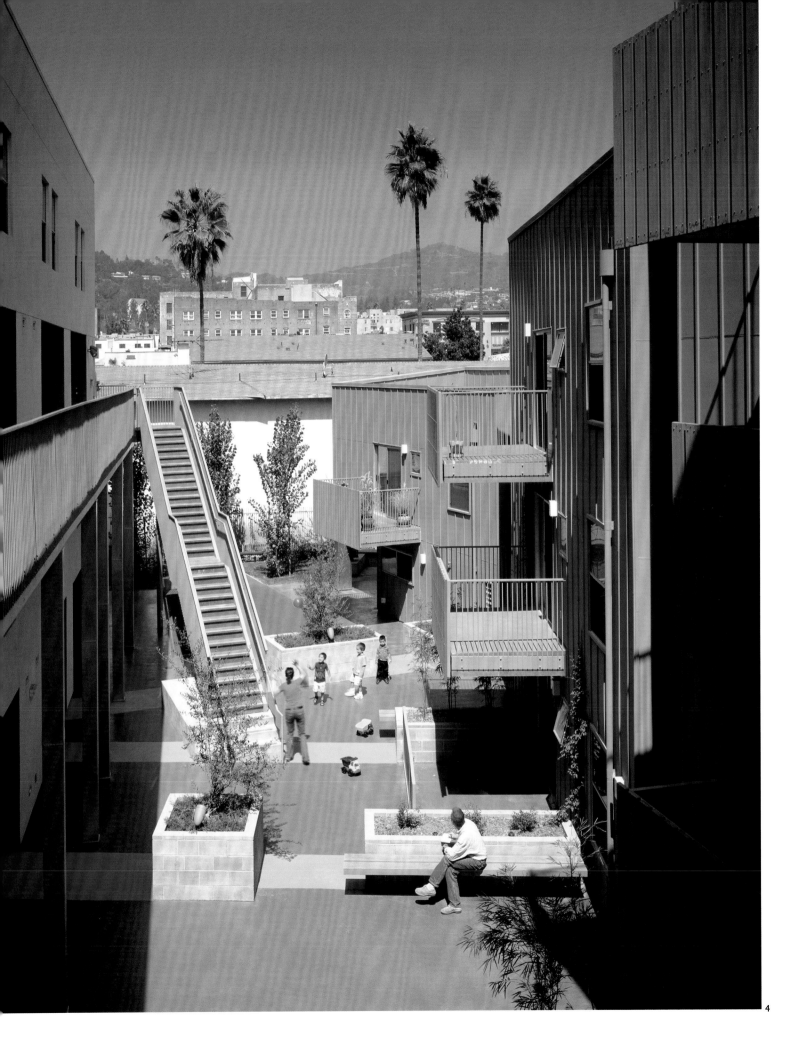

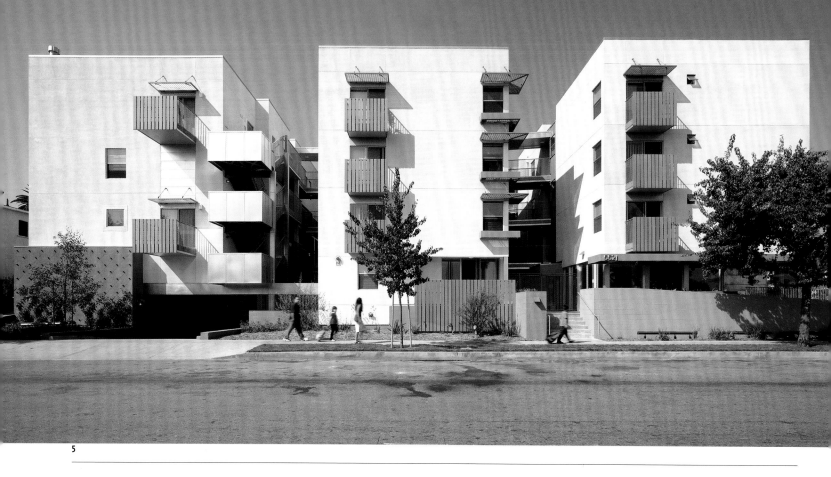

5

5 On Harold Way the entrance to the basement car park is to the west and the pedestrian entrance is via the steps up to the courtyard on the right.

6 The maisonettes have a recessed entrance area with external storage.

7 Second-floor plan, 1:500, with balcony access to the second level of maisonettes.

6

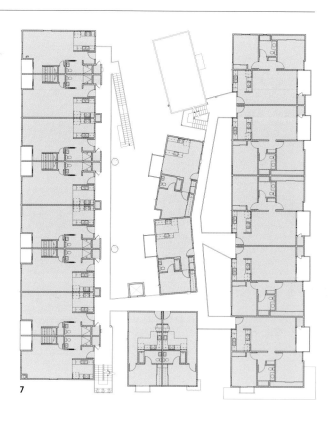

7

strip along the northern edge of the site has sufficient depth to accommodate the roots of the larger trees planted there.

The internal layouts are compact. Plans for the two- and three-bedroom types are identical and the varied one-bedroom apartments are one-offs fitted around entrance areas and other facilities. The ground-floor units have some private outdoor spaces and, above, apartments have cantilevered balconies that modulate the façade. With minimal space to work with, none is wasted on internal corridors. Similarly, entrance areas are not enclosed but delineated spatially, and kitchens are small work areas only, to allow more space for living rooms. Balconies have external storage. The maisonettes have conventional terraced-house plans but without space given over to corridors.

In such a dense scheme, the architects have sought to achieve a balance between the conflicting demands of privacy and community. The external-access galleries, which use bridges for reaching individual front doors without passing in front of bedrooms, and doors recessed in alcoves, enhance a sense of privacy. In contrast, the lively, apparently chaotic layout of the courtyard provides an animated social space close to the dwellings.

8

8 External access balconies are distanced from the façade away from the windows, with bridges leading to the paired entrances to the flats.

9–14 Floor plans, 1:200. Three-bedroom maisonette (9-10), two-bedroom flat (11), one-bedroom flat plan variations (12–14) with different layouts to suit the relationship to the external space and balcony access.

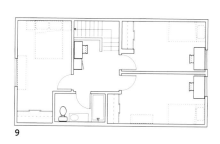

9

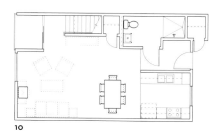

10

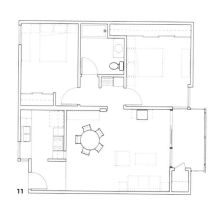

11

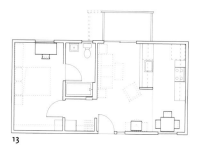

12

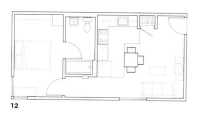

13

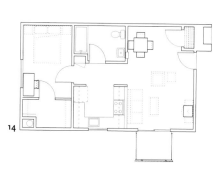

14

This prominent corner site in the East End of London was the site for an open competition Circle 33 Housing Association in 2002, won by Peter Barber Architects. The scheme is intended to work with the original urban grain of the surrounding area by reintroducing the idea of the street. The high-density nineteenth- and early twentieth-century terraced houses that line the streets of northern European cities, especially London, are now firmly associated with notions of security, neighbourliness and appropriate levels of privacy that promise social sustainability. In this scheme the architect is committed to the idea of the street as a means of bringing people into close proximity and making them highly visible to each other, thereby encouraging the interdependence that is considered necessary for a cohesive local community. No parking space is provided within the scheme and all access is via the narrow pedestrian streets.

The scheme is made up of one basic unit – the interlocked plans of two basic dwelling types – a flat at street level and a maisonette at first-floor level. Despite the high density, every dwelling has its own front door opening either directly onto the street or onto an external courtyard or patio.

Internally, the plans are less conventional than many social housing schemes. At street level the front door leads directly into the living space, which extends the full depth of the plan. The kitchen units are at one end and at the other a glazed screen opens onto the patio, while doors open straight into the two bedrooms and bathroom. Alternatively, an external stair leads up to the first floor and access to the upper maisonette via a courtyard. It too has an open-plan living space with the kitchen included, and a partially enclosed stair, lit by a rooflight, leads to an upper floor with two bedrooms and a bathroom.

The patios are an unusual innovation in a social housing scheme of this nature. They extend the space visually and make daylight commonplace throughout the plan. They have been designed as 'exterior' rooms within the building envelope, and the inclusion of a window opening onto the street sets up a new kind of relationship between the exterior space of the home and the street. At first-floor level the patio also works like a foyer; it has to be crossed to reach the private space of the interior. Initially, this could be seen as just an unusual kind of undifferentiated space open to the elements, but eventually it could allow for occupants to customize their space to use it as a garden, or a place to build a lean-to or a conservatory.

Donnybrook Quarter
London, UK
Peter Barber Architects
2004

1 Site plan, 1:2,500. The units are arranged to form three parallel terraces.
2 A corner window brings light into the living space.

3 Along Parnell Road, the ground-floor flats form a continuous terrace, and at the upper levels the maisonettes alternate with the open patios.

4 A flat, white-painted render forms the background for projecting windows and cantilevered balconies.

5 Part ground-floor plan, 1:500. The open-plan interior space of the flat is extended into a patio.

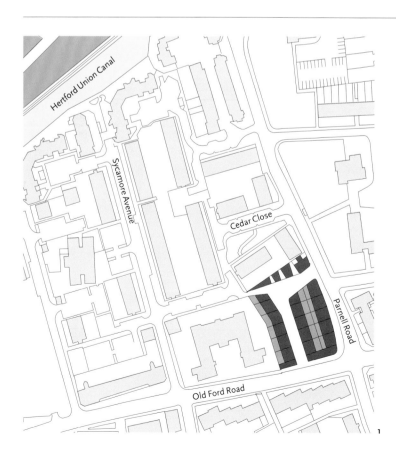

1

2

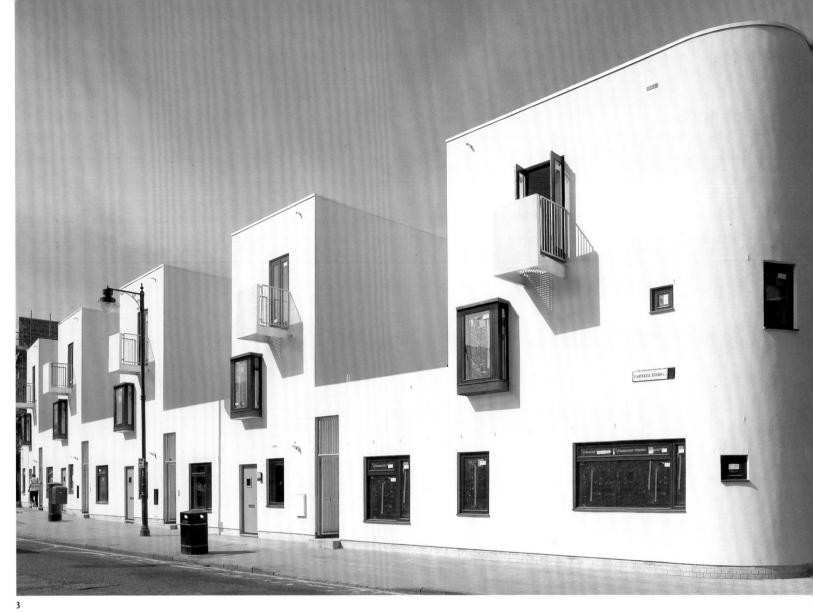

3

4

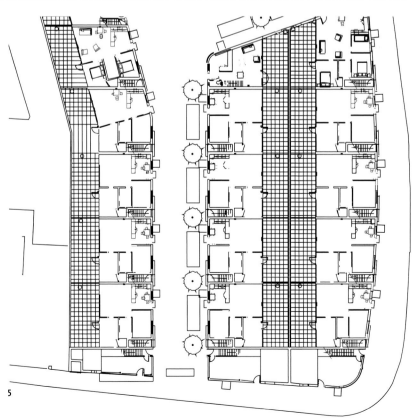

5

Chapter 3

City Blocks and Infill

1 Unité d'Habitation, Marseille, 1957, Le Corbusier.

2 Unité d'Habitation. Section, 1:200, of maisonette Type E2.
1. bedroom
2. double-height living space
3. kitchen
4. shared access corridor

In the search for an analogy for the pace of life and rhythm of urban space, the block can be seen to represent something of a microcosm of the city in the interaction of functional and formal variety.
Josef Paul Kleihues, *750 Jahre Architektur und Stadtebau in Berlin*, 1987, p. 82

The central London city block that is the Brunswick Centre (1965–73), designed by Leslie Martin and Patrick Hodgkinson, belongs to modern architecture's history of the quest for the ideal city. Above a raised podium with parking below, concrete and glass stepped blocks of apartments, with shops at ground level, define a pedestrian 'street'. This city block maintains the existing street pattern and provides a mix of commercial and residential space at high density in a coherent whole. Such built examples of the formulation of new urban paradigms are few and far between. Berlin's housing exhibition of 1984–87, under the directorship of Josef Paul Kleihues, rigorously analyzed existing typologies and proposed, among other concepts, the 'open-plan block'. This is a reinterpretation of the urban villa demonstrated in the schemes by O.M. Ungers in Lutzoplatz, and in the Tiergarten scheme by Rob Krier and others, which maintain urban character but put multi-family dwellings in place of large houses. Le Corbusier's Unité d'Habitation in Marseille, 1957, interprets the block as a single building that includes all the facilities found in a small town. In more recent decades, dealing with the density and texture of the urban fabric has shifted to include redundant industrial sites and, increasingly, the reuse of existing structures.

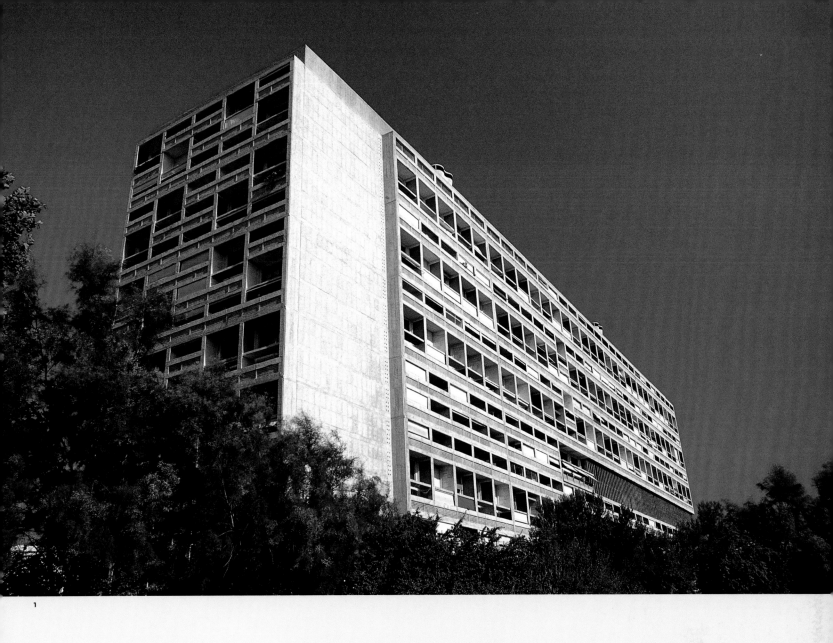

1

2

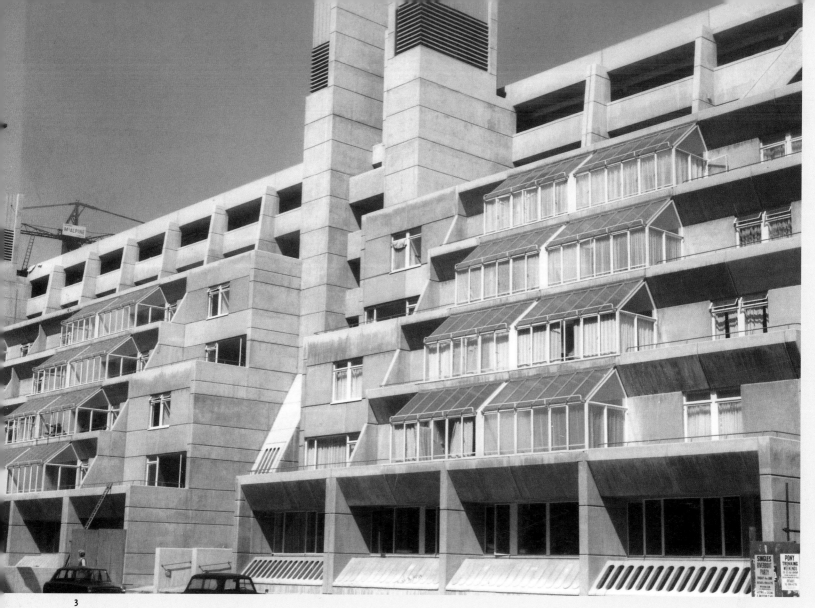

3

Inserting a new building into the fabric of an existing city is not a question of adding it to a static environment, but rather of incorporating it within an ever-changing context. Knowledge and understanding of the textural complexity of what already exists is a way to inform the design of the new intervention. The projects described on the following pages have been developed in relation to the surrounding urban fabric, including the reworking of an existing typology or the reinterpretation of a historical precedent. Buildings often take on the dimensions and scale of adjacent buildings, which may not be housing types, and the dwelling typology is often not standard but a hybrid that has been developed to suit a particular site and set of conditions. The complexity of working with constrained urban sites, in comparison to other typologies and standard-plan types on open sites, means that the success of these kinds of projects, perhaps more so than others, is most likely to be dependent on the inventive design skills of architects.

In Berlin, the two Estradenhaus buildings, designed by popp.planungen, conform to the dimensions of the buildings on either side; the roofline is continuous and the depth is identical. The depth of the building plot becomes the depth of an individual apartment, and the architects have used the 'estrade' of the name, which extends inside as platforms and outside as balconies, to define the less private zones of the external façades.

Less obviously at first glance, the form of Frédéric Borel's rue Pelleport apartments in Paris has also been developed in response to the site – a triangular shape resulting from the convergence of several streets, only one possible access point to the basement carpark and the blank elevation of a 1970s block that has become a backdrop. The space at each level is as if

sculpted within the overall maximum envelope permissible, taking into account the various controlling planes and dimensions – the converging sightlines, daylighting limits, height and façade constraints.

Dellekamp's apartment building in Mexico City treats an 'end' site very differently. In response to the excessive noise from the street and a major traffic intersection nearby, the scheme turns its back effectively on the streetscape and presents largely blank walls to the city. The only clue to the building's purpose is its disjointed overall appearance and the clerestory glazing that runs around each floor at high level.

The programme for student housing is often likened to the city in microcosm. In the Simmons Hall scheme by Steven Holl Architects, the familiar campus layout of a series of buildings is eschewed in favour of a hall, ten storeys high and 100 metres (330 feet) long, that provides everything within one vast block. The metaphor of the city continues with the siting of the student cafeteria at street level, as if a public restaurant and facilities such as a theatre, cinema and shops are included.

Kreis Schaad Schaad's much more modest Winterthur scheme proposes the housing block as a container clearly drawn at the scale of its urban surroundings and at a very different scale to the individual dwelling units. This scheme also brings individuality into the design process by consulting with prospective tenants who choose from a variety of options designed for each dwelling type.

In an area of San Francisco occupied by warehouses and light industrial buildings, Stanley Saitowitz's Yerba Buena Lofts fill a gap in the city block, aligned with existing buildings on both sides and extending full depth

between the two parallel streets. The scheme effectively 'domesticates' the warehouse type, which is reinterpreted as a new loft-type apartment with narrow, very deep plans.

The heritage industry is increasingly playing a part in shaping the future of the urban environment through preservation of historic monuments and the designation of conservation areas where development is prohibited or constrained. In Venice the very fabric of the city is considered as a historical monument but, like any other city, it is still necessary to reinvent the redundant industrial areas – in this case, the watchmakers who had occupied a large area of Giudecca, an island across the lagoon from the centre of the city. In the first building to be completed as part of the overall strategy for the area, one small piece – a brick chimney – is retained as a memory of an industrial past.

The four enormous, cylindrical gasometers in Vienna have long been redundant but, because they are such remarkable structures, are listed for their historical value as monuments to an industrial past. All four of these structures have been converted for reoccupation and the one described in this book, designed by Coop Himmelb(l)au, is also used to anchor a parasite structure that relies on the ponderous weight of the existing gasometer.

The Shinonome Canal Court Centre Block project conforms to the familiar idea of rectangular grid planning, and occupies a plot of land formed by the intersection of major roads in both directions. This particular scheme is noteworthy for the collaborative way in which the whole city block has been organized and developed. Riken Yamamoto and Field Shop, along with architects for the other buildings, contributed to the overall masterplan for the block and conceded to design guidelines arrived at collectively.

In contrast, S333's Schots 1 + 2 proposes a new and intense relationship with the landscape. Unlike the ubiquitous orthogonal planning schemes, where carefully dimensioned road layouts are overlaid onto the existing topography, here different elements of the urban landscape are mixed together to become indistinguishable. Ground planes rise up to form rooftop courtyards, buildings meander to enclose external spaces, apartments look out over planted rooftops and plants continue the natural landscape onto vertical surfaces. Undulating surfaces are used as if they are elements of the landscape to make new types of urban spaces.

3 The Brunswick Centre, London, 1965–73, Leslie Martin and Patrick Hodgkinson. The ziggurat shape is reminiscent of the drawings of the Futurists.

4–6 Unité d'Habitation. The housing unit as a model for a new kind of town. Facilities other than dwellings include restaurants, play space, nursery, offices and retail space.

Plans, 1:200, of lower level (6), middle level (5) and upper level (4) of a pair of Type E2 maisonettes for families with two to four children.

1. bedroom
2. double-height living space
3. kitchen
4. shared access corridor

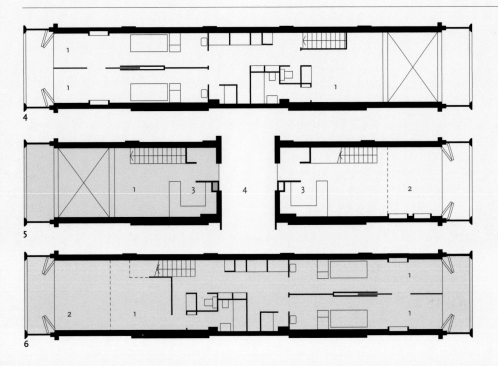

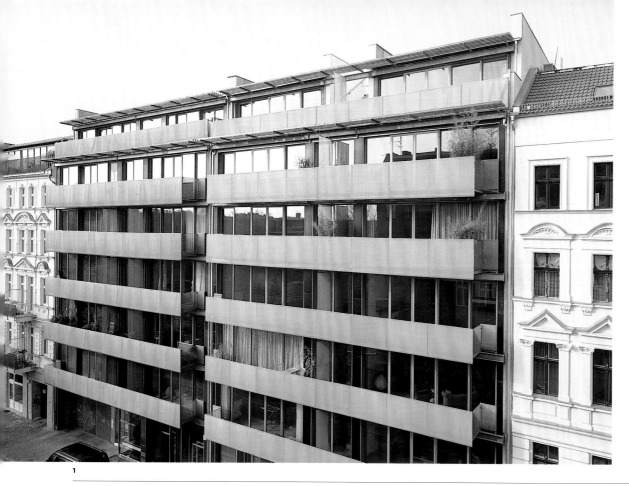

In architectural terms, 'flexibility' can be interpreted in several different ways. Despite being frequently cited as a desirable quality, it rarely seems achievable. Flexible space is often taken to mean simply a space that can be used for a variety of purposes, or it might relate to a relationship between rooms that allows them to connect to each other. Most commonly in housing design it refers to the arrangements for partitioning, to allow partitions within a standard apartment shell to be configured and constructed in different ways. A further definition is that of spaces that can be easily reconfigured or rearranged by the occupants at their whim.

Estradenhaus
Berlin, Germany
popp.planungen
1998–2001

1 Open metalwork balconies are continuous across the façades.

2 Site plan, 1:2,500. The two buildings fill a gap in the existing street.

3 The façade is made up of timber-framed glazed panels between the 'estrade' inside and the balcony outside.

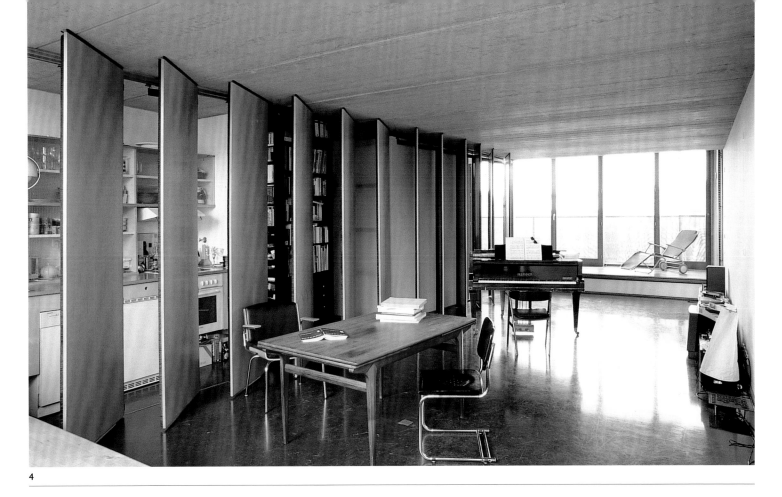

4

4 The panels in half-open position reveal the kitchen and storage areas behind.

5 When fully closed, the panels form a continuous partition along the length of the apartment.

6 The space of the 'estrade' and the façade glazing continue full-width beyond the end of the moveable partition.

7 Typical floor plan, 1:200. The services are grouped along the central dividing wall to leave the rest of the space open.

5

6

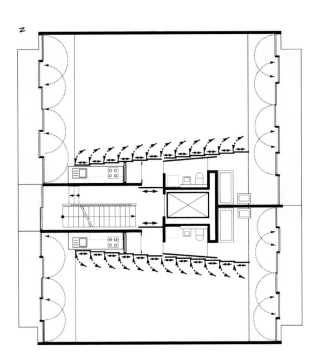

7

8

9

10

The Estradenhaus, a small, seven-storey-high infill block in Berlin, demonstrates the achievement of this ultimate form of flexibility. Within a rectangular plan the basic layout is very simple. Access stair, lift and service ducts are arranged along a central spine, on either side of which is a single apartment occupying the full 13-metre (43-foot) depth of the plot. Instead of a conventional layout of a series of rooms with designated purpose, two unusual spatial devices are introduced that invite occupants to engage with the space on their own terms. They can divide it in different ways, over time to suit changing family needs, or in the short term for a particular event.

The 'estrades', which give the building its name, are raised platforms, 40 centimetres (16 inches) high, which extend full width across the front and back façades. They extend 1 metre (3 feet) inside the building and outside as a perforated metal balcony. The façades are made up of full-height, fully glazed, timber-framed window panels, individually hinged and openable, which extend the interior space to the balcony outside. With no defined purpose, the estrades can be used for seating as part of a living space, as a permanent or occasional sleeping platform, or as a loggia or balcony area. Visually, they form a defining edge – clad in pale timber – that

contains the main floor space of the apartment with its dark blue resin finish.

Between the raised estrades are 12 full-height panels approximately 1 metre (3 feet) wide suspended from the ceiling. When lined up, one next to the other, they form a continuous partition, enclosing the fixed elements of kitchens and bathrooms. All the panels can be moved separately, either opened and closed like so many doors, or rearranged in the open space of the apartment to divide it and create separate areas.

From the outside, Estradenhaus fills a gap left in the street modestly, conforming to the height of adjacent buildings and continuing

the existing street line. The block was developed and designed speculatively by the architect, popp.planungen. Since its successful completion, a second block has been constructed on the adjacent site almost identical to the first. The architects have been able to repeat the success of the first block and refine its design. The estrades are a little wider inside the apartments and incorporate a 90-degree return to meet the stairwell enclosure. In addition, the moveable panels have become more elaborate to include storage.

8 In the second building, the moveable panels are developed in depth to form storage units.

9 Section, 1:500. The main floor space of the apartment is contained between the raised platforms and balconies at front and back of the building.

10 The storage units can be arranged in a variety of ways.

11–13 In the second building, the platform returns parallel to the spine wall at the end.

11

12

13

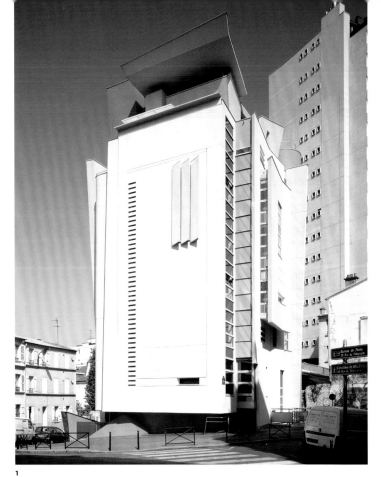

1

A challenge for the development of a social-housing project was presented by the particular difficulties of a site in the north-east of Paris: the plot is triangular, at the convergence of two radiating streets, neighbouring buildings vary in height from three to 17 storeys, and there were planning constraints that imposed set backs at upper levels.

Frédéric Borel, who has completed social-housing schemes in rue Oberkampf and boulevard de Belleville in the same neighbourhood, designed a building that responds to a broad idea of site and location rather than borrowing from, or attempting to relate in material terms, to the surrounding buildings. The apartment building, which is located at the junction of rue des Pavillons and rue Pelleport, forms a colourful and sculptural termination of the vista along the incline of rue Pelleport. Its fragmentary forms, and the jutting parapets of the façades that lean outwards and accommodate set backs at the upper levels, make visual reference to the jumbled and jagged outlines of the surrounding rooftops of the smaller-scale nineteenth-century buildings. Its presence lessens the impact of the 17-storey, blank end wall of the nearby housing block that has dominated the site since it was built in the 1970s.

Rue Pelleport apartments

Paris, France
Frédéric Borel
1999

1 The 'closed' south façade addresses the busy intersection of several streets.
2 Site plan, 1:2,500. The more open and glazed façades face the two streets on the east and west sides of the building, with the more closed façades on the north and south sides.
3 The angled, inclined walls and set backs mean that each apartment is different.
4 The distinctive fragmentary form of the building, with its inclined and jutting parapets, makes it a highly visible addition to the neighourhood. The stair and lift are located on the north side in anticipation of a second phase of the project.

2

3

4

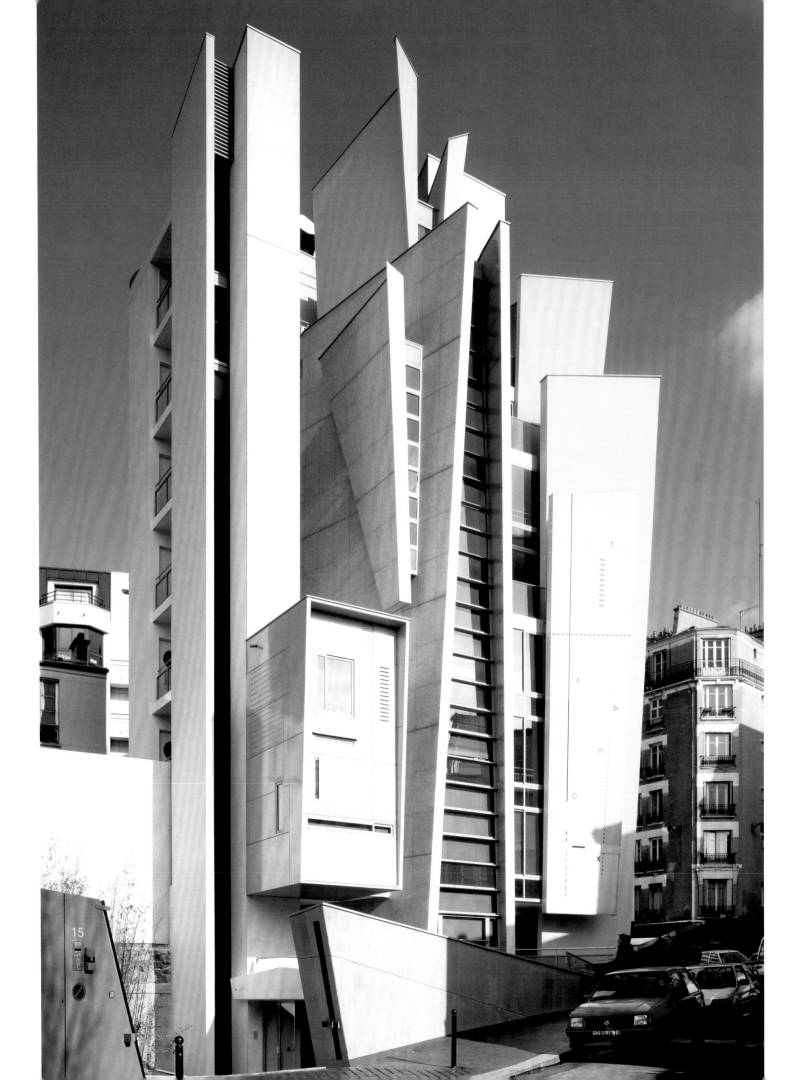

5

6

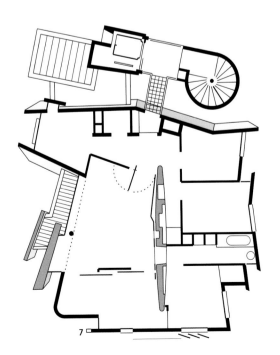

7

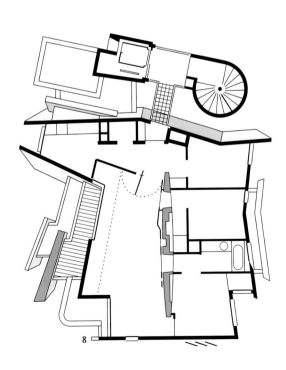

8

In place of clearly defined enclosing walls, the building appears to be made up of independent planes of concrete, which seem to overlap and float at random across its surface. In the plan, too, just as the walls lean vertically outwards towards the upper floors, it appears as if an invisible force is also working horizontally to push the enclosure outwards and break the walls apart.

The somewhat complex geometry has been overlaid with a social-housing programme to develop the overall three-dimensional form. Ten storeys tall, the building includes two levels of parking. Its entrance is located on the west side, on rue des Pavillons, where there was sufficient length to provide the access ramp. The stair and lift are on the north side, detached from the main volume and separately articulated in anticipation of the second phase of the building. The geometry starts from alignments with the different street edges and evolves into a plan through the manipulation of the different angles of the façade as they meet with, or intersect, internal partitions. The gaps between the different planes are glazed to open up the spaces, admit daylight and sun, and frame views across the city.

In the first phase, each floor level has only one apartment with a surface area of 50–100 square metres (550–1100 square feet). An aerofoil-shaped concrete structural core is clearly visible within the apartments as it penetrates each level, its tapering thickness exposed where it is cut into for doorways or storage. Positioned centrally, it reduces the structural span and serves to divide the bedrooms on the east side of the plan from the living spaces on the west side. A certain amount of flexibility is introduced to the larger apartments, where the living rooms have sliding room dividers and interconnecting doors. Each apartment has a large expanse of glazing on the west side, and set backs at upper levels provide external terraces.

5 Doorways are cut through the thickness of the central concrete structure.
6 Full-height glazing to a west-facing roof terrace.

7–9 Plans, 1:200. Third floor (7), fifth floor (8) and sixth floor (9). Each floor level has one apartment, with the space divided by the aerofoil shape of the central structural element.

10 Section, 1:200. In the centre of the building is a structural spine from which everything is supported.

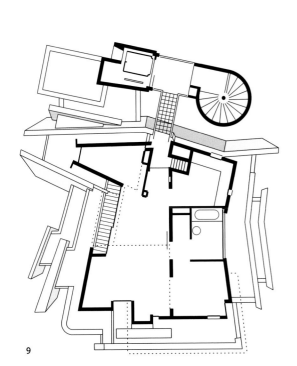

9

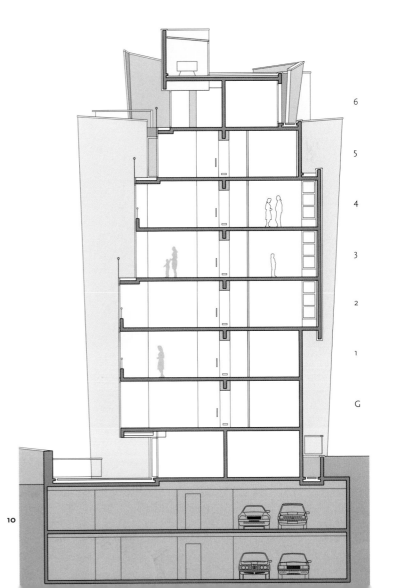

10

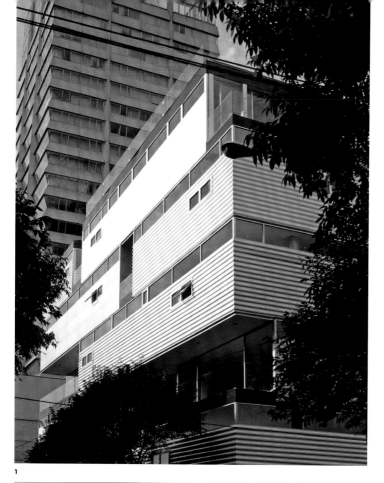

1

At first, this building appears to be a random pile of bits of buildings stacked carelessly one on top of another, but this is not the case. There is logic and a clear organizational system related to the specific location. The site, on the end of a city block, is exposed to high levels of noise from busy streets on three sides and a nearby road junction. The architects' first move was to create an open space on the north-facing, quieter side of the plot. Staircases and other services are then arranged around the courtyard façade, thereby freeing up the space along the street fronts for uninterrupted living spaces that could take full advantage of the sunlight. These living spaces are then enclosed by solid external walls to insulate them from the high noise levels. To compensate for the enclosure, the floor-to-ceiling height in all the apartments is a lofty 3.2 metres (10½ feet).

Several of the apartments have a second level, either above or below, that does not extend over the same space as the main area. This includes the ground floor, which has a shop on two levels. In this way, the apartments are interlocked like so many pieces of a three-dimensional puzzle to form the whole. The exterior spaces are neither the cantilevered balconies or recessed loggias of modern architecture, nor the light wells

Alfonso Reyes 58 Apartments
Mexico City, Mexico
Dellekamp Arquitectos
2003

1 The unusual overall appearance is of a loosely stacked collection of unrelated pieces.
2 Site plan, 1:2,500. The building sits at the end of a city block with a north-facing light well behind.
3 The clear glass balustrades are barely visible on the façades, making the gaps between the apartments clearly identifiable.

4 Each apartment is identified with a different finish to the external cladding using two different shades and smooth and corrugated surfaces.

5–6 External 'terraces' set deep into the plan separate the neighbouring apartments and lead to more conventional habitable outside spaces.

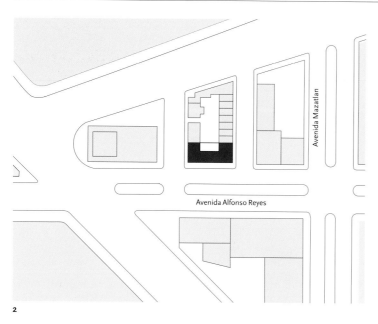

2

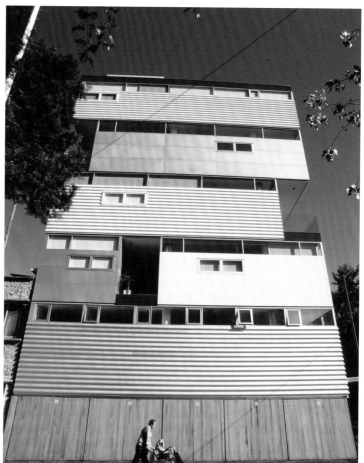

3

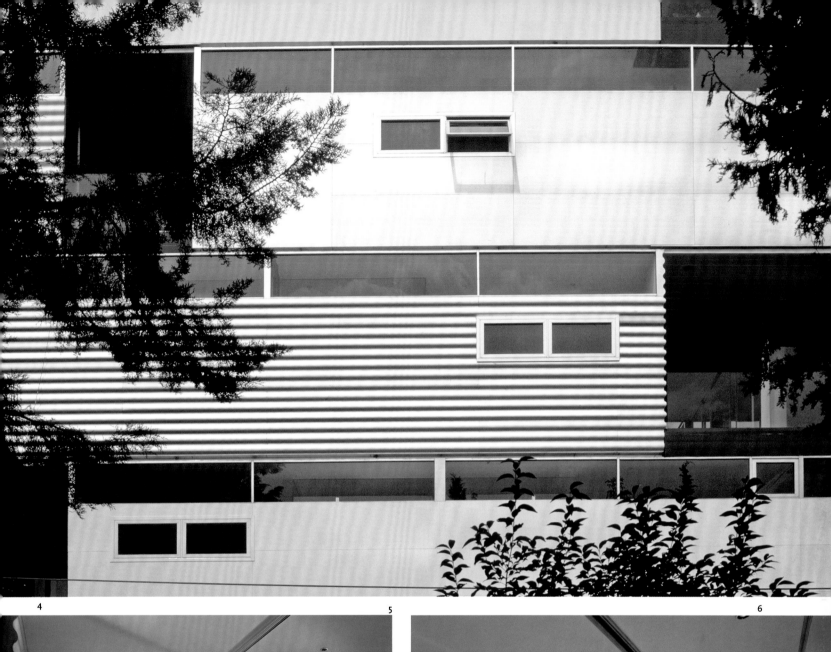

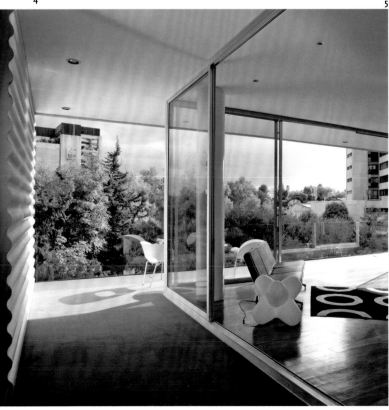

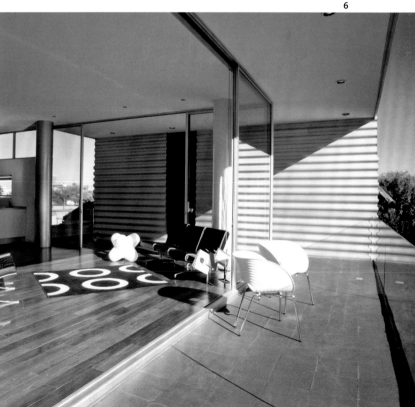

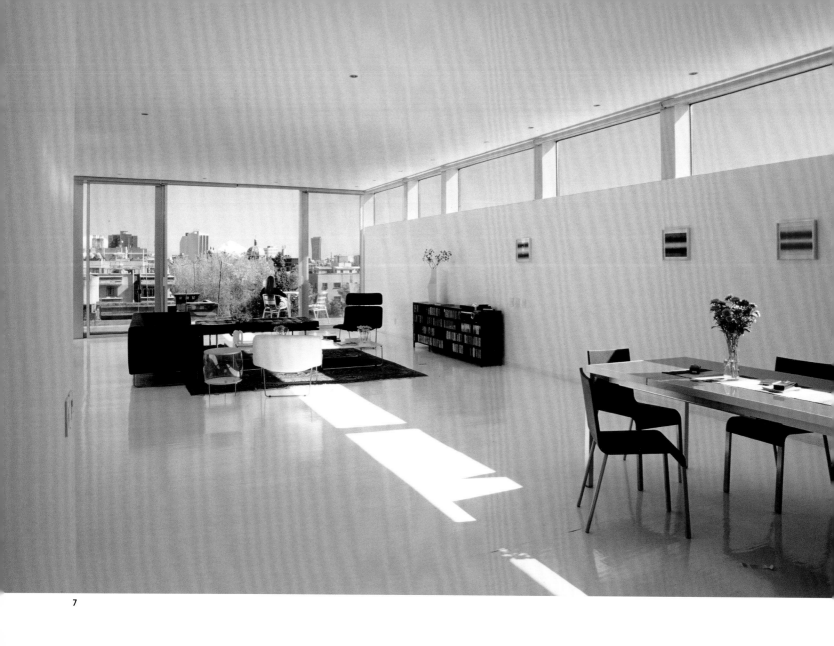

7

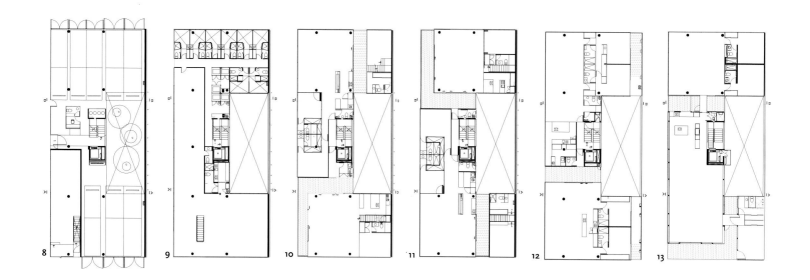

8 9 10 11 12 13

14

carved into the dense fabric of eighteenth- and nineteenth-century buildings, but a series of open spaces that penetrate the form of the building. By means of these 'terraces', some wide enough to use as a terrace but some only the width of a corridor, each apartment is separated from its neighbour. The delineation between the different apartments is enhanced by the use of clear glass to form balustrades where these voids or 'terraces' reach the façade, and by the use of different colours and textures on the cladding panels of adjacent apartments. The detailing of the cladding is identical throughout, but four different finishes are created with combinations of two different shades, and either a smooth or corrugated surface texture to the sheet aluminium used.

The interiors are spacious with very large living rooms and either one or two bedrooms, each with a bathroom or shower room en suite. Kitchens are open-plan within the living area, with fixed wall and island units. Clerestory glazing is continuous around all the external walls, drawing the eye above the enclosing walls to the sky and letting in daylight. A few, very small windows pierce the wall occasionally, carefully positioned to make visual contact with the street outside or to provide natural ventilation.

Whether or not it is considered successful, this project engages with an important issue for housing design – the need for an expression of individuality and potential of variations in design. The introduction of open spaces at high level within the curtilage of the building can also be considered in relation to other experimental projects. These include projects that investigate the use of such external spaces as formal devices to break up the mass of a building, or those that are created in pursuit of new ways of living, in order to explore how such spaces might be identified and inhabited in collective housing.

7 The apartments have high solid walls to block out the noise of the city. Clerestory glazing at high levels brings in daylight and sun.

8–13 Plans, 1:500, of ground to fifth floors. The apartments are large and unconventional, interlocked around the external spaces.

14 Specific views are framed with small windows inserted into the solid façades.

15–16 Sections, 1:200. An internal column structure and cantilevered floor slabs mean that the façade can wrap around the spaces independently.

15

16

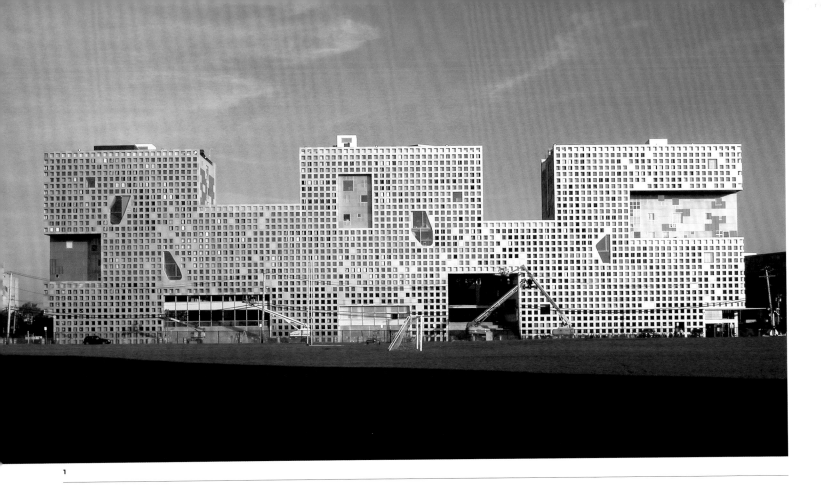

Simmons Hall, MIT
Cambridge, Massachusetts, USA
Steven Holl Architects
2002

1 The regular loadbearing masonry structure of the façade is interrupted seemingly at random by irregularly shaped openings.

2 Site plan, 1:2,500.

3 Incisions several storeys high break up the rectilinear mass of the building and form external terraces at the upper levels.

Albany Street

Vassar Street

Briggs Field

Charles River

Despite the acknowledged significance of Le Corbusier's Unité d'Habitation (1957), which provides a single structure to contain not just the basics of living accommodation but also services such as nurseries, shops and recreational facilities, there have been few other similar developments. As an alternative to low-density suburban development the 'vertical garden city', as it was named, introduced a new way of thinking about housing design. It challenged our perceptions of the distinctions between 'private' and 'public' space, specifically in relation to the idea of the 'internal street'. The development of shopping malls, international hotel chains and airports 50 years later has provided other paradigms of public internal spaces that blur these distinctions, and that have changed our thinking about the street. Steven Holl's Simmons Hall of residence for students at MIT in Cambridge, Massachusetts, has been likened to the Unité – a reinterpretation of the model.

From the outside, the building has an unusual and distinctive form among the other campus buildings. Its rectilinear purity is cut into at the upper levels by external terraces, and the regular, square grid of windows that covers the entire façade is invaded, apparently at random, by large, irregularly shaped windows. The

5

4 The voids that cut through define the shared spaces, in contrast to the repetitive rectilinear study rooms. Their free-flowing curves signal spaces for more relaxed activities.

5 The curved concrete forms of the light shafts appear to spill out into the otherwise ordered environment.

6 Part section, 1:500. The free-flowing geometry of the light shafts cuts through the regular structure. The voids, several storeys high, are cut into the building to bring light down into lower floors.

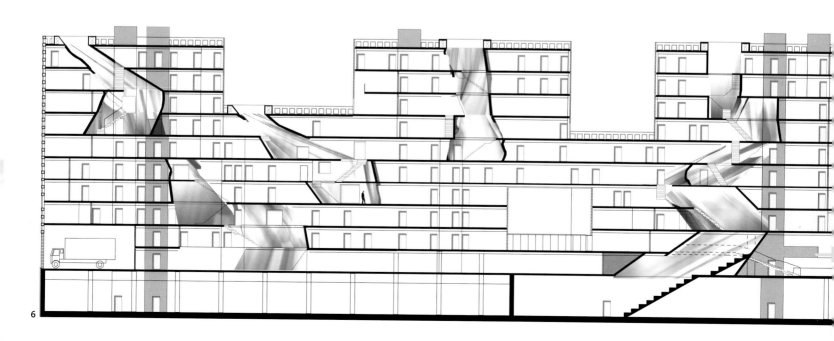

6

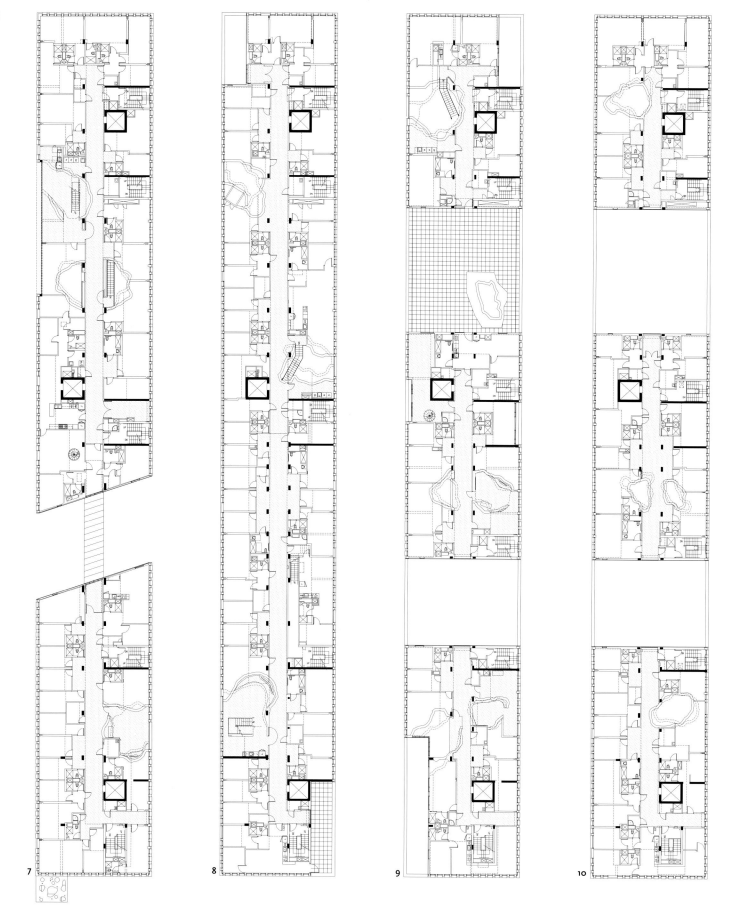

grid is deceptive in itself. On first impression, the assumption would be that the grid defines a structural frame related to each floor level, thus making the building appear to be 30 storeys high rather than its actual, more modest, ten storeys. For a building of this scale, a construction that uses a dense masonry structure is unusual and its depth also contributes to the deception in scale. Colour is used on the façades in two different ways. The first is a simple grouping of the rooms into ten 'houses' identified by colours on the deep window reveals. The second is a seemingly random colour scheme, the result of coding in relation to the size of steel reinforcement bars

specified by the engineers to stand up to different maximum structural stress anticipated in different areas of the structure.

In the plans the interruption of what might be a regular linear arrangement of individual rooms divided by a central corridor is yet more dramatic. Whereas on the façade the incisions into the structure follow the vertical lines of the grid, in section the light wells carved through the structure appear to crash through at random. At different angles, their presence intrudes on corridors and other shared spaces. They serve to light the shared meeting spaces where their curves stand out in contrast to the rectilinear arrangement of

rooms and corridors, and a thin shell concrete is used to form these more fluid, curving forms in juxtaposition to the massive, ordered rectilinear forms of the rooms. The whole is suggestive of the chance occurrence encountered at the scale of the city rather than the ordered environment of a building.

The internal 'street', which, at 3.3 metres (11 feet), is much wider than a corridor might be, seems highly appropriate as a device for encouraging casual encounters in a building specifically designed for students for whom social interaction is part of the programme. While the Unité included shops and cafés, the

MIT programme goes further, also providing restaurant facilities and a theatre.

7–10 Plans, 1:500. The plan is a simple arrangement of student study rooms either side of a central corridor, with three lifts and enclosed stairwells along the length. The central corridor is

conceived as a street, wider than a conventional corridor and interrupted along its length by the curving concrete forms.

11 The 3 x 3 grid on the façade demarcates a standard study bedroom, 3 metres (10 feet) high and 3 metres (10 feet) wide.

12–13 Short sections, 1:500. A wide flight of stairs leads up to the main entrance, which is one level above ground. Study rooms are on both sides of the central corridor, while open

stairways are located within the light shafts.

11

12

13

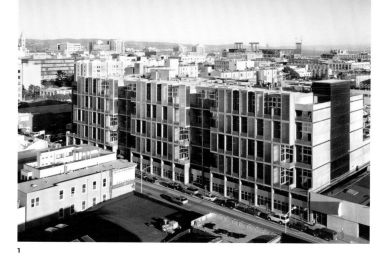

1

Light industrial and warehouse buildings made redundant in city centres during the 1960s and 1970s provided a cheap, alternative form of accommodation. Built as functional places for temporary storage, their deep plans, low ceilings and limited daylight, often only available through doors to loading platforms on a street façade, did not conform to existing ideas of a domestic environment.

Despite the obvious drawbacks, however, the spatial opportunity afforded by large-surface, open-plan areas very soon became a popular alternative to more typical forms of living accommodation. A few years later, the 'loft' became an established type. The main drawback experienced with the occupation and reuse of lofts, or warehouses, is the lack of daylight in what are usually very deep plans.

The design of the newly built Yerba Buena Lofts follows a typical loft, or warehouse, design – low floor-to-ceiling height, a deep plan and a close structural grid. To make the building habitable, however, every unit includes double-height living spaces. All 200 units are simple, rectangular plans with a uniform width of 4.5 metres (15 feet) and vary in depth from 15 to 20 metres (49 to 66 feet). Each is a double-height volume with full-height glazing on the façade and a mezzanine floor towards the centre of the block. Variations in plan type include the overall depth of the plan and the extent of the mezzanine.

The building occupies the whole depth of the city block between

Folsom Street, a busy commercial thoroughfare on the north side, and Shipley Street, a quieter, smaller-scale residential street on the south side. To maximize daylight and to relate better to a domestic scale, the building along the residential street is limited to two double-height lofts. The additional depth across the site over the four lower floors is occupied by carparking, which is laid out efficiently to coincide with the floor levels of the apartments. All the units have access to private outdoor space. Most have a small loggia; the ground-floor units have direct access to the street and units above the set back have roof terraces. Apparent in the plan is the same

Yerba Buena Lofts
San Francisco, California, USA
Stanley Saitowitz Office
2002

1 Fair-faced concrete walls and floors form a regular grid structure visible on the façade.

2 Site plan, 1:2,500. The building occupies the whole depth of the city block.

3, 4 A full-height glazing to the façades is either translucent or transparent around the loggias.

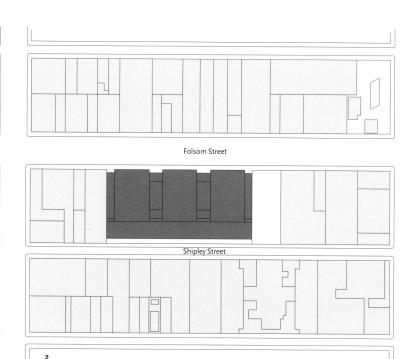

Folsom Street

Shipley Street

2

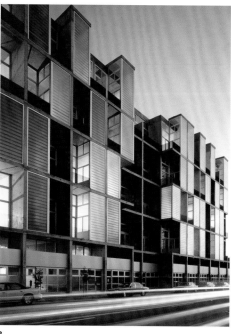

3

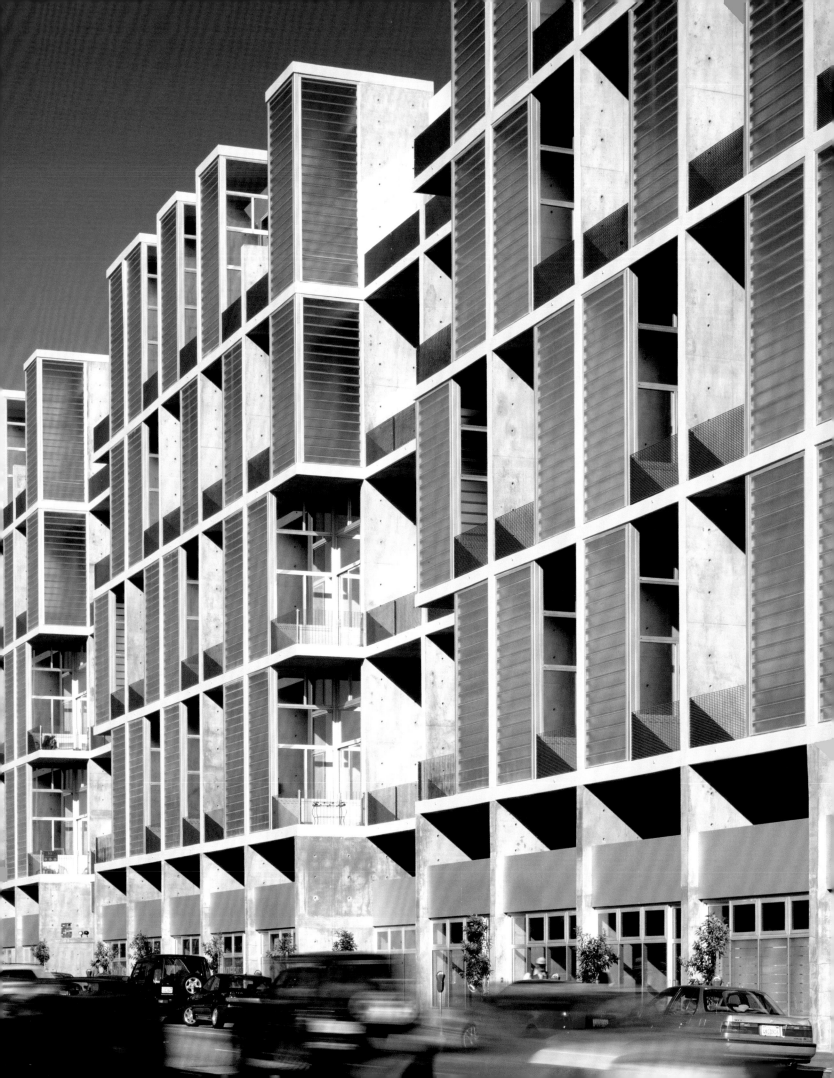

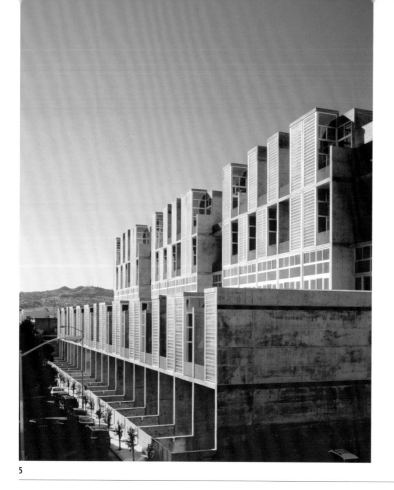

5

6 7

5 To accommodate the different scale of the buildings on Shipley Street, the block is reduced in height.

6–7 Plans, 1:200. Larger unit type with open plan and stairs up to mezzanine level. The crenellated façade separates the neighbouring loggias.

8 Section, 1:200. Parking is accommodated in the central, dark part of the plan. All the units have double-height spaces at the façades and mezzanines of varying depth.

9 The concrete structural columns frame the double-height glazing and the loggias on the façade.

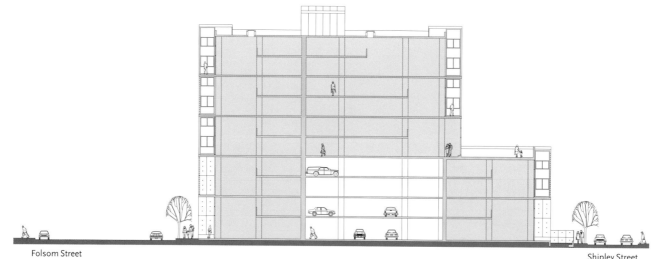

Folsom Street Shipley Street

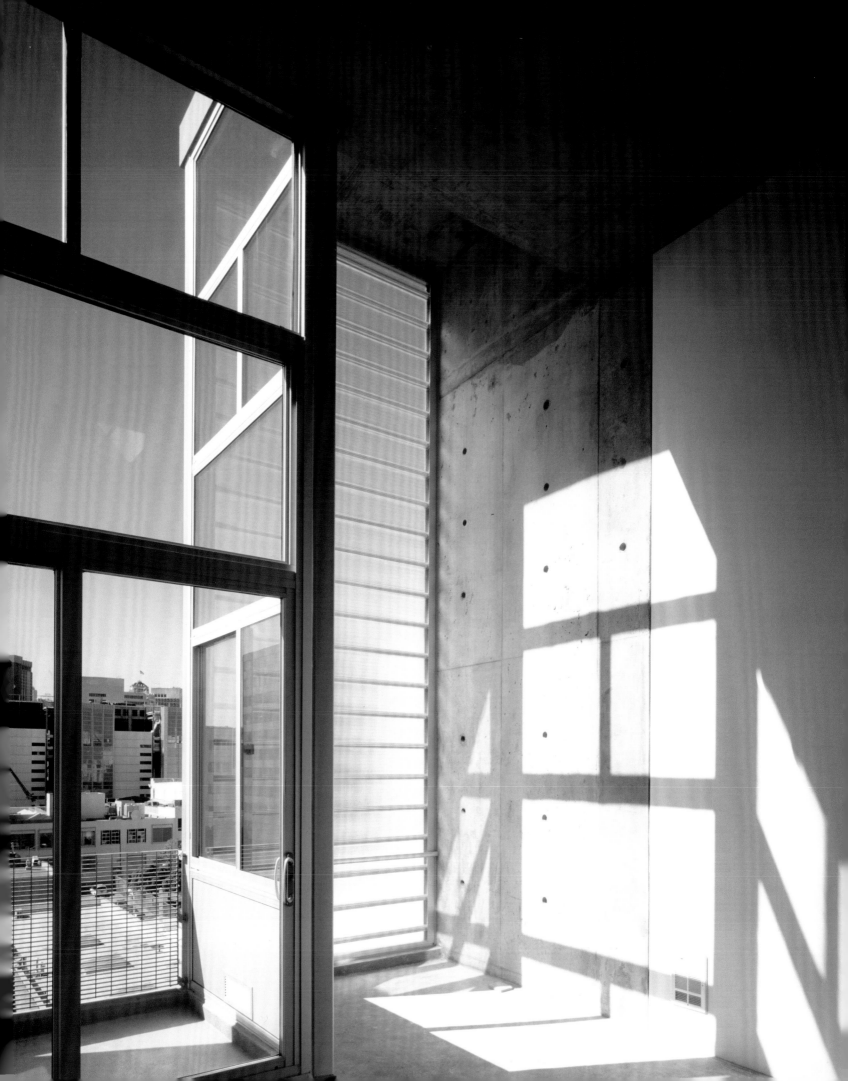

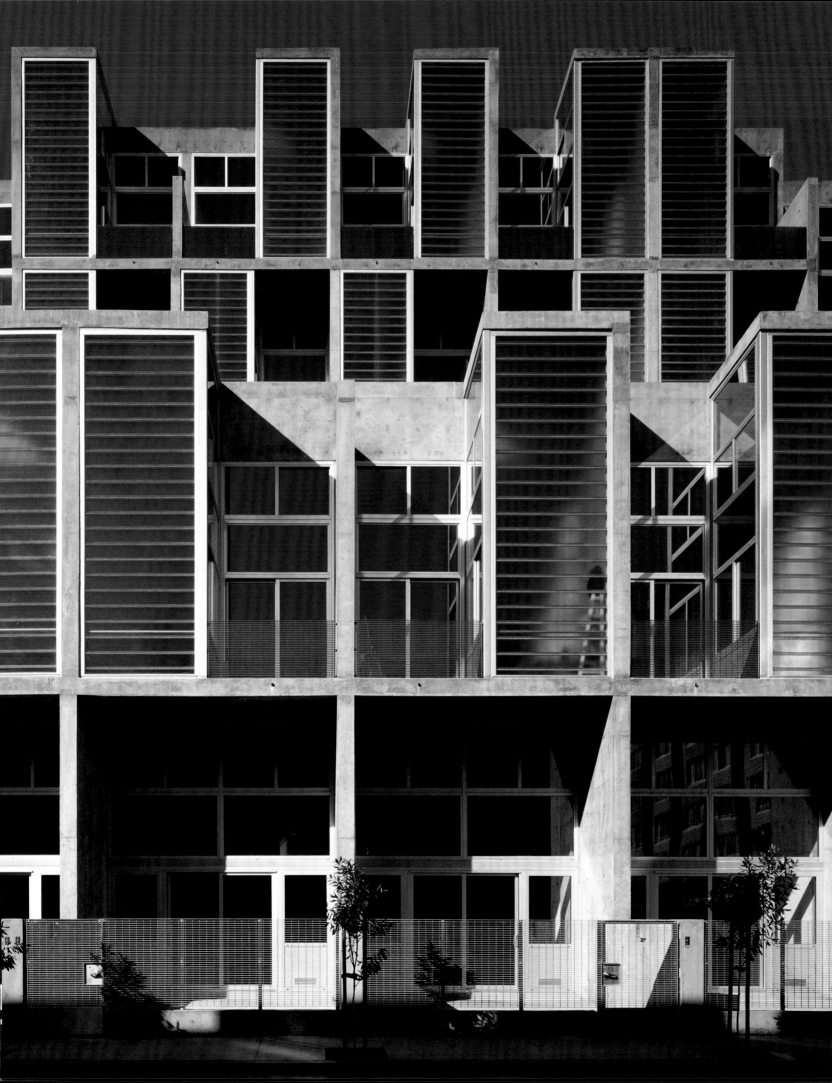

erosion of regularity at the edges of the mezzanine, and an opening up towards the façade.

The building appears utilitarian and functional. It uses a very limited, simple palette of materials and finishes, and its Modernist approach to design and construction is evident. The concrete construction is visible, each of the squares on the façade describes one unit, the glazing is either transparent around the loggia or translucent, and steel is used for balustrades and railings.

Slender columns – 2 metres (7 feet) wide and 30 centimetres (1 foot) thick – on the street façades form a regular, clearly visible 'eggcrate' structure. The edges of the 'fins' and the edges of the concrete floor slabs are exposed where they meet at the façade to form the subtle, underlying square grid that defines each unit. Glazing is organized within the grid on different planes to provide balconies and set backs. The system of narrow, concrete columns was used to support shuttering for the floors during the construction process, avoiding the need for scaffolding. Within the apartments, concrete gives visual definition to an area adjacent to the façade, forming a double-height loggia.

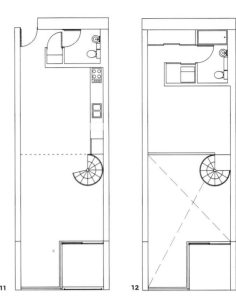

11 **12**

10 The Shipley Street side has two double-height units at lower levels, with the upper levels set back to form a roof terrace.

11–12 Plans, 1:200. Small unit type with spiral stair from the lower level (11) up to the mezzanine (12).

13 Interior of a typical smaller unit.

13

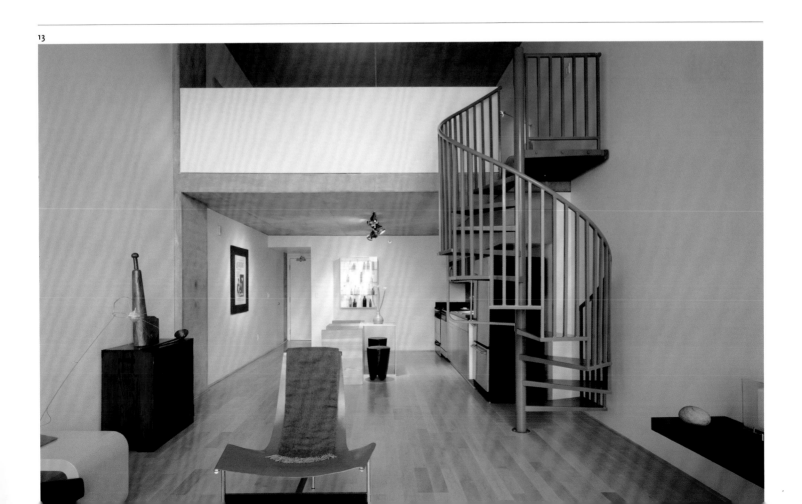

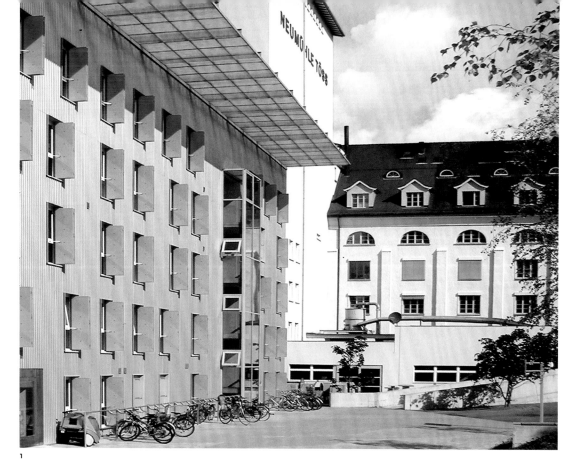

This project was built as a result of an open competition inviting the exploration of new and innovative strategies for low-cost housing. The competition was held by the Society for the Construction of Low-Cost Housing, a society with many years of experience in the provision of workers' housing, and with the confidence to build experimental projects and to test new models. The scheme that they chose to build tackles one of housing design's most important issues – individual expression – taking into account the unalleviated regularity and repetition of identical modules, and building elements, that are typical of so many housing projects.

Housing in Auwiesen
Winterthur, Switzerland
Kreis Schaad Schaad
2001

1 Facing the square, the building is related in scale to the adjacent mill tower. The austere façade is interrupted only by the grid of wooden shutters and the glazed circulation.

2 Site plan, 1:2,500.
3 The different apartment types are evident on the rear elevation: the lower-level maisonettes have recessed façades, and the top floor is set back to form roof terraces.

4 The domestic nature of the block is evident at the rear, with clear signs of occupancy on the terraces, patios and winter gardens.

5 Section, 1:200. Three main types of unit are provided: two-storey apartments at roof level, maisonettes on the lower levels and two storeys of flats in the middle.

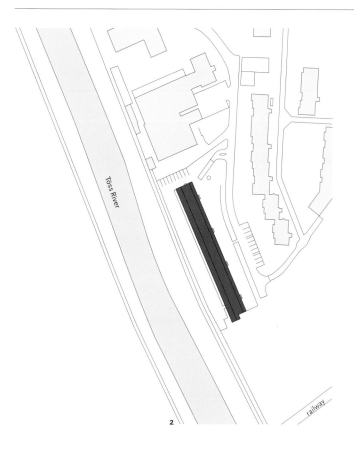

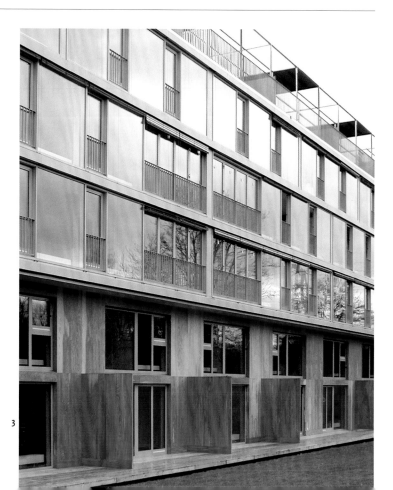

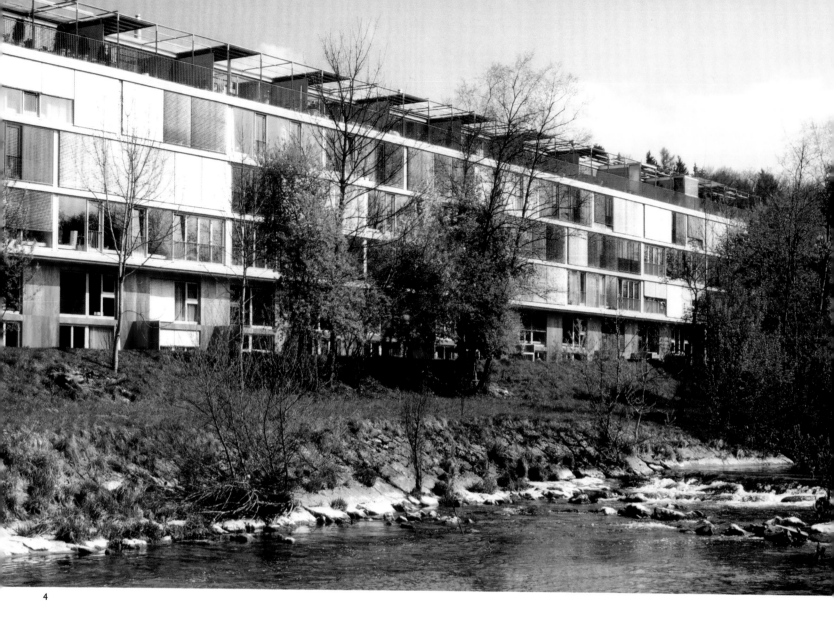

4

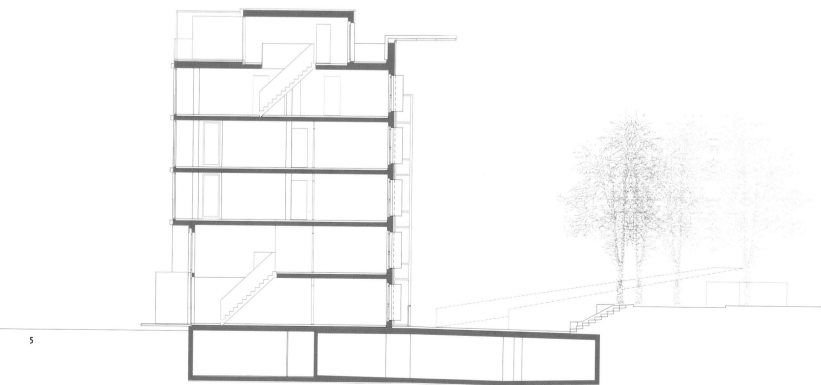

5

The architects, Kreis Schaad Schaad, have conceived the building as a warehouse or container for the individual dwellings to slot into. The façade on the paved square could be that of a warehouse, clad with corrugated-sheet aluminium, an austere, unmodulated plane interrupted only by the regular grid of wooden shutters and four glazed stair towers. At the eaves, an over-sized overhang completes the effect of scale. In contrast to this anonymous and uncommunicative wall, the façade at the back of the block communicates its domestic purpose. Clear signs of occupancy are given by the glazing, pergolas and terraces that make up a much more relaxed, less regular arrangement.

There are six floors: two-storey apartments are at roof level, maisonettes at ground-floor level and one-storey flats on the two middle floors. Each staircase serves two dwellings per landing. The most innovative aspect of this project is not the design either of the 'container' or the individual apartments, but the process by which the layout of the apartments was arrived at. For each of the three main types, the architects drew up a series of options that varied from conventional layouts with several small rooms to more open-plan 'loft' versions with small mezzanines. The purchasers were then able to choose the layout for their unit and negotiate directly with the architects for the specification of the finishes and fittings. With a relatively low budget, the entire project used everyday building components and standard fittings selected from catalogues.

The site was particularly difficult, close to the river with a high noise level from a nearby railway and busy roads. To reduce the noise level, the architects had originally proposed a glazed verandah running the full length of the back. Instead, the flats on the two middle floors are provided with small winter gardens that can be opened up in warm weather to provide outdoor space.

The roof-level two-storey apartments have terraces with pergolas and, at ground-floor level, the maisonettes have direct access to the communal garden.

6 Flats on the second and third floors have winter gardens in the corners.

7–12 Plans, 1:500. The architects designed a variety of different layouts within the three main apartment types. Ground floor (12) and first floor (11) are maisonettes with gardens at the rear; the second floor (10) and third floor (9) have flats with winter gardens; and the fourth floor (8) and fifth floor (7) make two-storey units with terraces at front and rear.

6

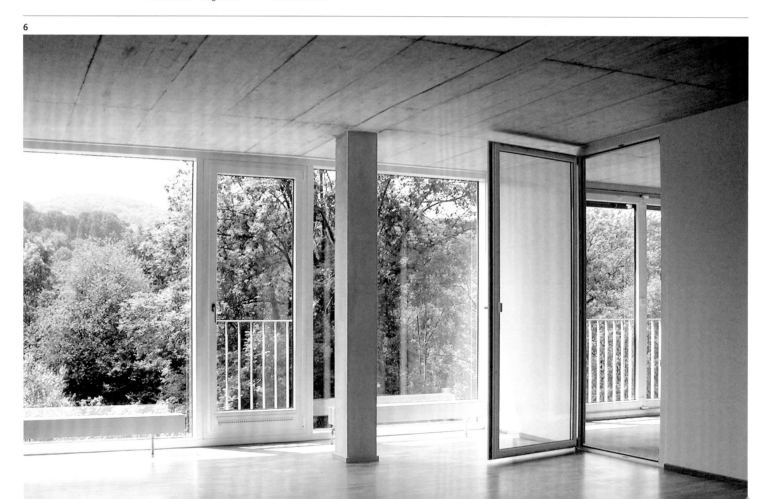

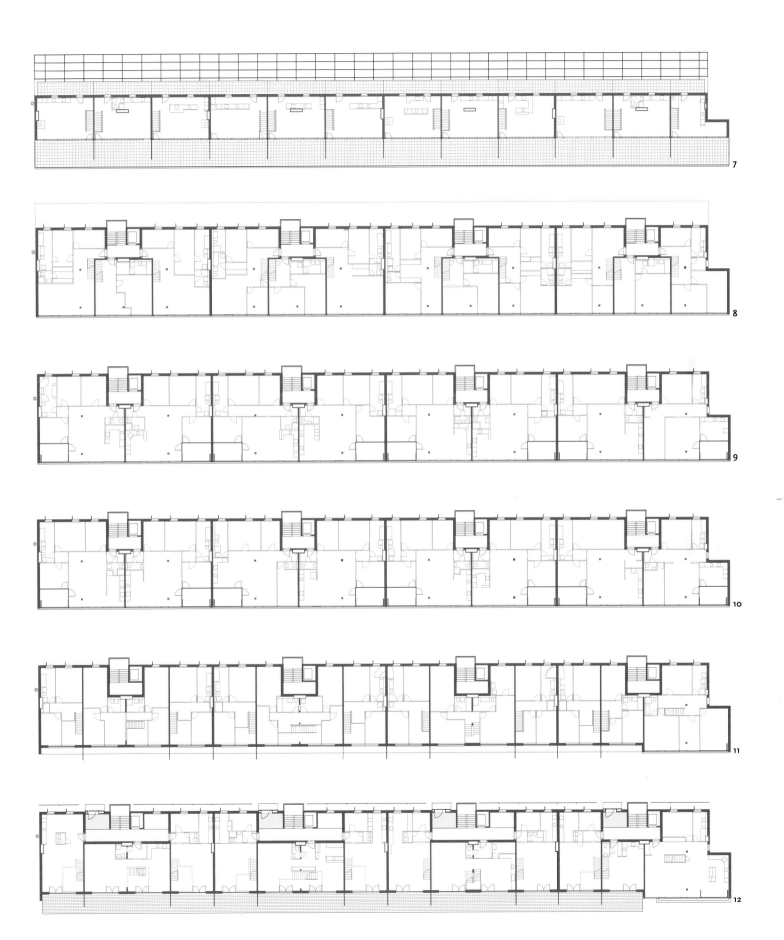

7

8

9

10

11

12

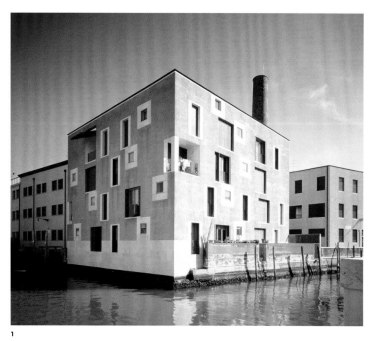

1

Finding a way to insert a modern building into the rich historical setting of Venice requires skill to avoid clichés of historicism or pastiche. Cino Zucchi's D Residential Building has successfully established a contemporary approach to building in Venice that uses modern sensibilities in conjunction with the constraints of the context and an obligation to use a limited palette of materials.

The building on the island of Giudecca is one part of a much larger project to redevelop the site that was occupied for decades by the Junghans watchmaking works. The island's north side, facing San Marco and the centre of Venice, has long been densely residential, but the south side is much more sparsely developed and largely industrial. Cino Zucchi's project involves a careful appraisal of the range of existing buildings and a measured approach to their redevelopment. Some buildings are preserved with only necessary repairs and minor modifications, some are in the process of conversion and major refurbishment, and others have been demolished to make way for new buildings. The urban landscape is considered as a whole, with particular regard to the scale of the intervention and to maintaining a continuity in relationship to surrounding buildings, squares,

D Residential Building

Venice, Italy
Cino Zucchi Architetti
2002

1 The building is located at the junction of two canals.

2 Site plan, 1:2,500.

3 Little external space is provided, and only a few flats have loggias cut into the building's rectilinear form. The walls continue upwards, forming parapets masking a pitched roof behind.

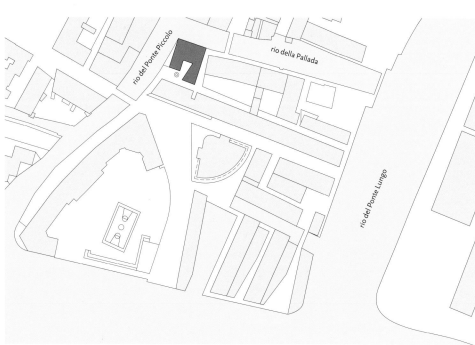

2

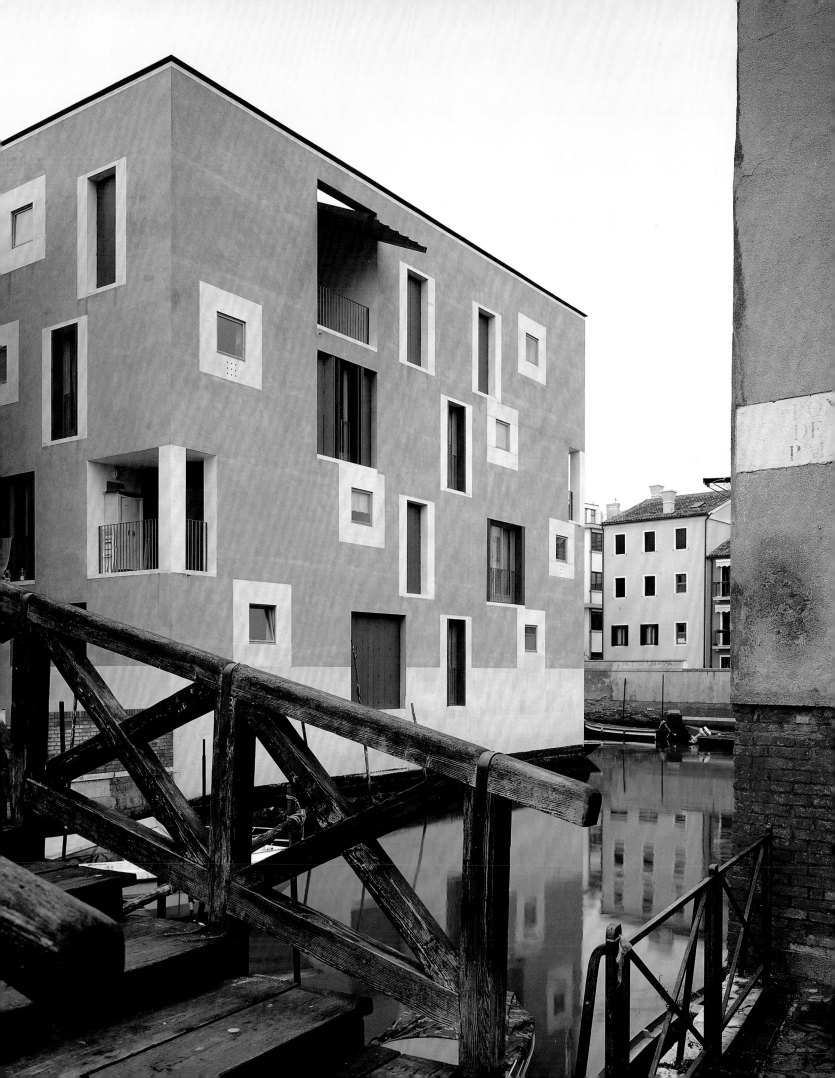

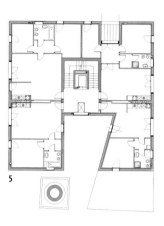

5

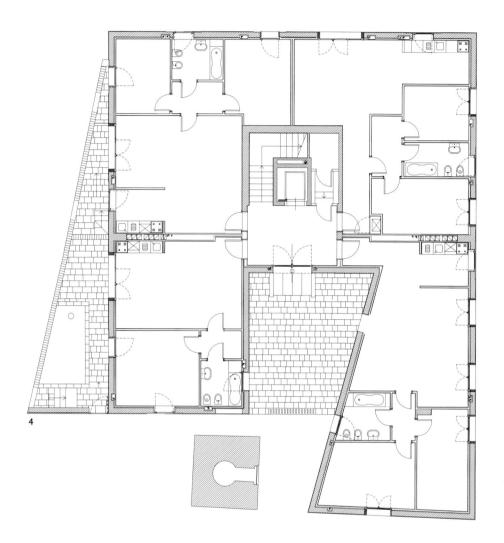

4

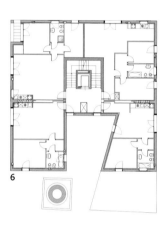

6

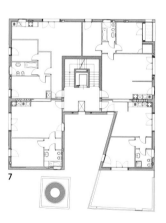

7

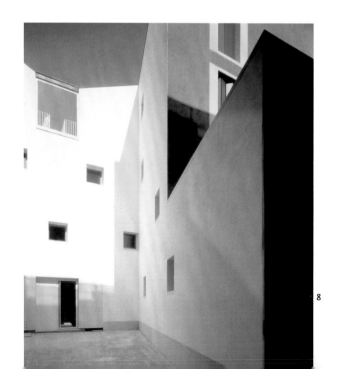

8

paths and canals. The project includes housing for students, single people and families, and introduces a denser matrix more like the northern, residential side of the island in place of the looser arrangement of the industrial area. The first project to be completed, known as D Residential Building, is a new construction to provide state-subsidized housing.

D Residential Building is small, containing just 16 apartments, four per floor. The accommodation is minimal: one- and two-bedroom apartments of small area with layouts that maximize the available floor space. Front doors open directly onto open-plan living rooms so that no space is wasted on entrance halls or corridors, and there are no fitted cupboards. From the living rooms the bathrooms and bedrooms are reached via small internal lobbies. One of the apartments has a roof terrace and three others have small loggias. In place of the provision of any other outdoor space all the living rooms have wide French windows.

Externally the building is distinctive. The construction is of loadbearing brickwork. At the base, a durable facing is added for protection against water damage, and the remaining façade is of smooth-finished render. The entrance area is painted white and has only small windows puncturing the surface, a characteristic more likely to be found in a private rear courtyard or a light well. The rendered walls continue uninterrupted to form a parapet concealing a pitched roof and emphasizing the cube-like form. The windows initially appear set out at random, perhaps as the result of additions or alterations at different times. Yet this is not so; they relate to the interior spaces, positioned either to maximize views of Palladio's Church of the Redentore (1577) nearby or to provide a different level of light and ventilation to the various internal spaces. The small, square windows with high sills light kitchens and bathrooms, the rectangular windows light bedrooms and the large, square windows open on to living spaces.

The cube-like structure sits at a T-junction of two branches of the canal. The north façade borders the water and, to the west, a tiny wedge-shaped courtyard fills the space between the 90-degree geometry of the building and the water. The entrance is recessed into the otherwise square plan forming a courtyard partly enclosed by the asymmetric extension on one side. The other side is marked by a brick chimney, left standing as a memory of the building that previously occupied the site.

4–7 Ground-floor plan, 1:200 (4). First- (7), second- (6) and third-floor (5) plans, 1:500. The apartments are small, with open-plan living areas. Separate lobbies lead to bedrooms and bathrooms.

8 A small courtyard at the entrance is partially enclosed by the asymmetrical projection on one side.

9 Three different window types relate to the spaces behind: high-level square windows for kitchens and bathrooms, and full-height french windows are either narrow for bedrooms or wide for living rooms.

9

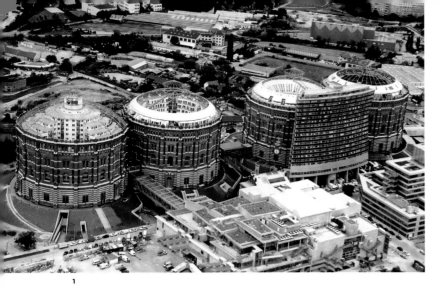

Buildings that represent our industrial and cultural heritage are fast becoming as important as palaces and museums, once the only buildings considered worthy of preservation. The important questions of how such buildings are to be preserved, how they are to be accommodated in the urban fabric, and whether their reuse is appropriate, are ones that will affect us increasingly. The project to convert the gasometers in Vienna to housing and offices, particularly the one carried out by Coop Himmelb(l)au, demonstrates a successful approach to such reuse. As Wolf Prix, partner at Coop Himmelb(l)au, states: 'It's an attitude about landmarks that says they are not sacred. We should find new programmes for them as well as preserving them. It's what keeps a city alive.'

The gasometers on the southside Simmering district of Vienna were built in 1896. Long since redundant as gas holders, the neoclassical brickwork façades, built to camouflage their functional structures, had already been elevated to 'landmark' status. They were unlikely to succeed as a tourist destination. However, their image, in giving character to an otherwise undistinguished area, could be used to attract investment and activity – a necessary precursor to defining a new part of the city – and the creation of mini-downtowns separate from the central and historic areas.

A competition was held and four architects were selected to work on each of the gasholders. Three, Jean Nouvel, Manfred Wedhorn and Wilhelm Holzbauer, developed designs within the confines of the huge cylindrical forms. By contrast, Coop Himmelb(l)au extended their site, inserting a multi-purpose concert space into the lower levels with a shopping mall above, and adding a narrow, shield-like strip of building to one segment outside the cylinder. There is no attempt for the new addition to blend in with the existing building. In contrast to the firmly grounded solidity of the brickwork of the old building, the new building, with a structure of concrete and steel, appears much

Apartment Building Gasometer B
Vienna, Austria
Coop Himmelb(l)au
2001

1 The regeneration project focuses on the four gasometers. Gasometer B is the only one of the four to add another built element to the existing cylindrical form.

2 Site plan, 1:2,500. A. Jean Nouvel, architect; B. Coop Himmelb(l)au, architect; C. Manfred Wedhorn, architect; D. Wilhelm Holzbauer, architect.

3 The new building is joined to the gasometer by a bridge connecting to one of the three main circulation cores.

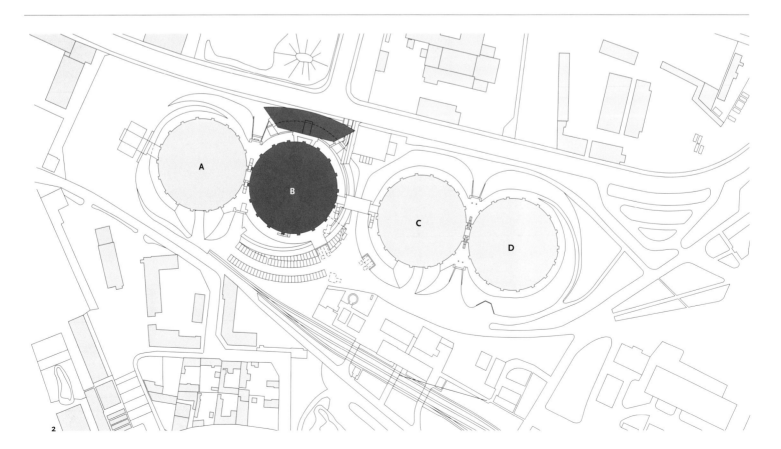

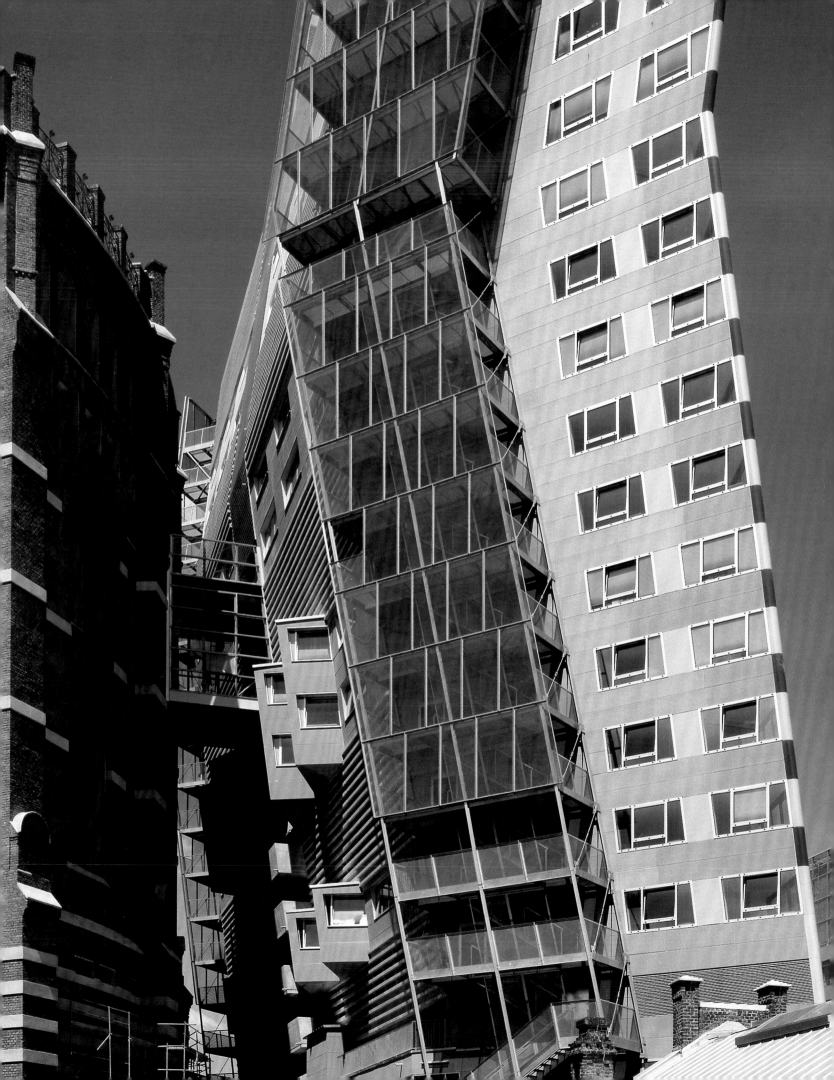

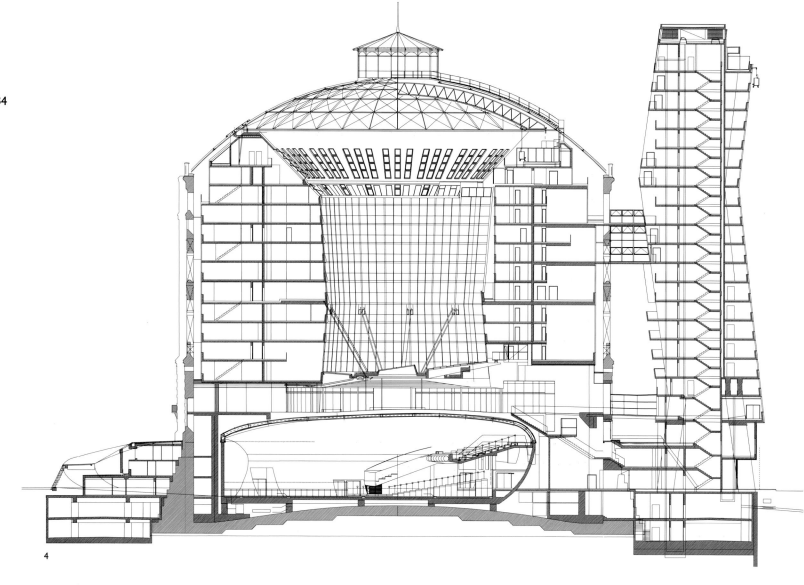

4

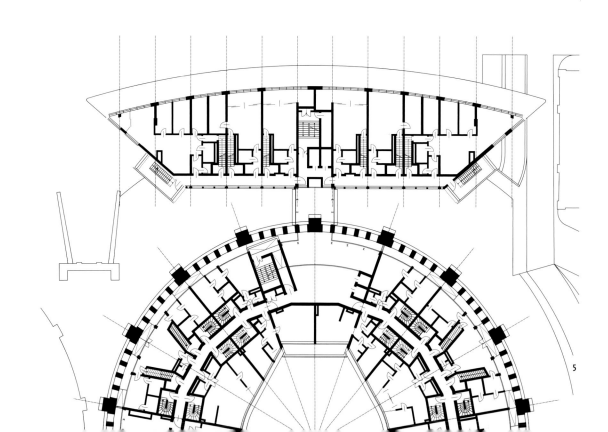

5

lighter. Its slender form is raised up several storeys on inclined columns and the façade is concave, which further adds to the sense of fragility. The gasometer itself is unchanged apart from narrow strips of glazing inserted into the brickwork, next to the main piers, to allow adequate daylight into the apartments.

Inside the shield and the cylinder, the 330 apartments, including 76 student rooms, are mainly two storeys, which reduces the shared circulation spaces. The planning of the individual apartments is conventional, although many have unusual room shapes where they fit into the tapered segments of the cylinder or the inclined façade of the 'shield'. There are three main circulation cores, one of which is located at the narrowest junction with the 'shield'.

Citing Rome – where the interventions of Modernists are overlaid on the conversions of the Renaissance on ancient structures – as their model, Coop Himmelb(l)au are confident that reusing existing structures, without being unnecessarily cautious about fabric or reputation, can enhance their status as monuments while maintaining their usefulness. Most importantly, the adaptive reuse of buildings such as the gasometers in Vienna, reflecting both the past and the present reality of the city, contributes positively to the necessity of urban growth.

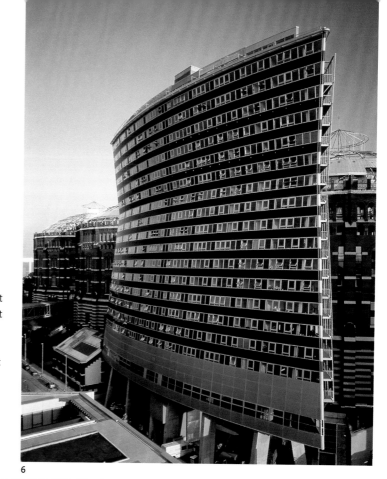

6

4 Section, 1:500. In addition to the apartments, the cylinder contains a multi-purpose concert hall at the lower levels and a shopping mall.

5 Part plan, 1:500, ninth floor. Most apartments are two-storey duplexes to reduce the need for communal circulation space.

6 In contrast to the solidity of the brick cylinders, the new building – raised above the ground on *pilotis* – appears much lighter.

7 Looking up into the glazed roof of the atrium space inside the gasometer.

7

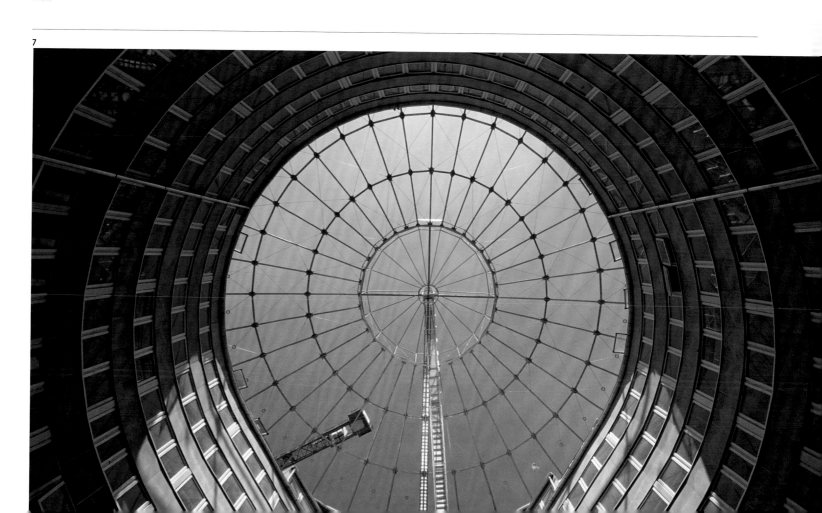

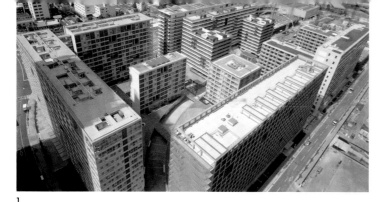

1

Shinonome's Canal Court Centre Block on Tokyo's waterfront is the site for six high-density rental-housing schemes, each designed by a different architect. Although all the architects have a different approach to the design of the housing blocks, they worked together to arrive at a coordinated overall plan for the Centre Block and collaborated on the landscape design. Agreement was reached on overall heights, to use perimeter blocks to enclose the site, and to use consistent floor levels to simplify connections between the blocks. A desire for flexibility to accommodate change in the future also led to the decision to limit intervention in some aspects of the design.

The external spaces around and between the different housing schemes are a significant element of the architectural composition. Labelled as 'OSL' (outside living spaces) by the designers, thought has been given to how they might be used for different activities at various times of the day. Between the housing blocks, the spaces designed for planting have narrow strips of open ground alternating with strips of paving to provide flexibility. The open-ground strips can be planted with grass, with taller shrubs and bushes to form barriers and delineate different spaces, or be simply covered with metal grills to give a continuous surface. Their presence creates a 'natural' habitat for insects and other wildlife, as well as providing rainwater runoff. Closer to the housing units, lower levels are occupied by commercial spaces and service spaces. A timber deck at first-floor level, with open wells, connects the two levels. A curved path crosses the middle of the site, linking the housing blocks and locating the children's facilities and other communal buildings and services.

The importance given to external places as a key way to find different ways of living and new definitions, or delineations, between private and public spaces continues into the Block 1 scheme, designed by Riken Yamamoto and Field Shop. The basic infrastructure is an 18-metre (60-foot) deep concrete frame. It has a six-metre (20-foot) structural grid, which is divided in half to give a standard room 'module' of 3 metres (10 feet). The architects have identified a space within each apartment called a 'foyer room' located next to the entrance and one of the largest rooms in the dwelling. It is

CODAN Shinonome Canal Court Centre Block, Block 1
Koto-ku, Tokyo, Japan
Riken Yamamoto and Field Shop
2003

1 Architects for the different schemes in the centre block worked to agreed heights and site layouts.
2 Site plan, 1:2,500. 1. Block 1; 2. Block 2, Toyo Ito; 3. Block 3, Kengo Kuma.

3 The perpendicular blocks are connected via bridges at upper levels. Double-height terraces interrupt the regular grid of the façade.

4 The central space is organized around the curved pathway connecting the various different facilities.

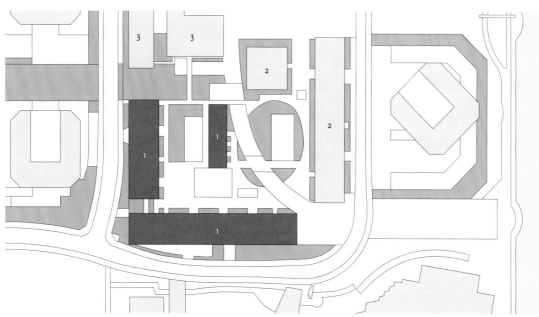

2

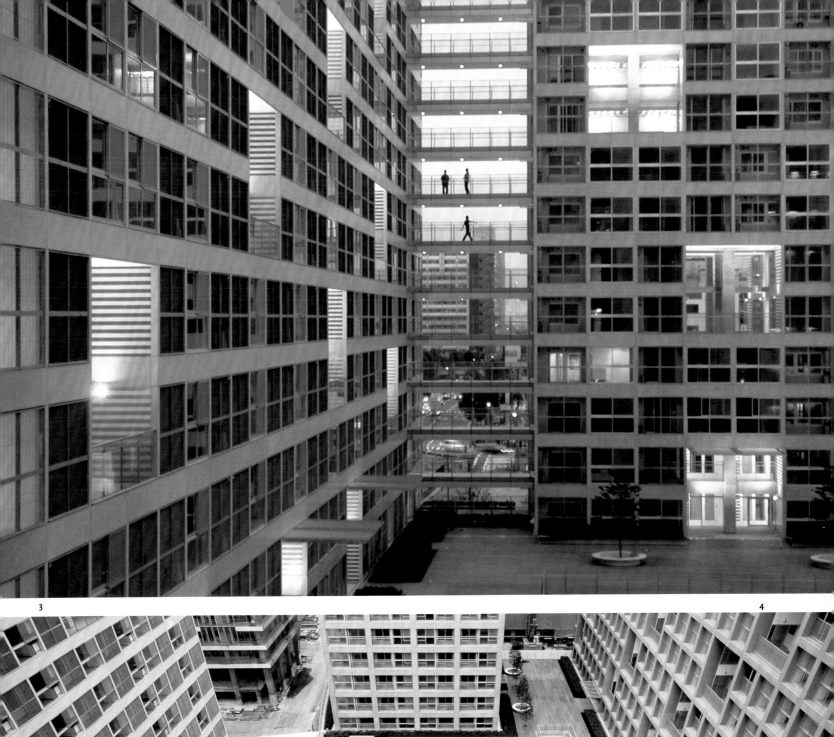

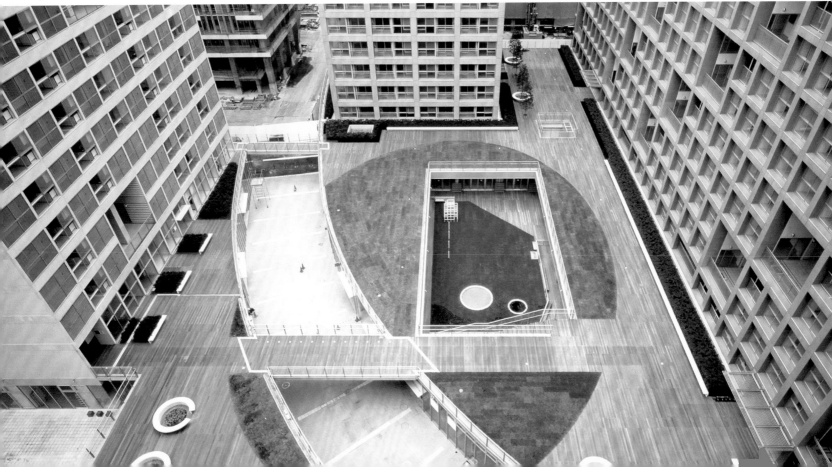

6

5 Foyer rooms are visible from the corridor, with none of the conventional devices to indicate a boundary between private and shared spaces.

6 Corridors are 1.8 metres (6 feet) wide and incorporate storage spaces.

7 Bridges connect the levels across the two-storey-high open terraces.

5

7

described as somewhere between the clearly private space of the dwelling and the common or shared corridor of the block. Further, the wall to the corridor is glazed to make the space clearly visible from the outside and therefore less private. Its ideal use is as a working space – SOHO (small office home office) – and it has also been likened to a conservatory or a porch, spaces usually outside the boundary of 'home'. This blurring of the conventional boundaries between private and public spaces continues in the access corridors. A generous 1.8 metres (6 feet) wide, the corridor is interrupted intermittently on every floor level by two-storey-high open spaces or 'terraces'. Together with the borrowed light via the glazed façades of the foyer rooms, the terraces bring daylight into the access corridors.

The interior layout of Block 1 follows a contradictory logic to most conventional planning of an apartment building with a central, or double-loaded, corridor. To locate the foyer rooms adjacent to the corridor, the bathrooms and kitchens are sited on the exterior façades of the building. More usually found in the darker areas close to the centre of the block with the service cores, it is the fully glazed bathrooms that have the best views and daylight levels.

8

8 Open-plan living and sleeping space leads to the bathrooms and kitchens beyond, located on the exterior walls.

9–10 Typical apartment plans, 1:200. There are numerous variations. The basic unit (9) is organized within the 6-metre (20-foot) wide structural grid. Other units are combinations of the standard width plus a foyer room (10).

11–12 Two-storey apartment plans, 1:200, with foyer room adjacent to a double-height terrace.

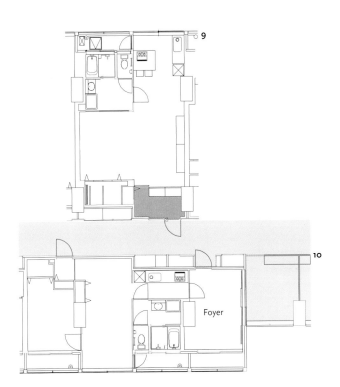

9

10

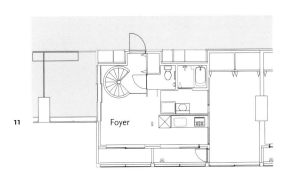

11

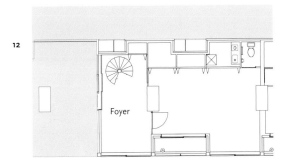

12

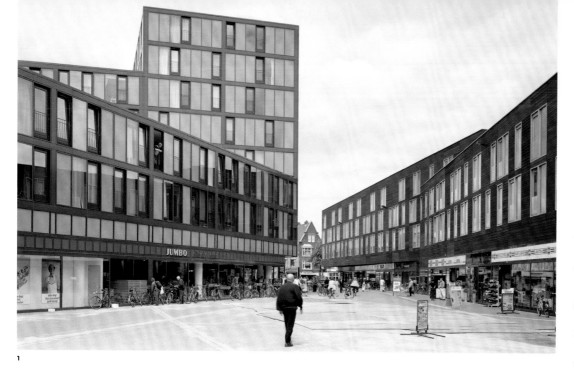

buildings but in the Modernist sense as free-flowing space within which various different buildings are located. Its definition, surface and direction change to accommodate and link to existing structures. The result is a volumetric landscape where there is no longer a consistent 'figure and ground' plan, and the distinction between buildings and background is blurred.

Within this overall framework, S333's two buildings, Schots 1 + 2, appear as if a continuation of the three-dimensional landscape – either growing from, or cut into, the different levels of the 'ground'. The two blocks, one of terraced houses, the other an eight-storey block of

These two buildings are part of a much larger urban regeneration project, won in the Europan Competition of 1993. The architect, S333, proposed a form of hybrid urban structure that combines both the form of the traditional city – closed blocks defining streets – with the Modernist ideal of the isolated building set in open green space. They identified that the inner-city, brownfield site could form a connection with the green-park zone to the north and the existing waterway to form a continuous linear 'ecological' zone. This zone, a low-traffic area, is conceived not as streets between

Schots 1 + 2
Groningen, The Netherlands
S333 Architecture + Urbanism
2002

1 The two parts of the scheme are divided by a central pedestrian shopping street.

2 Site plan, 1:2,500.

3 Schots 1. Some of the façades have training wires for planting. The façades are conceived as a part of the constructed natural landscape that extends across the horizontal and vertical surfaces of the buildings.

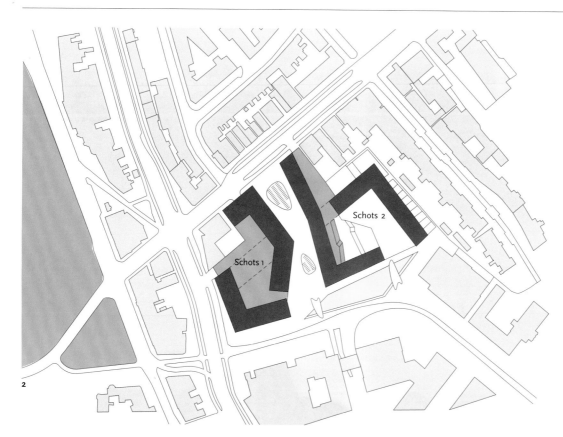

2

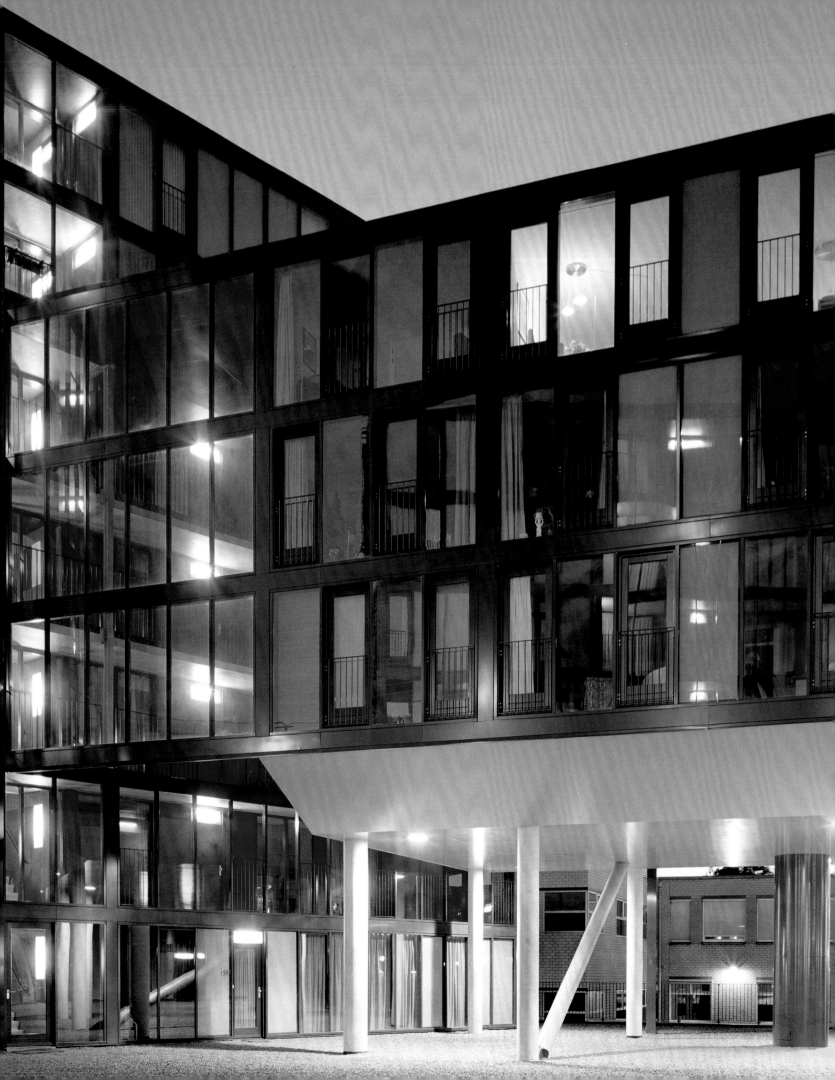

flats, have a very different external appearance in terms of both form and cladding materials. The terrace is clad with a western red cedar rain screen arranged in horizontal strips and windows framed in meranti. The block is mostly clad with panels of glass – either transparent, translucent or opaque – with an aluminium frame forming a consistent rectangular grid. The idea that the buildings are part of the landscape continues at the upper levels. Some of the flat roofs, which are visible from the flats, are planted, and the adjacent flank elevations are fitted with a mechanical watering system and training wires to support climbing plants.

Despite the differences in appearance and plan, there are formal and organizational similarities between the blocks. The long length of the terraced houses is cranked and angled to partly enclose an open courtyard, and the block is similarly made up of two, much narrower, single-loaded blocks facing an open space. A basement level extends under both elements, providing carparking across the whole site, and the ground-floor areas extend to provide space for commercial and retail units.

The programme called for a diversity of accommodation to suit the elderly, students, and lone parents as well as families. All of the housing types are for rent with a 30 per cent social-housing element. The internal layouts are unremarkable. The typical terraced house, with a width of 5 metres (16 feet), has an efficient stair with winders top and bottom, and bathrooms located in the centre of the plan to maximize the size of the living areas at the front and back. The plans include only minimal fittings, no provision for laundry and no fitted cupboards.

The 'ground' level, adjacent to the terrace, rises up interspersed with broad flights of steps to form an open space away from the main thoroughfare. This gives direct external access to a large number of dwellings and also means that the

shopping street is flanked by taller buildings as it cuts through the middle of the two elements, giving it a more urban scale.

4 Schots 1 apartments have full-height glazed façades that incorporate french windows.

5–6 Plans of apartments, 1:200. From the glazed access corridors, the rooms are organized either side of a central corridor with the bathrooms and kitchens located in the central, darkest part of the plan.

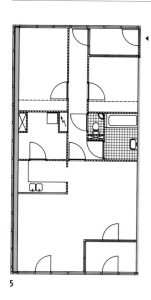

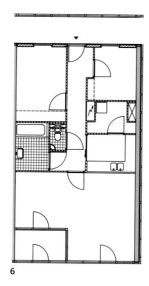

5

6

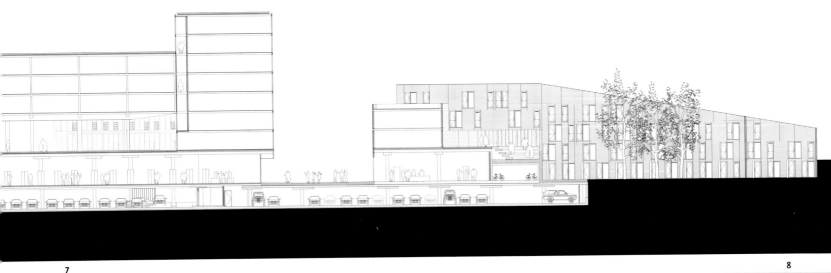

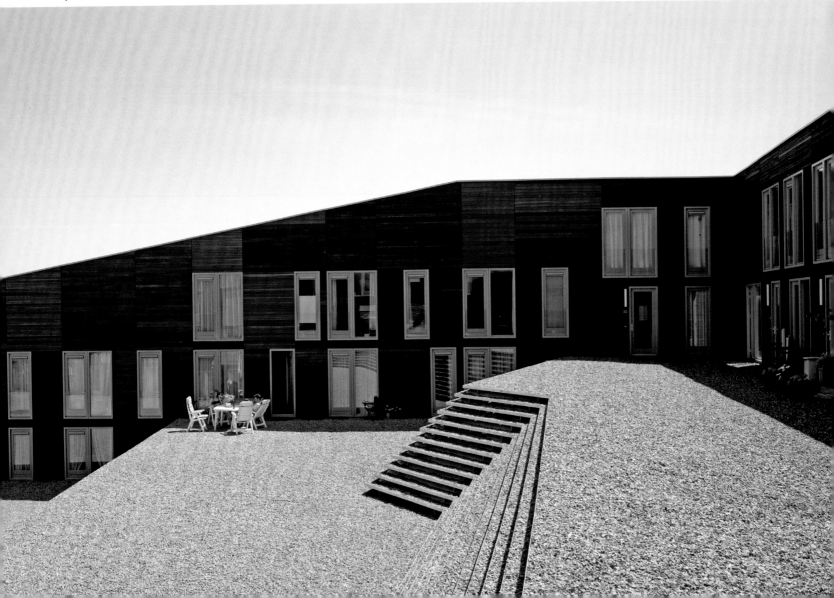

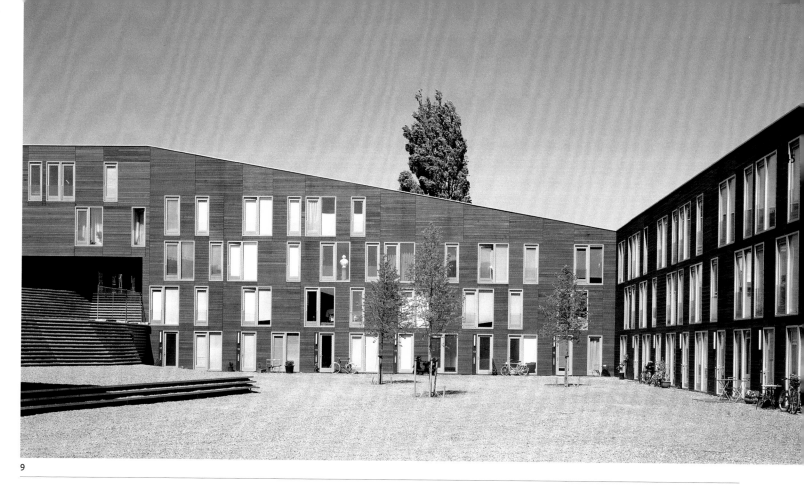

9

7 Section, 1:500. A basement carpark extends under the whole area of the site, and shops occupy the ground-floor level either side of the central street.

8 Within the partly enclosed spaces formed by the cranked terraces, steps lead to rooftop courtyards above the ground-floor shops, where the houses have direct external access from the higher 'ground' levels.

9 The terraced houses step up under a continuously sloping roof line above and behind the shops at ground level.

10–15 Schots 2. Typical terraced house plans, 1:200. Two-storey houses (10–11) and four-storey houses (12–15). There are many variations on the basic house type.

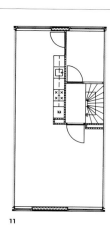

10

11

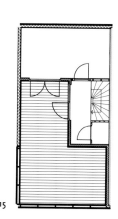

12

13

14

15

Chapter 4

Towers and Slab Blocks

1 Nemausus, Nîmes, 1987, Jean Nouvel. Industrial and off-the-shelf materials and fittings, used to reduce overall costs and increase floor space, create a distinct aesthetic for public housing.

2 Garage doors open up onto the perforated metal balconies from the double-height living spaces in the Nemausus apartments.

One of the major challenges of current thought on housing, is, in effect, that of stimulating a renovation of residential space not only from the required spatial and technical reformation of the given built 'cell', but also from the investigation of new urban orders.

Manuel Gausa, *Housing: New Alternatives, New Systems*, 1998

Unlike housing schemes that take as their starting point a direct relationship with the street, or integration into an existing urban block, tower and slab blocks, standing apart from their surroundings, tend to take as their starting point the design of the dwelling. The overall building can be defined in its own terms, offering the opportunity to create new formal and spatial typologies. Due to their high visibility, distinct both physically and typologically from the surroundings, these buildings often have considerable impact on the urban landscape over a sizeable distance. In the European context, largely through their association with social-housing projects, such buildings have, however, not been much admired.

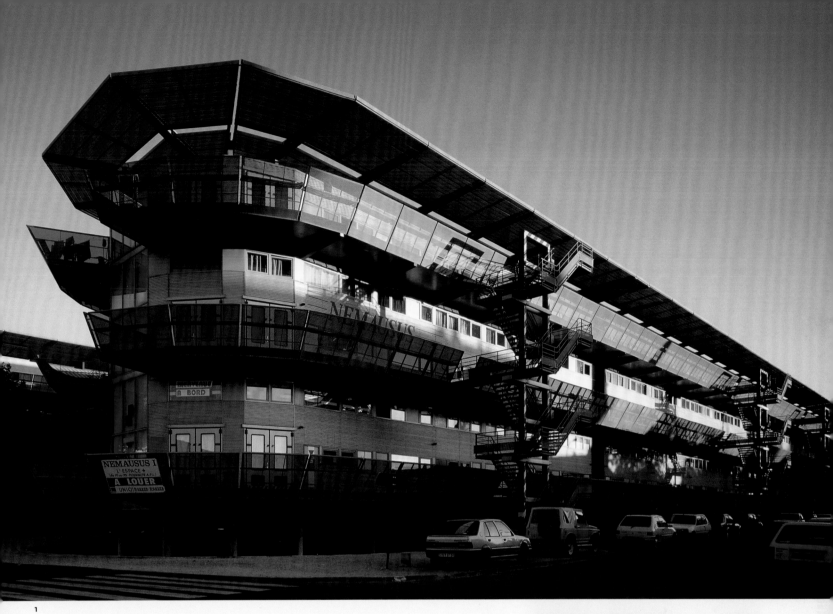

1

2

At ground level, too, the increasing number of tower and slab blocks built across Europe, especially during the latter half of the twentieth century, necessarily meant a reinterpretation of the street. New kinds of spaces had to be invented for these buildings – which were at a different scale and set apart from the immediate surroundings. New ideas were needed for the in-between spaces of shared corridors and circulation cores, entrance lobbies and foyers, and special thought had to be given to how the exteriors were to meet the urban landscape – the forecourts and plazas, parking and access ramps, as well as the green spaces and playgrounds. The design of these elements often lagged behind that of the dwellings.

In London, the towers of Denys Lasdun's cluster blocks explored ways to create 'neighbourhoods' on upper landings, and the Barbican (1959–79), by Chamberlin Powell and Bon, grouped towers above a 'podium' with social and cultural facilities. Jean Nouvel, in his Nemausus slab blocks (1987) in Nîmes, in the south of France, set out to build the biggest possible apartments offering the greatest of flexibility.

The recent examples included here exist independently of their surroundings, and are largely defined formally and spatially in their own terms. At an unusual scale, the footprint of the glass towers on Manhattan Island's Perry Street and Charles Street is small, and each floor contains just one, or sometimes two, apartments. With panoramic views across the Hudson River, these apartments are located to take advantage of the urban regeneration focused on the Hudson River Park and the redevelopment of the redundant piers.

The Contemporaine in Chicago's North River area uses a plinth – with four storeys of parking – to separate the residential tower from the surrounding urban environment. Above the plinth the 'skeletal' concrete structure and carefully articulated floor plates are visible behind fully glazed façades.

Steidle + Partner's Housing Tower in Theresienhöhe develops the tower form away from the enclosing geometry of a series of identical floor plans to produce a more varied exterior. Cantilevered balconies and loggias, apparently placed at random, interrupt the clean lines of the elevations and give variety to the apartment plans within. A modular layout, allowing the position of windows and railings to be varied, also contributes to the appearance of disorder.

Similarly, the Flower Tower in Paris, France, which has rather conventional internal plans within a more-or-less rectangular floor plate, relies on the continuous cantilevered balcony to define the architecture. Most architectural projects would consider planting at ground level, and the landscap-

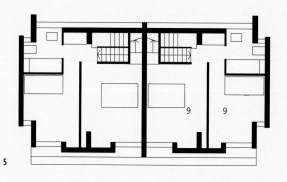

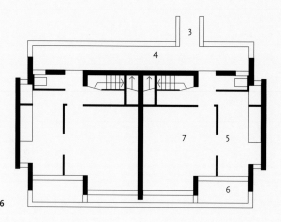

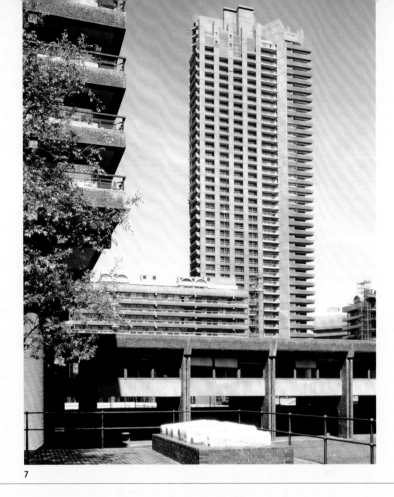

7

3–6 Cluster Block, London, 1958, Denys Lasdun. Plans of tower, lower (4) and upper levels (3), 1:500. Typical maisonette plan, 1:200. Lower level (6), upper level (5). A 16-storey tower with 56

two-bedroom maisonettes and eight one-room flats. At ground floor the towers house fuel and boilers, calorifier and water pumps and one has storage rooms for tenants.

1. main stair and lifts
2. refuse chutes
3. bridge
4. access balcony
5. dining/kitchen
6. private balcony
7. living room

8. drying platform
9. bedroom

7 One of the three towers at the Barbican Centre in central London, 1959–79, Chamberlin Powell and Bon.

ing of the site, a normal part of the completion of the scheme. They would leave the planting of terraces and balconies to the whim of the individual occupant – the Flower Tower, however, relies on planting at every level. Bamboo – as if a building element – is planted in rows of pots with an integral irrigation system that form the balustrade to the balconies.

Souto de Moura's scheme in Maia, Portugal, has a very different, but equally significant, façade. At first it appears that such a rigidly designed exterior, with a repetitive grid of aluminium louvres, must compromise the design of the interior. However, on closer inspection, any such compromise is hard to detect. With this kind of anonymous approach there is very little to distinguish one apartment from the next, and only a hint of different use of space is described by either fixed or moveable louvres.

The façade is also a key element in the Macquarie Street Apartments in the centre of Sydney, Australia, which take the glass wall to new levels of sophistication. Full-height winter gardens, contained between two layers of glazed façades, provide a physical separation between the private space of the apartments and the public space of the city. The internal glazed façade can be fully opened to the winter garden and the external layer, with fully operable louvres, allows apartments to be opened up to the outside.

Following the rules of early Modernism, Ercilla & Campo's social-housing project in Spain has blocks set out to avoid overshadowing, and aligned to maximize light on both sides and allow cross ventilation. The starting point for the dimensions of the blocks is that of the ideal individual dwelling.

In the Sejima Wing of the Kitagata Apartments project, the individual room rather than the dwelling is the base unit combined in different ways –

either above, below or parallel – to form the separate dwellings. Although there is a rigid starting point and a certain 'anonymity' of space, each individual room is separately accessible, identical and indistinguishable from its neighbour. Externally, the result is a façade of varied texture, differing transparency and seemingly random composition.

The Mirador Apartments building, recently completed in Madrid, Spain, by MVRDV + Blanco Lleo, is effectively a collage, or montage, of different blocks containing different dwelling types held together in one 'superblock'. The scheme revisits familiar urban elements and reinvents them, introducing new terms such as 'vertical streets', 'sky plazas' and 'aerial suburbs'.

The Hudson River Park is a major urban landscape design proposal to reclaim the waterfront along an 8-kilometre (5-mile) stretch of Manhattan from Riverside Park at 60th Street down to Battery Park at the southern tip of the island. Following the decline in shipping, the strip of land that was once occupied by thriving docklands and other commercial activities became an inaccessible wasteland of redundant buildings and neglected piers. The construction work to provide a public park and other leisure amenities, which the developers claim will provide 'a remarkable urban oasis', is structured in six phases. The first of these, the Greenwich Village segment, was completed in 2003. It has opened up a stretch of the waterfront from Clarkson Street to Horatio Street and includes the redevelopment of three piers.

On such a site – between Perry Street and Charles Street, on the edge of this segment of the new park with uninterrupted views across the Hudson River – the three residential towers designed by Richard Meier are not for low-cost rental. On the contrary, with every luxury included, they must be some of the most expensive real estate in New York.

The pair of towers on opposite corners of Perry Street, constructed first, were completed in 2002. The same architect, Richard Meier, also

1

designed the third, on the corner of Charles Street, working with a different property developer. In the two Perry Street buildings, the circulation is distinct from the main volume; it is in enclosed towers, and positioned on the east, or city, side to maximize the river views from the living spaces on the other three sides. In both towers, each

173 Perry Street / 165 Charles Street
New York, USA
Richard Meier
2003/2005

1 The glazed façades give views out across the Hudson River and onto the parkland constructed on the redundant dockside and piers.

2 Site plan, 1: 2,500.

3 In the two Perry Street towers circulation is enclosed in towers facing the city, allowing maximum river views on the other three sides.

Hudson River

Hudson River Park Pier 45

West Side Highway

West Side Highway

Perry Street

Charles Lane

Charles Street

2

3

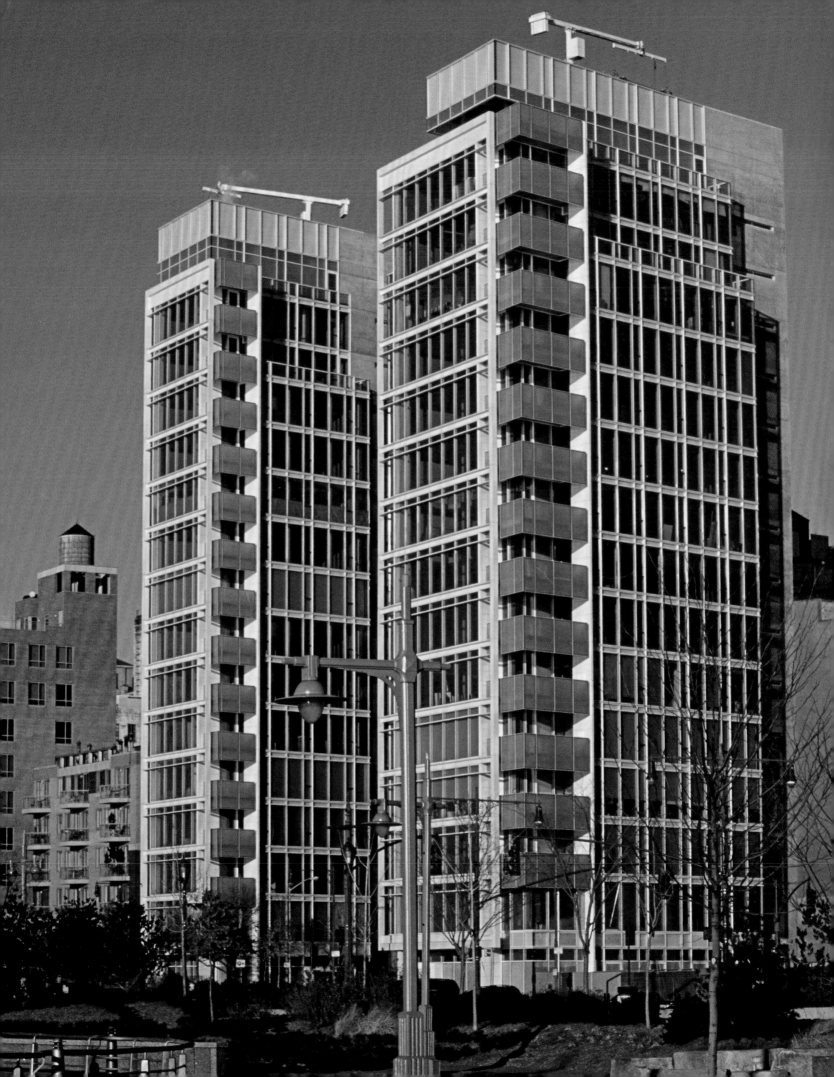

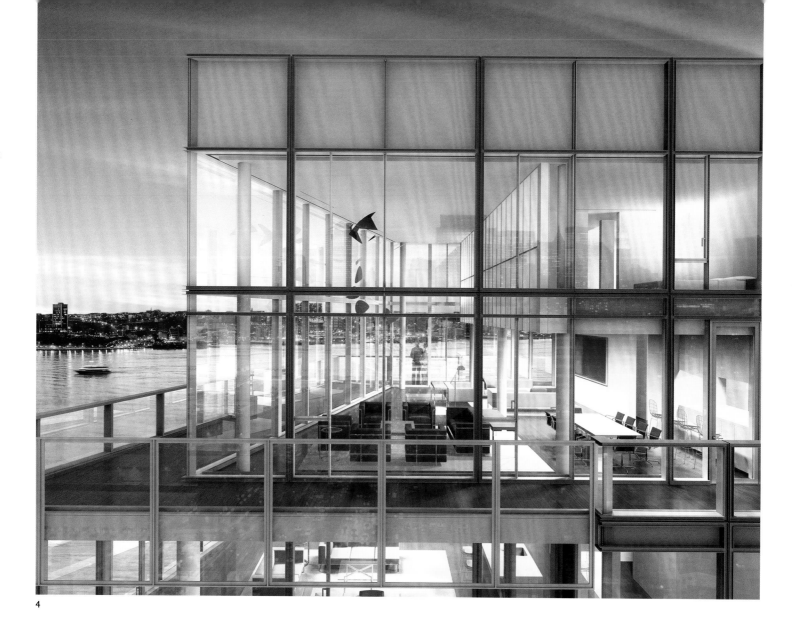

4

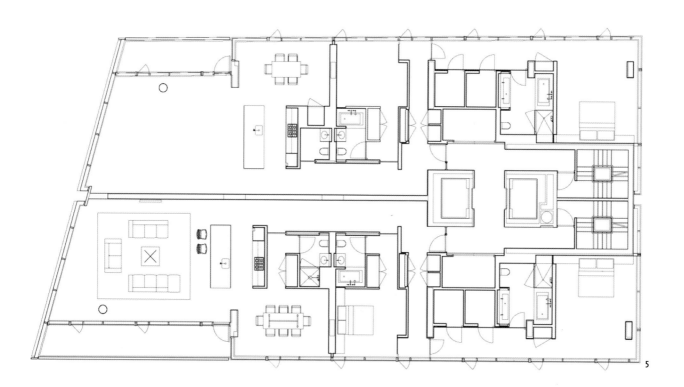

5

floor is dedicated to just one apartment with a floor area of either 180 square metres (1,936 square feet) in the smaller tower or 375 square metres (4,035 square feet) in the larger one. Despite their large size, the interior layouts include only two or three bedrooms, leaving most of the area to open living space. Each apartment has only a very small area of external space, provided by loggias on the south-west corners and a balcony on the north-east corner of the smaller tower. However, openable windows are incorporated into the entirely glazed façades to provide natural ventilation.

The third tower, on Charles Street, is a further development of the same type. It is the same 16 storeys high and has the same generous 3.4-metre (11-foot) floor-to-ceiling heights. The façade is similarly composed of steel and glass curtain walling. Unlike Perry Street, the interiors were designed by Richard Meier. The penthouse is a duplex set back to form a terrace around the perimeter. At first- and second-floor levels, smaller studio and one-bedroom apartments incorporate double-height living spaces between the two floor levels. The Charles Street tower floor plate is larger and, while there is a similar loft-like, open-plan approach, a typical floor is divided into two apartments, north and south, by a central spine wall. At approximately 250 square metres (2,690 square feet), although smaller than some in Perry Street, these apartments are spacious by any standards. If the panoramic views are not as extensive as those from Perry Street, the additional facilities provide adequate compensation. There is a lap pool and fitness centre, a basement with individual climate-controlled cellars for each of the 31 apartments and a 35-seat film screening room.

At the ground-floor level of all three towers on the West Street side, public spaces including an art gallery and café form a direct link with the park in an attempt to incorporate them as part of a new public amenity. They stand out in stark contrast to the surrounding area in form, in scale, and in material, but they are representative of a new wave of investment and part of the ongoing cyclical nature of urban decline and regeneration.

4 The top floor of the Charles Street tower has a double-height penthouse set back from the main façade to form a terrace all around.

5 Typical floor plan, 1:200, of the Charles Street tower with two apartments.

6 The open-plan interior layouts of the Charles Street apartments are organized around a central island kitchen fitting.

6

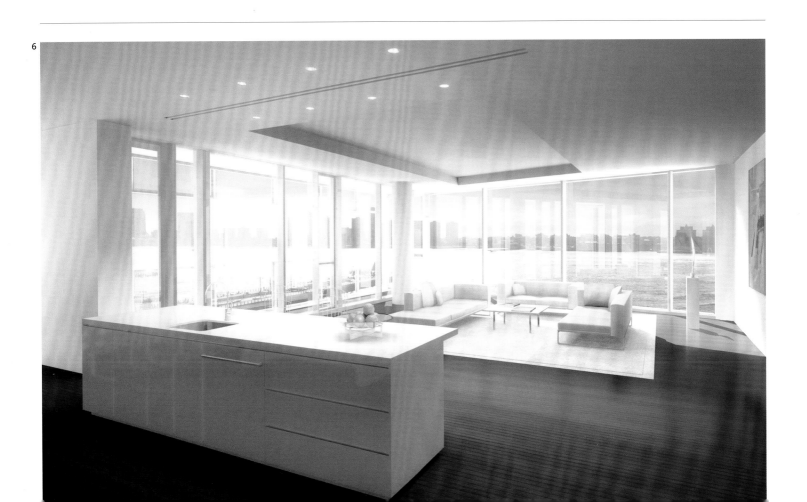

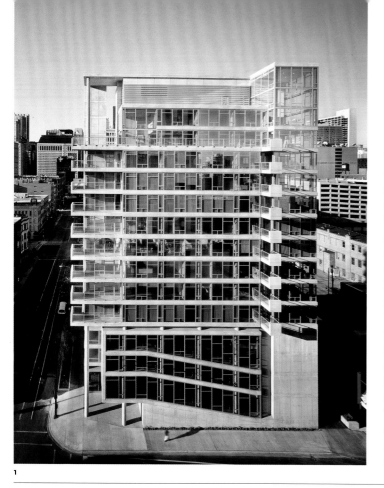

1

The Contemporaine building was given an AIA 2004 design excellence award for the way in which it successfully resolves issues of context and scale. It sits in the River North area of Chicago, in an area of redundant and converted warehouses, low-rise commercial buildings and a growing number of new residential developments. The building is conceived in two parts: a four-storey plinth covering the whole site, and a tower above. At street level there is a retail unit, the entrance lobby to the apartments and access to parking. The next three levels of the plinth are taken up by parking. The tower containing the residential units is a further 11 storeys high. It sits above the plinth and has a smaller footprint.

At the centre of the plan there is one central circulation core, with two elevators and two stairs, which rises up through the whole building. The internal layout of the units follows the common pattern, with the smaller rooms, bathrooms and dressing rooms arranged along a central corridor leaving the façade for the habitable rooms. The apartments – with either two or three bedrooms – vary in size; the smallest is 88 square metres (950 square feet) and the largest 250 square metres (2,690 square feet). Open-plan kitchens are placed in the corners of living rooms and include free-standing

Contemporaine
Chicago, Illinois, USA
Perkins + Will
2004

1 On the street elevations, the parking is visible on the lower floors with glazing following the ramps at each level. The concrete structural elements are clearly articulated as part of the overall composition.
2 Site plan, 1:2,500.
3 On the south and west façades, the parking levels are hidden behind solid concrete walls.
4 A four-storey-high plinth separates the apartments from the street context.

West Grand Avenue

North Franklin Street

North Wells Street

West Illinois Street

2

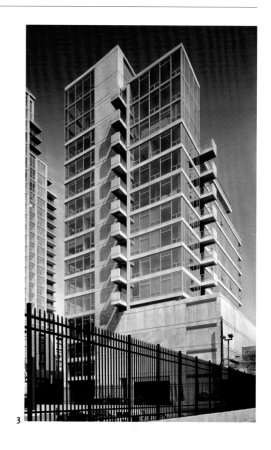

3 4

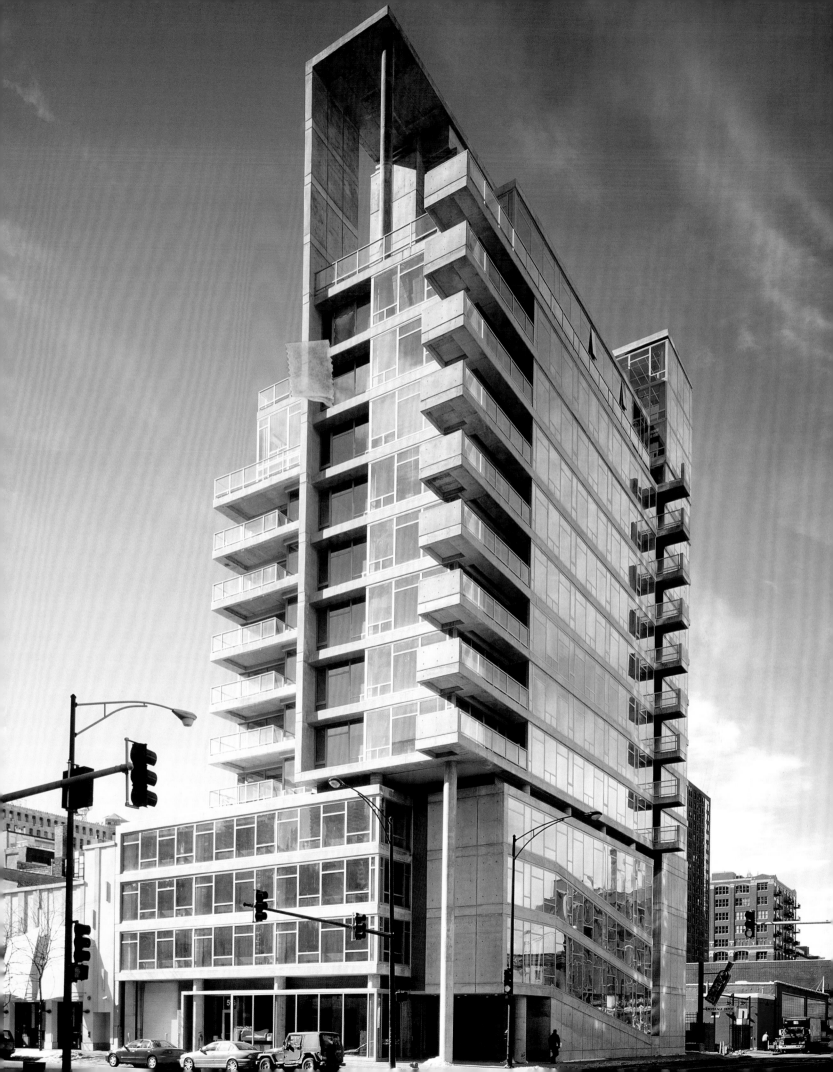

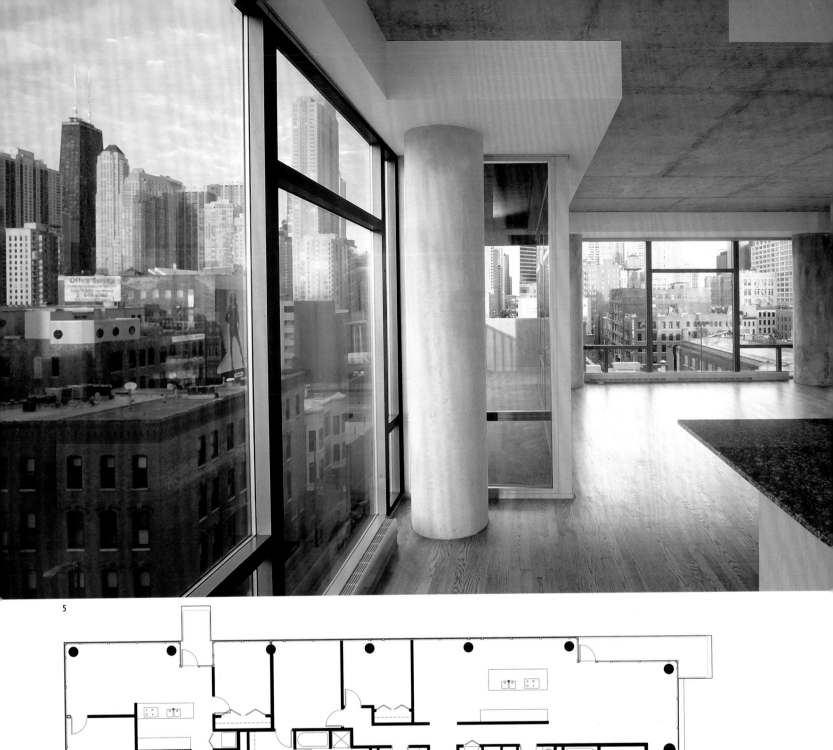

5

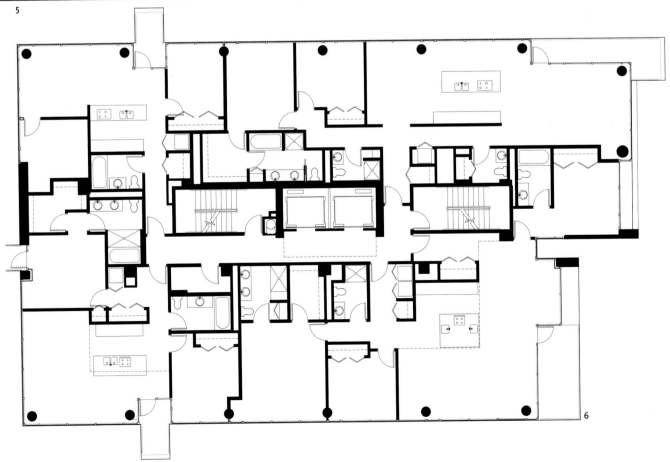

6

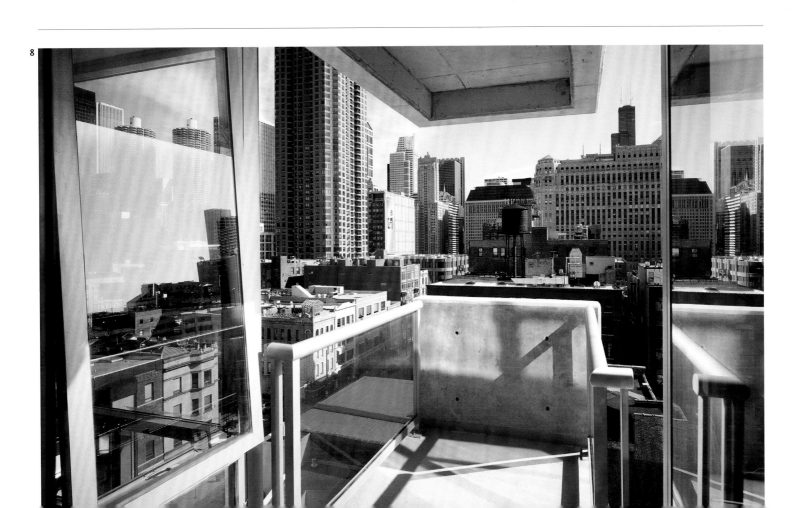

units. All the units have small balconies. The entrance halls are distinct from the living spaces, and the larger apartments have en suite dressing rooms and bathrooms. At the top of the tower, the floor plan changes again to include four penthouses with double-height living spaces and external terraces.

Throughout the scheme, the structural elements of the concrete planes and columns are clearly expressed. The floor slabs are highly visible elements of the overall composition. From a roughly rectangular plane, the edges are articulated with recessed 'slots' and cantilevered balconies that extend through the façade, where they 'fold up' to form the balustrade. Structural columns are inside the façade and appear externally to mark the entrance, extending upwards four storeys to link the tower to the street level and at roof level to connect the oversailing concrete canopy. Solid concrete walls flank the circulation core on the west and south façades of the plinth. The other elevations are fully glazed, including those of the carparking ramps, which are visible on the north façade and are intended to bring, according to the architects, 'dynamic expression' and 'relief and movement to the otherwise rectilinear structure.'

The composition makes a very definite separation between the residential spaces and the surrounding urban environment. The intervening retail and multi-level parking space provides a continuity of scale and activity at street level and allows the apartments to be designed independently, for the most part unconstrained by any of the surroundings. Despite this separation of form, the simplicity of materials, the continuity of geometry and the clearly expressed structure gives an overall coherence.

7

5 The glazed façade is independent of the concrete structure.

6 Typical floor plan, 1:200.

7 Apartments have full-height glazing on all external walls and small private balconies that extend beyond the façades.

8 The external space of the balconies is recessed into the façade.

8

The Theresienhöhe site in Munich, once home to trade fairs, became vacant when the exhibition halls were moved out to the edge of the city. To decide how best to modernize and reorganize this important city area – the site of Munich's famous Oktoberfest (beer festival) and close to the main railway station – a limited urban design competition was held in 1996, which was won by Otto Steidle + Partner.

The project prioritized the design of public spaces and semi-public spaces within new city blocks. One of the original exhibition halls was refurbished and upgraded to house a relocated museum, and just over half the area of the site is to be used for open green space. The built area was divided into 250,000 square metres (2,690,000 square feet) for offices, shops and restaurants and 150,000 square metres (1,614,125 square feet) for residential accommodation. The urban plan was developed in relation to the existing plan of Munich, with a similar grid of streets and blocks that would, in Steidle's words, 'recognize the scale and character of the existing architecture but still allow for diversity and freedom for new architecture to come'. The plan allows for a high-density mix of functions in a growing urban environment. This 'unity and diversity' has been planned for

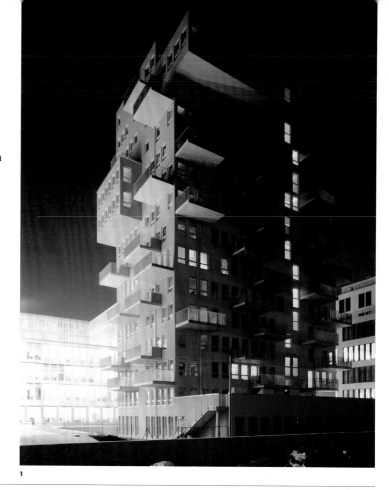

1

Housing Tower
Theresienhöhe, Munich, Germany
Steidle + Partner
2001

1 The fairground tower that once stood on the site was the inspiration for the architecture.

2 The tower stands out in the skyline above the surrounding rooftops.

3 Site plan, 1:2,500. The tower is one element of the overall masterplan for the area by Steidle + Partner.

4 The simple rectangular form is embellished with asymmetrically placed, cantilevered balconies and extended floors at some of the upper levels.

2

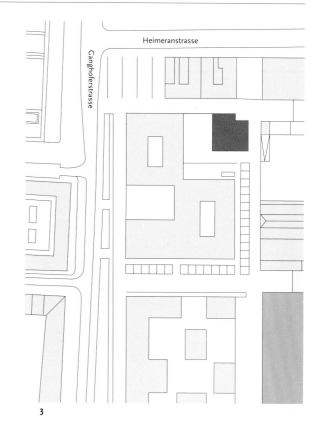

Heimeranstrasse

Ganghoferstrasse

3

4

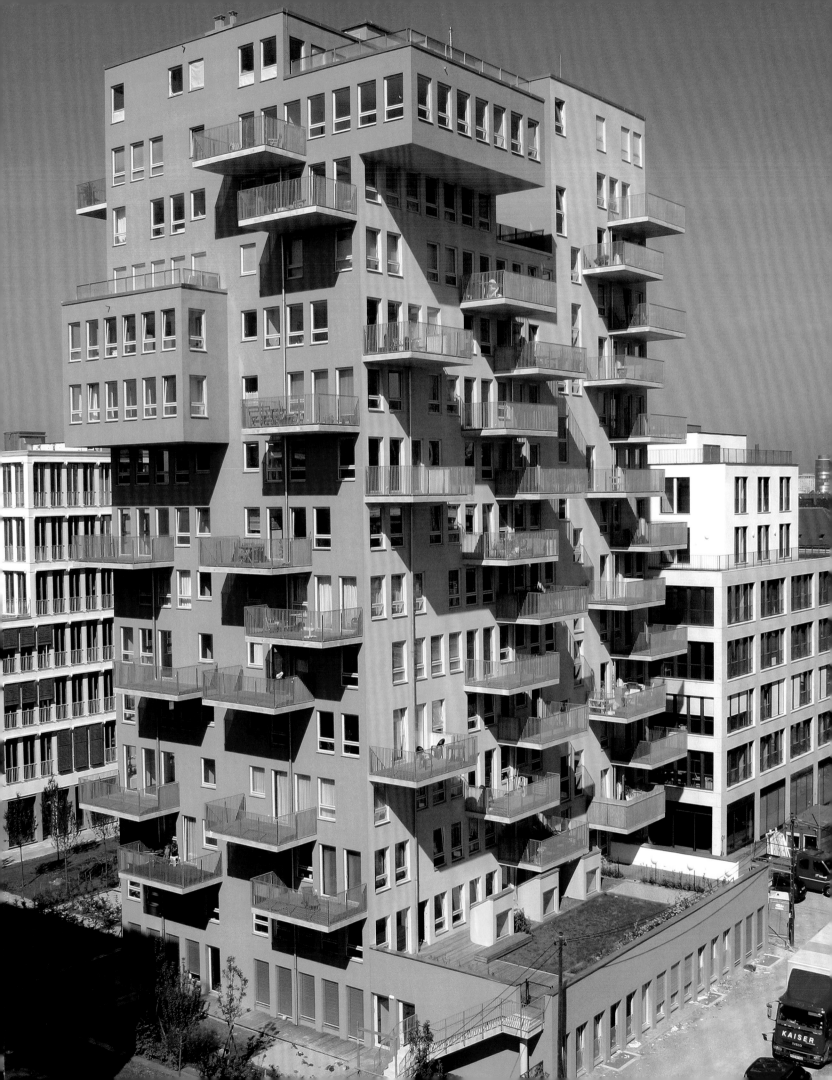

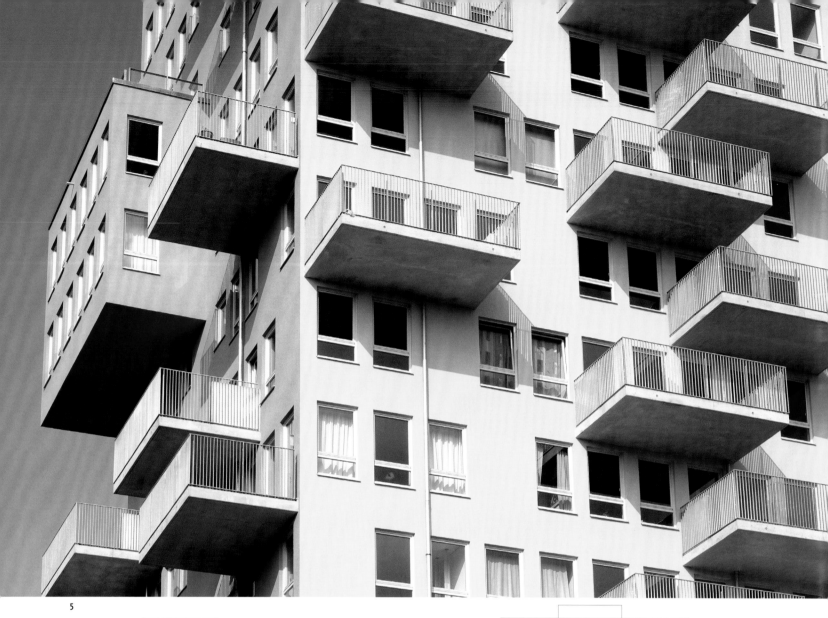

5

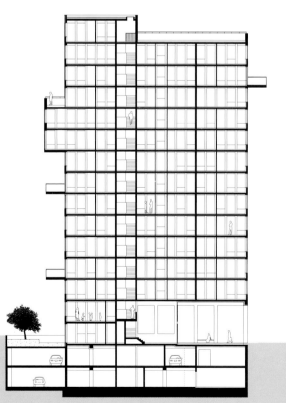

6

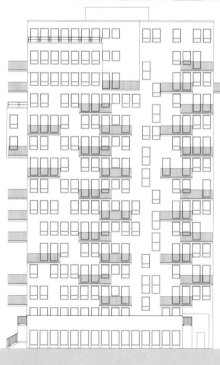

7

with a spatial matrix of squares, cycle paths and pedestrian routes that connect the public spaces.

Architectural competitions were used to introduce a variety of design approaches within the overall scheme. As well as the overall masterplan for the area, Steidle + Partner have designed office buildings in Ganghofer-strasse at the north-west corner of the site, and on the esplanade forming the site boundary to the west. They also designed two residential buildings: one belongs to a group of eight free-standing residential buildings; the other is a free-standing tower in the north-east of the site. The tower, which has a striking, colourful

appearance, acts as a type of visual cue to the memory of the fairground tower demolished in the 1960s that previously stood on the site visible above the surrounding, much lower exhibition halls.

The accommodation, in contrast to the local, mainly family dwellings, is mostly small, two-roomed apartments. On a typical floor there are six apartments organized in a simple rectangle accessed from a central corridor. The lifts are located internally, but the two access stairs are positioned on external walls. There are no adjustments for orientation and layouts are identical regardless of which way the apartment faces. The small size of these apartments

means there is little scope for flexibility. Little space is given over to internal circulation and bedrooms are accessed from the living space. Kitchens are located in the corners of the living spaces and can be accessed either from a hallway or from the living space. Front doors open directly onto the living space or, where there are hallways, these are contiguous with the living space and turned through 90 degrees to improve privacy; most have some built-in storage.

With so many identical apartments, one above the other, the façades are unexpectedly varied. Every apartment has a large 10-square-metre (107-square-foot) cantilevered balcony; a few at the

upper levels have cantilevered floors protruding from the main volume to increase the floor areas. Although the arrangement of the rooms is the same, the balconies are not positioned identically at each level. Windows are of uniform width and height but with lowered sills where these give access to the balconies. This simple system applied to what would otherwise be repetitive plans brings some variation in terms of use and dramatically alters the external appearance of the Housing Tower.

5 All windows are the same width with three different sill heights corresponding to different rooms.

6 Section looking west, 1:500. A double-height entrance foyer leads to the two circulation cores.

7 Elevation, 1:500. The regular grid of windows is interrupted by solid panels and the asymmetrical layout of the balconies.

8 Ground-floor plan, 1:500. A nursery and entrances to the apartments are linked to a public courtyard.

9 Sixth-floor plan, 1:500. Typically, six one-bedroom apartments are arranged either side of a central corridor.

10 Ninth-floor plan, 1:500. The floor is extended beyond the façade to provide increased living space for one of the apartments.

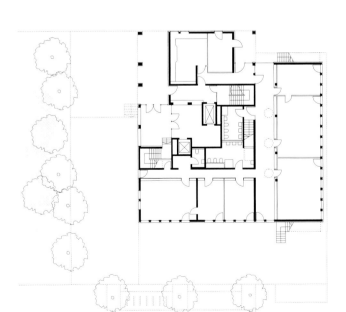

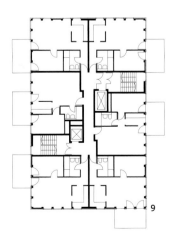

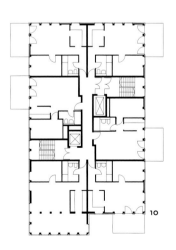

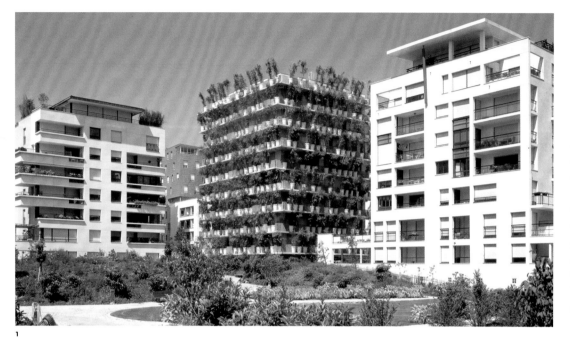

Edouard François has asserted that in this building, his 'Flower Tower', the claims so frequently made by estate agents – 'apartment with sunny living room, planted balcony and open views of peaceful courtyard garden' – are all true. The project is based on his proposition that buildings and gardens ought to be conceived together as one and the same. As in a forest clearing, isolated from its surroundings, where the façades are walls of trees, an impression of living in a completely natural environment could be created. The project follows an earlier experimental housing scheme that François completed in 2000, Berges du Lez in Montpelier, where rock plants are

Flower Tower
Paris, France
Edouard François
2004

1 The Flower Tower is one of several new apartment buildings bordering an open space in the urban redevelopment zone (ZAC) at Porte-d'Asnières.

2 Site plan, 1:2,500. The redevelopment zone is on the north-western edge of Paris adjacent to railway goods yards.

3 The cantilevered balcony incorporates concrete plant pots and a balustrade with an integral watering system.

2

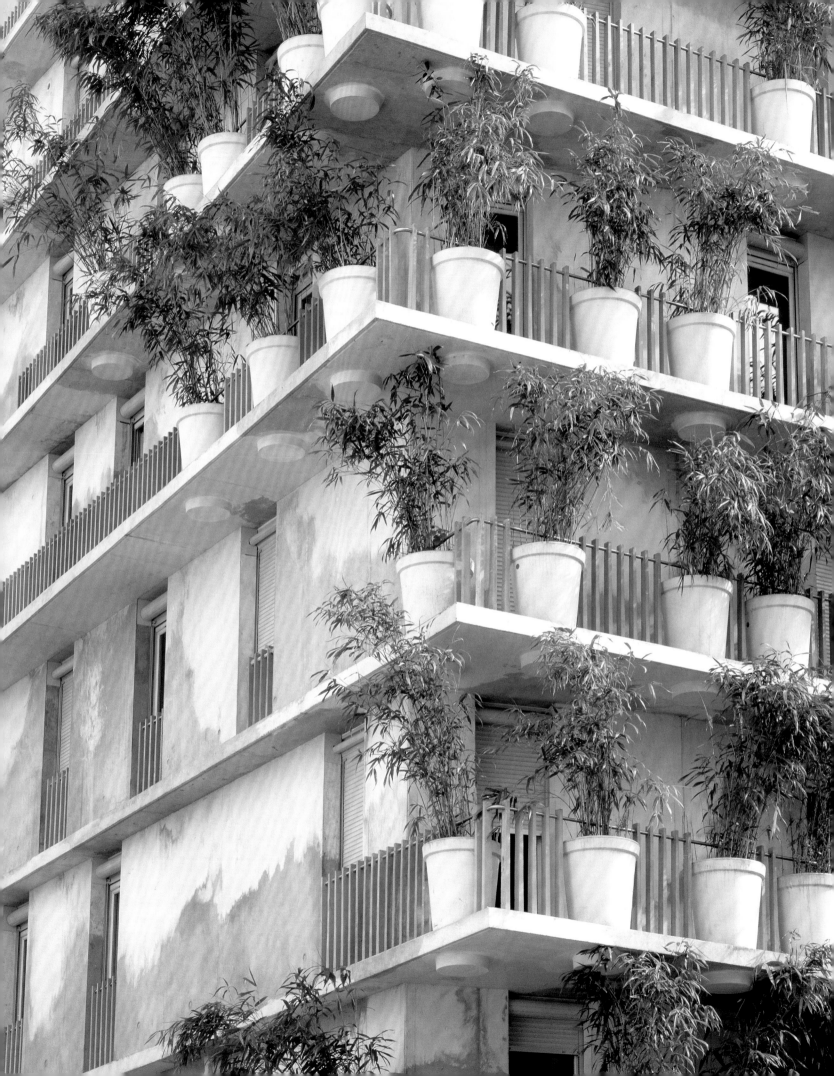

incorporated into a façade of modified gabions to produce a 'growing façade'. The Flower Tower, a free-standing block on the edge of a new garden, constructed as part of the development zone (ZAC) at Porte d'Asnières, in north-west Paris takes this concept one step further to build with plants as an integral architectural element and not just an add-on.

On the Flower Tower, plants grow at every level, almost all round the building. To achieve this, François designed a unique cantilevered balcony with concrete pots housed in its edge. Between the pots, tapering concrete balusters support a stainless-steel top rail, which is also the irrigation pipe and

part of the automated watering system. As an architectural element the screen of planting provides a *brise soleil* where it grows most densely on the sunnier façades and creates some privacy.

Bamboo was chosen, not just because of its hardiness and its ability to grow very quickly, but also because of its form and colour. François wanted to use a plant that had a very open structure and preferably a colour close to that of the concrete, which is marbled by mixing two colours randomly. The planting is intended to form the background structure and support for other plants, with the inhabitants using the pots outside kitchens to grow herbs and those

outside living rooms to grow decorative flowering plants.

Inside the Flower Tower, the apartments vary in size from one to four bedrooms with, generally, four per floor. Concrete walls, including several with 90-degree angles, form the vertical structural elements and define the layout of the central circulation, stair, lift shaft and apartments. The layout is relatively simple with internal bathrooms, cupboards and entrance halls in the middle next to the corridors, and the living spaces arranged around the façade. Additional space is given to entrance halls and to add second bathrooms to the larger apartments. Kitchens are enclosed but

have doors to connect them to the hall, and living rooms and separate internal corridors lead to the bathrooms and bedrooms. All living rooms are orientated towards the gardens and all the habitable spaces – kitchens, bedrooms and living rooms – have french windows giving access to the continuous balcony. The balcony itself defines its own parallelogram in plan and is not parallel to the external wall of the building. Rather than being at right angles, the corners have been cut back at different angles, resulting in a cranked façade. This increases the size of the balcony at the corners, enhances the privacy of adjacent dwellings and offers improved views.

4 Bamboo makes an effective screen along the length of the balconies, providing some shading and improving levels of privacy.

5 Fifth-floor plan, 1:200. The apartments are planned around folded structural concrete walls.

6 The bases of the concrete planters are located in the concrete slab.

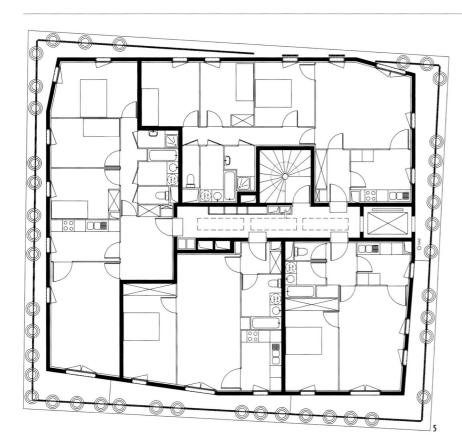

5

6

1

The form is a simple rectangular block with little indication as to its purpose or the activities it houses. Each of the four façades is composed of a grid of aluminium louvres; the only differentiation is between those that are fixed and those corresponding to windows, which can be drawn up like venetian blinds. Behind this indecipherable façade is a rigorously designed and, it might seem, effortlessly planned set of apartments. The rectangular structural grid at 5.9 metres (19 feet) determines a basic unit width of 2.95 metres (9½ feet), which also corresponds to the width of a parking bay. The unit width is then divided into three

equal-sized louvred panels; all rooms have at least one panel that is openable.

The ground floor houses commercial spaces and retail units, as will the ground floor of the adjacent buildings. The entrance to the underground parking, which extends beyond the ground-floor curtilage of the building, is on the east side together with the two entrances that lead to the apartments above.

Access, arranged via two independent entrances, leads to separate staircases. A pair of lifts and lobbies at each floor level greatly reduces the amount of shared circulation space and the number of occupants sharing.

Apartments
Maia, Porto, Portugal
Eduardo Souto de Moura
2001

1 Each of the façades is composed of a grid of aluminium louvres.
2 Site plan, 1:2,500.

3 With the louvres closed, only on the east side, the two entrances to the apartments and the entrance to the carpark interrupt the continuity of the façade.

4 The open louvres are the only external sign of inhabitation.

5 The venetian blinds extend to the ground floor, where there are eight units for commercial or retail use. The entrance ramp to the basement carpark is located centrally.

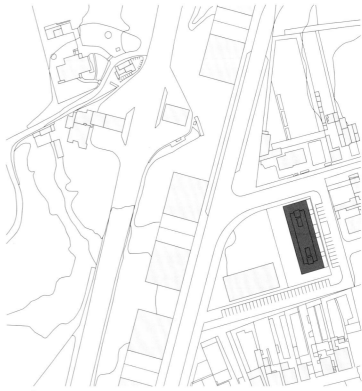

2

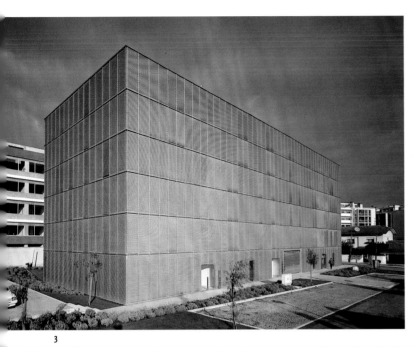

3

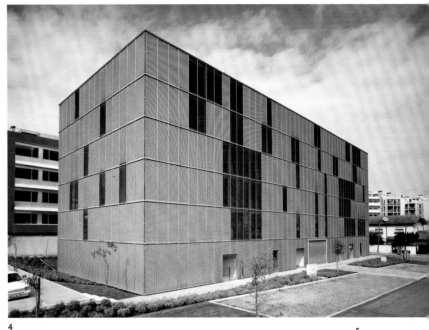

4

5

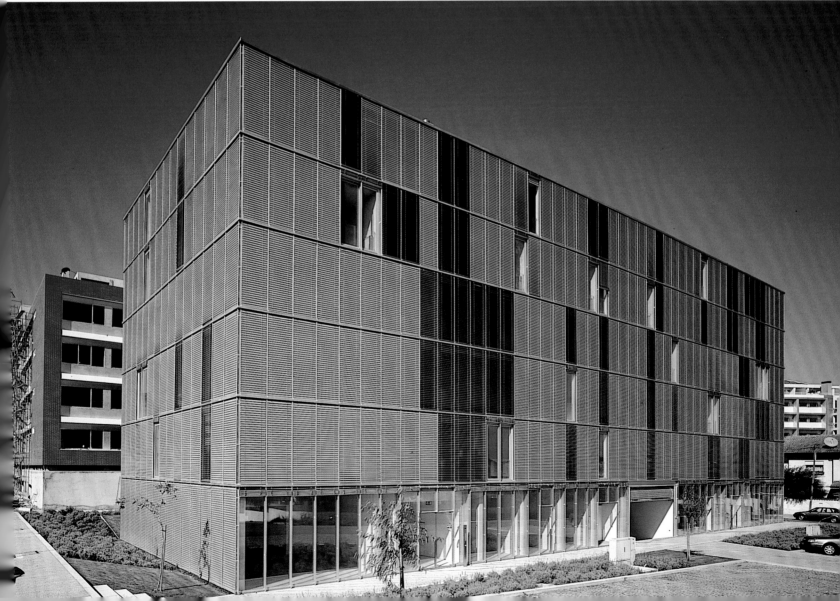

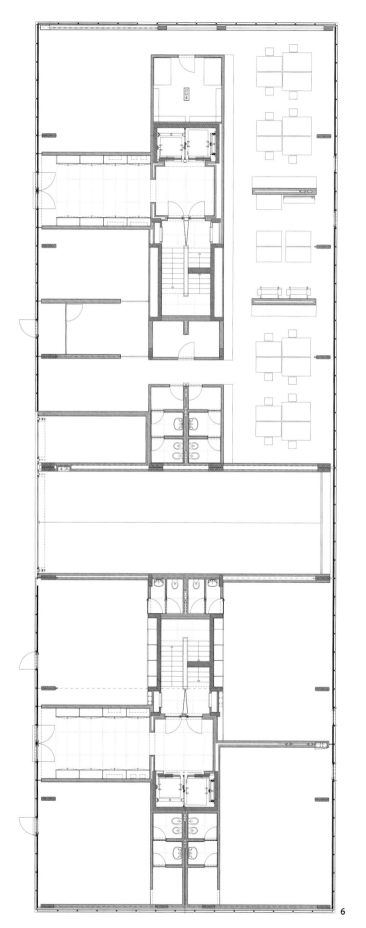

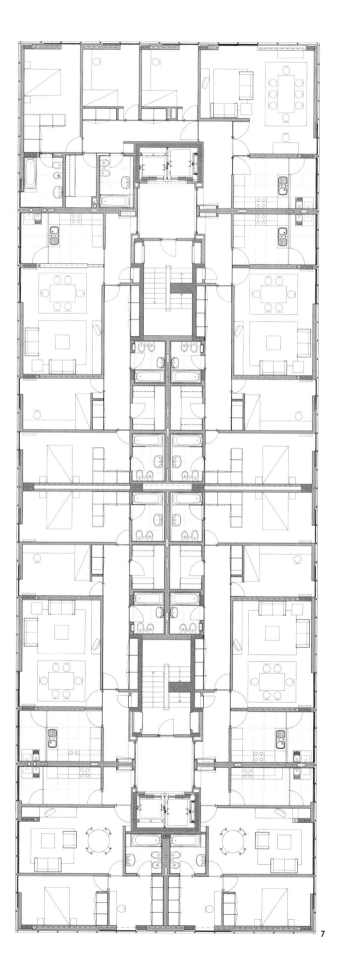

6

7

Lobbies at each floor level are shared by either three apartments at one end or four at the other. Most of the apartments have two bedrooms and the rooms are arranged in a conventional manner, but with some flexibility as to the ways in which they might be occupied.

The general arrangement of the plan is straightforward. The bathrooms and closets are located in the central area between the two circulation cores and the habitable rooms are located next to the façade. The apartments are spacious, with large rooms and a substantial amount of space allocated to storage and circulation. The corridor itself is a generous 1.4 metres (4½ feet) wide with fitted cupboards that line the walls to the shared staircases. A laundry room is attached to the kitchen and a dressing room, or dressing space, is attached to the main bedroom. The kitchen and living room are located closest to the entrance, and a door divides the corridor to give more privacy to the bedrooms and bathrooms.

Rather than seeking ways to create variety, or employing add-on devices to introduce variation in external appearance, Souto de Moura's housing block reinforces the repetitive nature of the apartment block as a type, with its almost seamless, uninterrupted cladding. The façade can only be varied by the activities of the inhabitants: it is animated only by light showing through the louvres, or by the opening and closing of the venetian blinds.

6 Ground-floor plan, 1:200, showing commercial and retail spaces and the ramp access to the basement carpark are in the centre.

7 Plan of typical floor, 1:200. The plan is divided into two parts, served by independent entrances and circulation cores. The corridor within the apartments is 1.4 metres (4 ½ feet) wide.

8 The interiors have polished timber floors, flat, painted wall finishes and full-height doors.

8

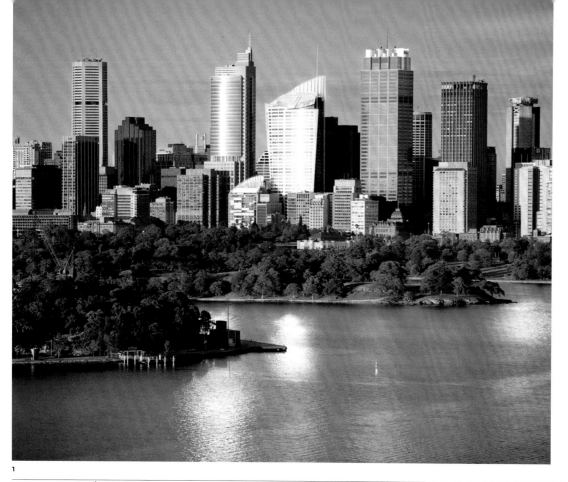

1

The Aurora Place office tower, at 200 metres (656 feet) high and with its asymmetrical sail-like forms, is highly visible as part of the Sydney skyline – its curved surfaces reflect the light in ways that the flat surfaces of adjacent rectilinear buildings cannot. At street level, the building's size and volume and the other half of the project – the Macquarie Street Apartments – are less visible, but the scheme is nevertheless significant in urban terms for its relationship within the context of the existing site and the spaces created.

In simple terms, each of the towers relates in form and volume to its immediate surroundings. On the east side, on Macquarie Street,

Macquarie Street Apartments
Aurora Place, Sydney, Australia
Renzo Piano Building Workshop
2000

1 The apartment building is part of the Aurora Place development in Sydney's Central Business District.

2 Site plan, 1:5,000.

3 The Macquarie Street elevation is composed of winter gardens overlooking the Botanic Gardens and has views towards the Harbour.

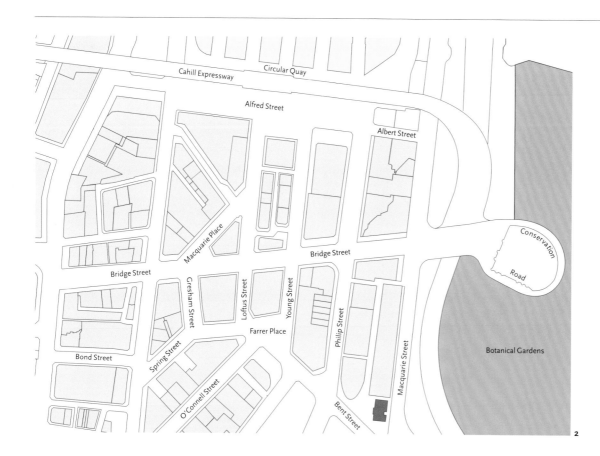

2

3

4

5

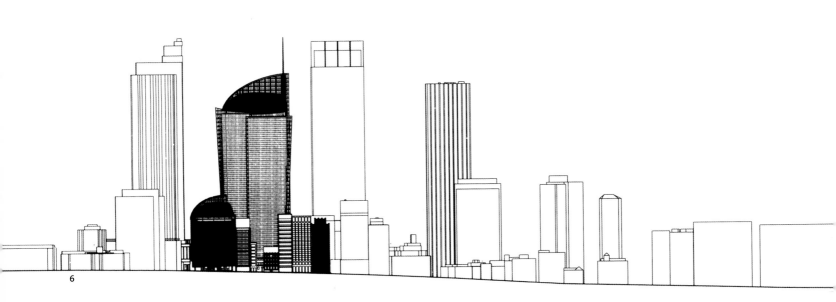

6

is the 17-storey residential building and on the west side, on Philip Street, is the 44-storey office tower, which belongs clearly with the other skyscrapers of the new business district. Together they form the ends of the two parallel streets facing onto Bent Street, Aurora Place, where the whole area of the site is defined by a uniformity of paving to create a continuous pedestrian space. Covered with a lightweight cable-and-glass canopy, suspended between the two towers, this external space appears as a kind of shared 'foyer' space – for residents, office workers and shoppers – belonging to, but set apart from the public area of the city's streetscape. The 'foyer' also

opens up a pedestrian link through to what was originally the 'service street', Philip Lane, which runs at the back of the buildings on the main thoroughfares of Macquarie Street and Phillip Street.

Located in the historic heart of Sydney and approximately a 500-metre (1,640 foot) walk to the harbour and the opera house, the location alone would make these apartments highly desirable. Making them recognizably the work of the Renzo Piano Building Workshop is the trademark red terracotta and familiar 'hi-tech' detailing. In response to the particularity of the site and the local climate, the architects have also designed what could be considered

a modern interpretation of the Australian verandah – transforming the whole of the east front into a winter garden using a sophisticated fully operable, fully glazed façade. The glass façade gives all the apartments uninterrupted views across Sydney's Botanical Gardens to the Opera House and the harbour. The external layer of the façade is divided into horizontal louvres – five operable and one fixed to each storey height – allowing residents to control opening but fitted with sensors for automatic closing in case of storms. Banks of automated blinds give further environmental control. The 'internal' glass façade is also fully glazed and can be opened up

fully to almost disappear within the structure. Both layers have specially formulated glass to maximize transparency and minimize any distortion of the spectacular views.

4 Above the red terracotta at street level, the Macquarie street façade has glazed horizontal louvres.

5 Sensors automatically close louvres in bad weather.

6 The apartments are located in the centre of Sydney, a short distance from Circular Quay and the Opera House.

7 The interior wall of the winter garden is also fully glazed.

8 Above a fixed balustrade, the horizontal louvres can be fully opened.

7

8

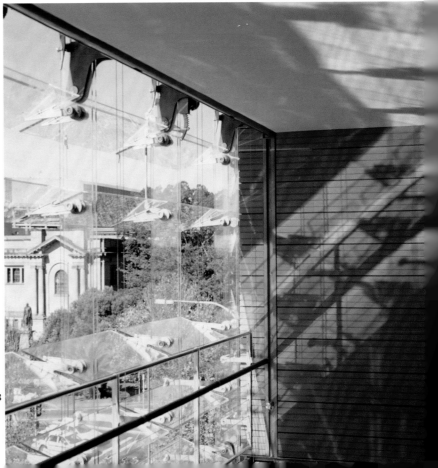

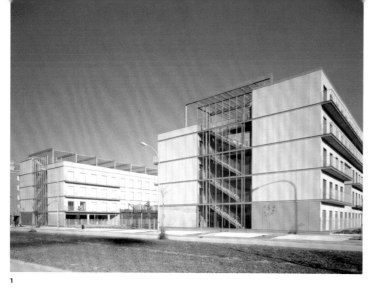

1

Designing for an area still under construction, without any physical context other than the basic infrastructure of railways and roads, the architect has only an abstract notion of the conditions and constraints of building legislation and zoning laws, density requirements and height limitations as a starting point. In this tabula rasa Ercilla & Campo

have used the same principles employed by the early Modernists to develop designs for housing blocks, set in green open space and arranged to maximize daylight and sunlight most effectively. Four rectilinear blocks of four and five storeys high are aligned on a north–south axis. In the central spaces, the apartments overlook a wide garden space planted with a

regular grid of trees. To increase the feeling of openness there are two- and three-storey-high voids cut through the blocks at different points to provide visual links across the site into the garden and to break up the linearity of the blocks. From a simple and well-rehearsed linear arrangement on the site, the architects have then concentrated on finding an innovative solution to problems of access and circulation, and the design of the ideal living unit.

All the 168 apartments are identical apart from a difference in width to make the provision of either two or three bedrooms possible. Each apartment occupies the full depth of the block, which

is 7.3 metres (24 feet) across and has window openings for natural ventilation on both sides. On one side, next to the entrance lobby, kitchens, bathrooms and utility rooms form a fixed service zone. On the other side, the remaining area is conceived of as one open space that can be subdivided according to the occupants' wishes. With a relatively small overall space and only four or five evenly spaced windows, the possibilities for positioning partitions are limited. Nevertheless, a variety of interpretations are achievable, from one open-plan space to a conventional three-bedroom layout. Within each apartment, the

Social Dwellings

Lakua, Vitoria, Spain
Ercilla & Campo Arquitectura
2002

1 The blocks are orientated north–south and are four and five storeys high.

2 Site plan, 1:2,500. The blocks are grouped in two pairs on either side of a central garden.
3 Part plan, 1:1,000, showing the pairing and access arrangement.

4 Two- and three-storey-high voids are cut through the blocks, breaking up the mass of the buildings and letting light and air into the spaces beyond.

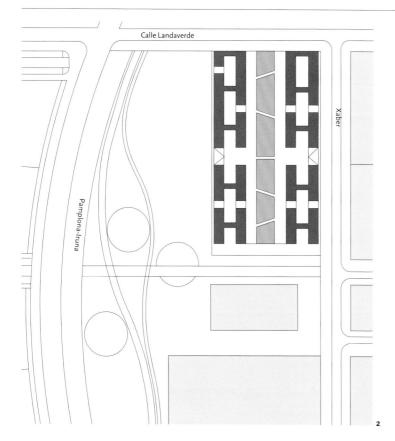

Calle Landaverde

Pamplona-Iruna

Xaber

2

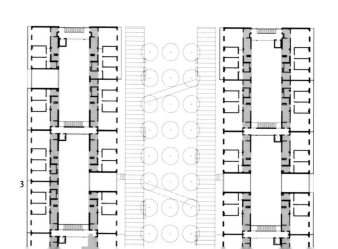

3

4

174

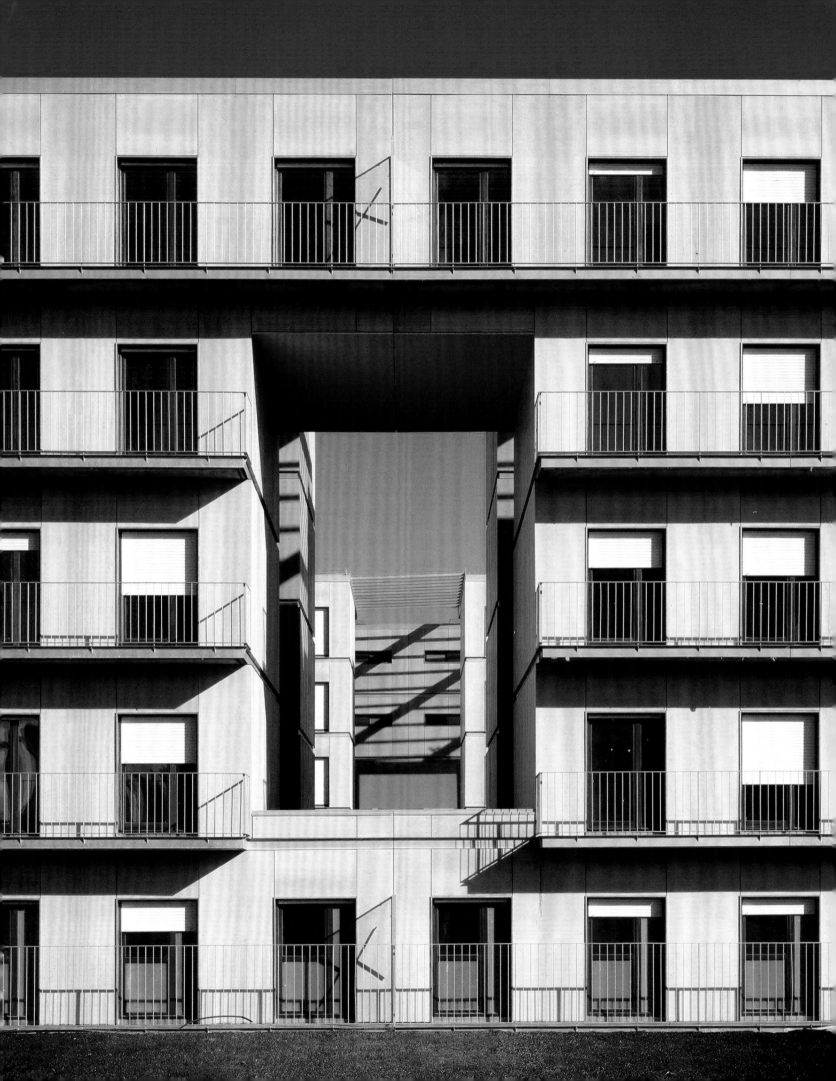

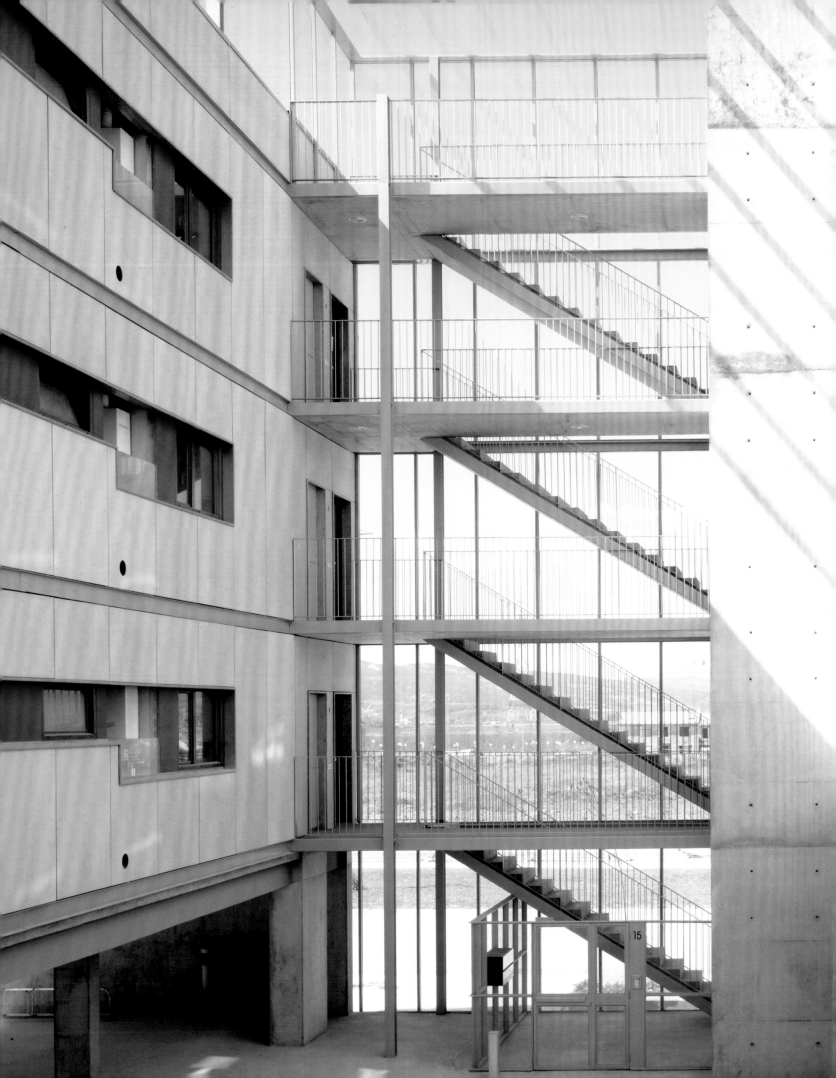

tiled flooring is laid as a continuous surface so that lightweight partitions can be put up and taken down more easily.

The failings of many large-scale housing schemes, especially the low-cost projects of the 1960s and 1970s, were not associated with the accommodation itself but with the circulation spaces and the access arrangements. Poorly defined distinctions between public and private spaces, coupled with inadequate maintenance, often resulted in unkempt, underused and desolate spaces. The all-too-frequent requirements to reduce costs impacted on privacy through reduction of the number of vertical circulation towers and an increase in the number of apartments sharing access landings and balconies. This scheme has introduced a new approach to access and circulation. Between each pair of blocks a lightweight, transparent roof creates a five-storey-high, atrium-like space, which forms the entrance lobby at ground-floor level and contains the circulation. Each circulation tower, including lift and stair, serves only four apartments per floor, two on each side of the bridges that cross the void. The circulation of the whole block is concentrated in this one hybrid space, which is visible through open ends glimpsed via the voids in the blocks and overlooked from every apartment.

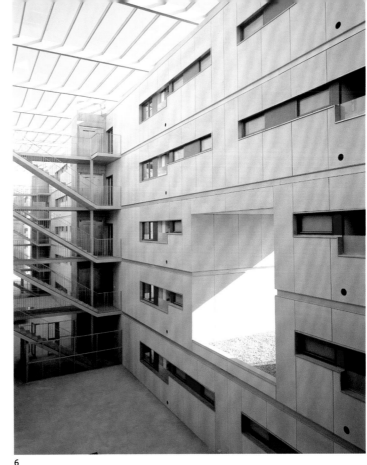

6

7

8

9

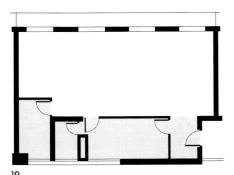

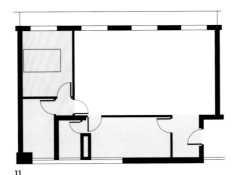

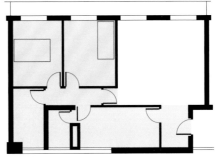

10

11

12

5 Bridges at every floor level provide access to two apartments on either side of the atrium.

6 Bathroom and kitchen windows overlook the atrium spaces.

7–9 Interior views showing layout options of a typical apartment. A regular window layout and a continuous floor finish mean that partitions can be easily placed and removed.

10–12 Floor plans, 1:200, of the smaller of the two apartment types, showing the different partition layouts.

177

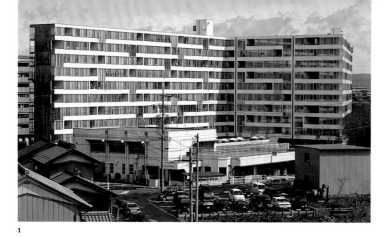

1

The Sejima Wing might better be called a 'block of rooms' than a block of flats. In the architects' own words: 'Collective housing today is not just for families but a place where people live in all kinds of collective ways. In other words, the base unit is not an apartment but a single room.' The design incorporates just four different types of rooms: a bedroom or private room, a living or dining room, which includes kitchen fittings, a *tatami* (Japanese-style room), and a loggia (open room). All are identical in size – 2.6 x 4.8 metres (8½ x 15½ feet) and are simply arranged in rows to form a linear strip.

The basic structure of the block is a reinforced concrete frame, ten storeys high and divided into an almost square grid that corresponds to the individual rooms. The uniform overall depth, including the access corridor, is just 7.2 metres (23½ feet). The size of the individual apartments is varied by the number of rooms. All have two bedrooms paired with bathroom facilities and a minimum of a living/dining space and either a Japanese room or loggia. A large number extend over two storeys and most have double-height living spaces. Essential to the functioning of the apartments is a glazed verandah on the south side, an all-purpose 'buffer' zone that forms the link between the different rooms and includes the open-plan stair in two-storey units. The living room extends into the verandah space and the loggia similarly extends the full depth of the plan to the façade.

A highly experimental scheme, this project examines many of our assumptions and familiar perceptions of collective living and in particular questions accepted notions of privacy.

The proposal to give all activities the same-sized room immediately removes the common notions of hierarchies of space within the dwelling. In addition, all of the rooms open directly onto the access corridors, which allows individuals to come and go independently, without necessarily meeting other members of the household. From the outside, the 'front door' has lost its significance – the boundaries between individual apartments are not clearly defined. Boundaries between public and private spaces

Sejima Wing, Kitagata Apartments
Gifu Prefecture, Japan
Kazuyo Sejima & Ryue Nishizawa/SANAA
2001

1 Open loggias and double-height living spaces interrupt the linear regularity of the elevation.

2 Site plan, 1:2,500. The block is a slim 7.2 metres (23½ feet) deep.

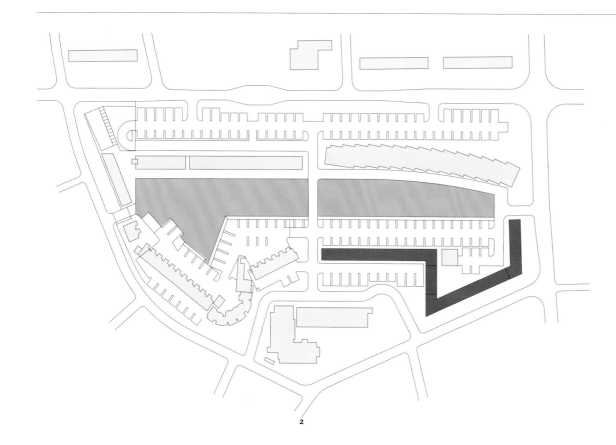

2

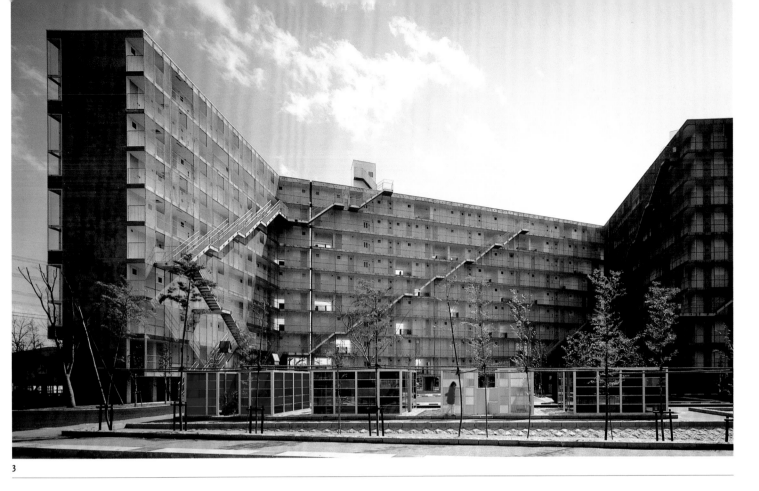

3

3 Facing the centre of the site, staircases connect the access balconies at every level.

4 Each room can be accessed independently from the balconies.

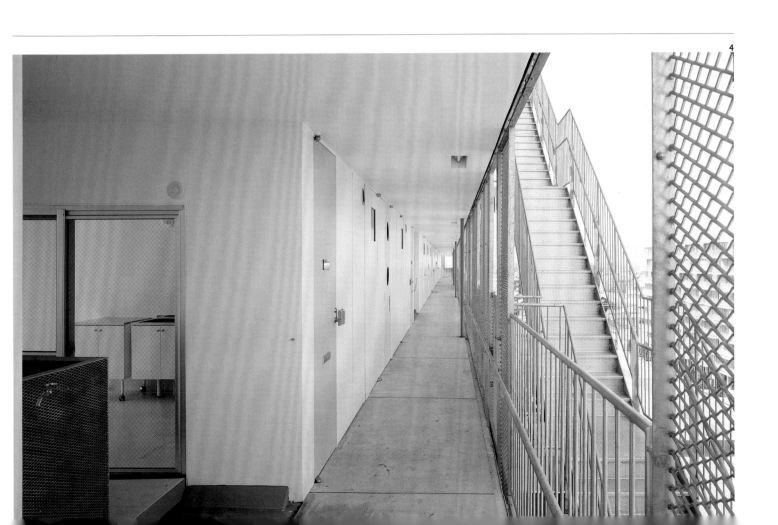

4

5

are likewise blurred. The decision to build perimeter blocks was part of the overall site planning and coordination of the project by Arata Isosaki Atelier and, although this scheme conforms to that decision, rather than enclose the site or form a boundary, the block is raised up on *pilotis* to open up access from any direction.

This very slim block, perforated with open terraces, or loggias, suggests a physical fragility and an openness that is unlike the more common, impenetrable nature of housing blocks. The arrangement of the apartments, visible on the façade with interlocking double-height spaces and loggias, means that neither the horizontal nor

vertical elements predominate, adding to the honeycomb-like impression of randomness and unpredictability. The openings allow views through the entire depth of the structure to the opposite side and the glazed verandahs offer glimpses into the apartments themselves, putting the inhabitants on view.

The scheme has been criticized for its naïvety in sustainability terms – the building relies on constant cooling – but this seems irrelevant in such a bold experiment to discover new models for collective living. It is yet more remarkable given the particular constraints of public-housing development.

5 The glazed verandah makes the inhabitants highly visible.

6 Shower and washing facilities are located with paired bedrooms within the glazed verandah.

7 A double-height living/dining room has the staircase within the verandah space.

8 Partial floor plan, 1:200. Within the overall 7.2-metre (23½-foot) depth, four different room types provide the basic unit for the scheme.

1. corridor
2. terrace
3. void
4. verandah
5. Japanese-style room
6. living/kitchen
7. bedroom.

6

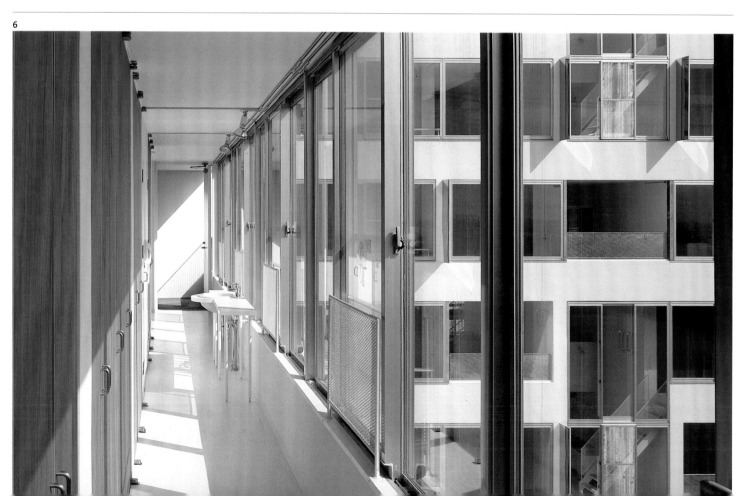

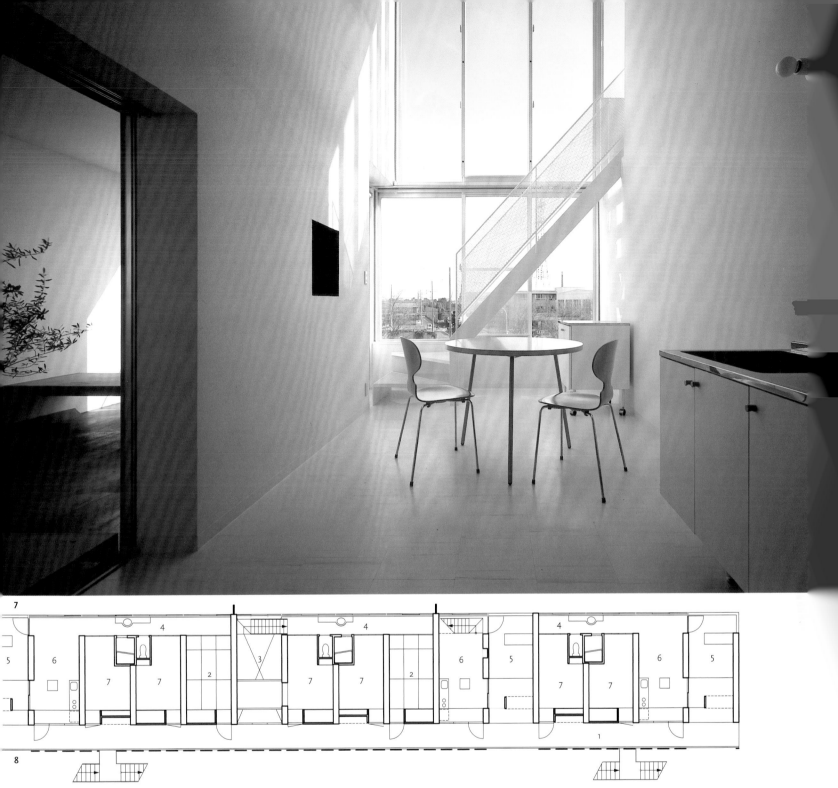

7

8

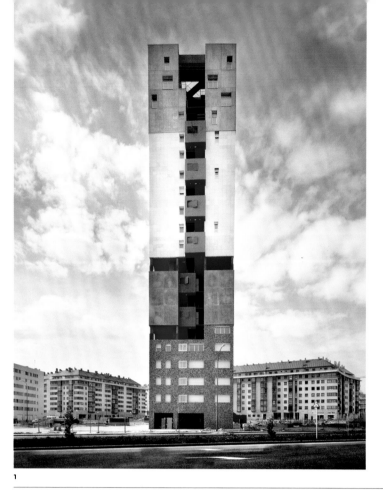

1

The towers of early Modernism aimed to give open space back to the city, and the new block that has risen up on the edge of Madrid claims to do the same. Instead of the six-storey-high closed blocks required by the urban plan the architects, MVRDV + Blanca Lleo, created a new form, which they call the 'superblock'. This 21-storey-high 'superblock' is made up of smaller blocks fitted together but clearly distinguishable on the façades. Conceptually like a series of suburbs, the analogy is highlighted by the architects' description of the vertical circulation as 'vertical streets'. A five-storey-high void cut through the block 12 storeys up frames views of the landscape in one direction, and of the city in the other.

The vast size and scale of the building makes it highly visible and provides the neighbourhood with its own landmark – a piece of domestic architecture elevated to the scale of the city. The visibly different parts of the whole are intended to give a greater sense of individual identity in contrast to the repetitive, anonymous nature of so many housing blocks, especially of this size. The Mirador Apartments project is clearly a further development of MVRDV's 2002 Silodam housing scheme in Amsterdam, which was a ten-storey version with 157 apartments – the

Mirador Apartments
Sanchinarro, Madrid, Spain
MVRDV + Blanca Lleo
2005

1 The superblock exists independently of its urban surroundings.
2 19th-floor plan, 1:500. A central corridor gives access to two-storey apartments and overlooks

the 18th-floor corridor below.
3 12th-floor plan, 1:500. The vertical circulation cores continue only in the end blocks on either side of the sky plaza.

4 The different apartment types grouped together are clearly visible on the exterior of the superblock.

5 Section, 1:500. The different elements within the superblock mean a very wide range of different apartments – one-, two-, and three-storeys – is included.

2

3

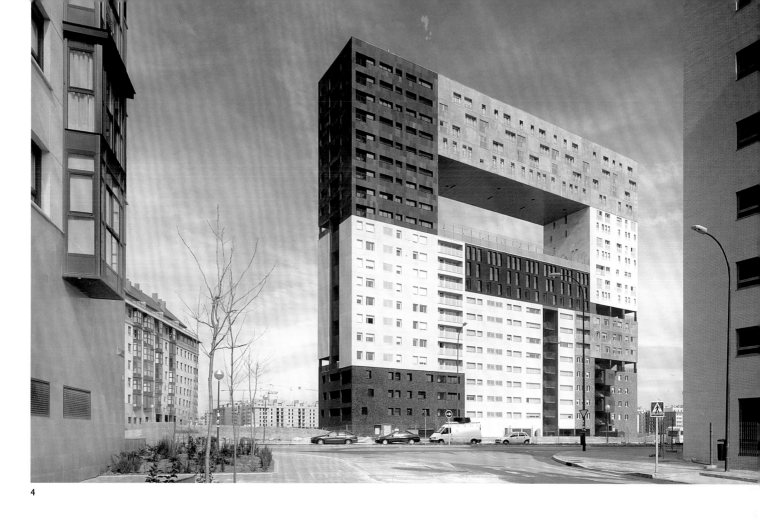

4

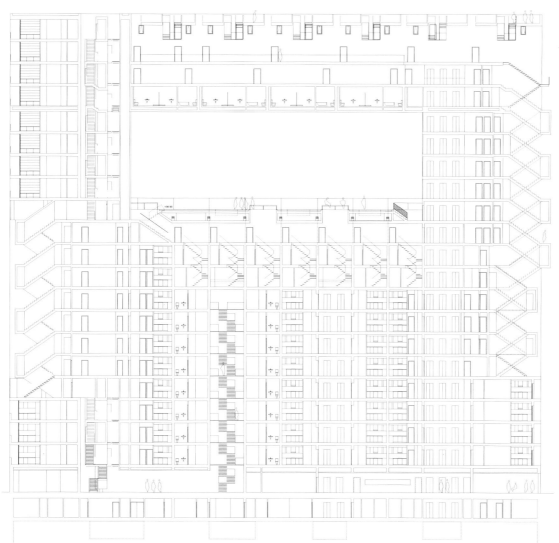

5

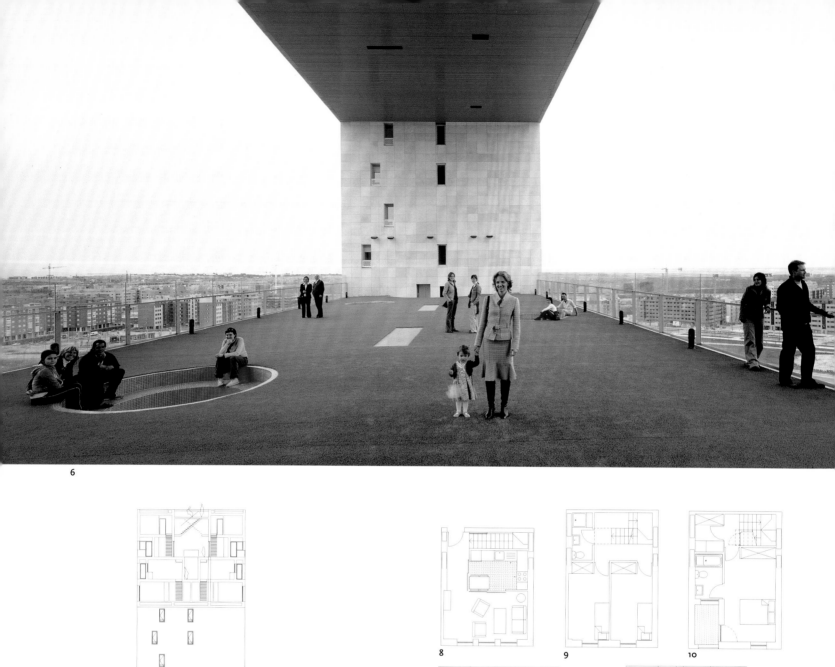

6

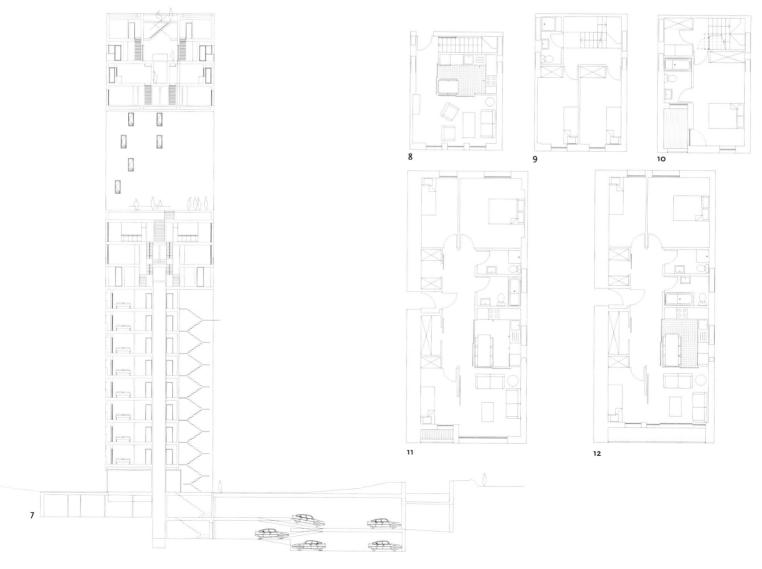

7

8

9

10

11

12

same number as the Mirador. Many variations of apartment types led to their grouping in what the architects describe as 'mini-neighbourhoods'. The groups of four to eight houses are of the same type and, by giving each group the same colour schemes in the galleries and access corridors, and using the same elevational treatments, they can be easily distinguished from other groups within the overall scheme.

As well as devising innovative ways to deal with conflicting needs for privacy or separation, and identity or belonging, the architects claim that they 'emphasize the unquestionable values of the inhabitants' space:

surface area, light, facilities and views'. Internal shared circulation is kept to a minimum and varies in different parts of the block. The overall plan is roughly divided into two end blocks and a central section. Lift cores at both ends serve generally either two or three flats per landing at one end, and flats and duplexes at the other. The central section has two further lift cores, serving two double-aspect flats per landing up to the eighth floor. Beyond that the apartments in the central section are all either duplexes or triplexes, and are accessed from the end lift cores via central internal corridors on the eleventh, eighteenth and nineteenth floors. There is a wide

range of different apartment types and variations to suit the location in the block. Common elements of internal planning are consistent throughout. Living spaces are generally open-plan with kitchens incorporated – some equipped with sliding partitions so that they may be left open or closed off – and stairways lead to bedroom floors, which are often at the lower levels. Bathrooms and shower rooms are provided in a multiplicity of different configurations, not always with WCs, including in bedroom alcoves behind sliding partitions.

Private external spaces are generally loggias recessed within the overall volume and usually located adjacent to kitchens or

living rooms. Duplexes on the nineteenth and twentieth floors have external terraces at roof level accessible via open stairways, visibly criss-crossing the double-height access corridor. The open space at level twelve is conceived of as a 'sky plaza'. In the same way that a plaza at ground level is seen as a public open space that belongs to the urban landscape, the sky plaza is potentially available for anyone – not just the residents – to use.

6 Twelve storeys up, the sky plaza is intended for public use as if at ground level.

7 Section, 1:500. The two-storey apartments at the upper levels are suspended above the sky plaza.

8–10 Plans, 1:200. Three-storey apartments on floors 9, 10 and 11 have the entrance at the upper level (8).

11–12 Plans, 1:200, of the apartment type that extends the full depth of the block on floors 2–11, accessible from the circulation core in the end block.

13 Two-storey apartments on the 19th and 20th floors have roof terraces above the double-height central access corridor, which are reached by open stairways.

14 Entrance from a central access corridor to the upper level of an apartment with bedrooms on the lower floors.

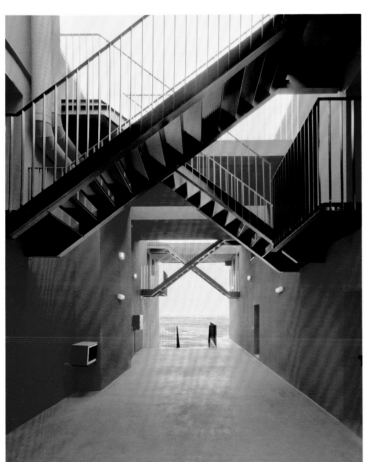

13

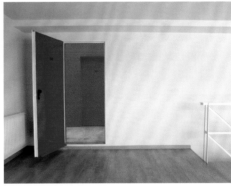

14

Footnotes

1 Robert Kerr, 'On the problem of providing dwellings for the poor in towns', in *RIBA Transactions*, series 1, vol xvii (1866), pp39–56

2 Thomas Locke Worthington, Report on the housing of the working classes in Paris and some large provincial centres in France, RIBA Archive (1892)

3 ibid.

4 César Daly, *Architectures Privées au XIX Siècle, Nouvelles Maisons de Paris et des Environs*, drawing catalogues (1864)

5 Standard building lot size is 7.6 x 30 metres (25 x 100 feet). No system of back alleys was incorporated in the Manhattan grid. For a full discussion see M. C. Boyer, *Manhattan Manners* (New York: Rizzoli, 1985), chapter 2: 'The Inheritance of the Grid'.

6 Until 1875 dwellings that occupied the standard building lot were classified in three types: class one – single family private dwellings; class two – multi-family, three- or four-storey dwellings with one family per floor; and class three – tenements of four or five storeys with between eight and twenty families. The new categories introduced to deal with growing complexity were designated 'French flats' and 'hotels and boarding houses'. See E. Cromley, *Alone Together* (New York: Cornell University Press, 1990).

7 Andrew Saint, *Richard Norman Shaw* (New Haven and London: Yale University Press, 1976)

8 CIAM 1928 declaration, quoted in Kenneth Frampton, *Modern Architecture* (London: Thames and Hudson, 1992), p269

9 See exhibition catalogue *Henri Sauvage 1873–1932*, Archives d'architectures modernes, Brussels, 1978

10 Peter G. Rowe, *Modernity and Housing* (Cambridge, MA, and London: MIT Press, 1993), p48

11 Mies van der Rohe, 1925, quoted in Reyner Banham, *Theory and Design in the First Machine Age* (London: Architectural Press, 1960), p274

12 Sherban Cantacuzino, *Wells Coates: A Monograph* (Gordon Fraser, 1978)

13 As the Head of the Standardisation section of the Construction Committee for the Russian Republic, Ginsburg went on to develop many more standard dwelling types aimed at efficient production through prefabrication. See Milka Bliznakov, *Russian Housing in the Modern Age* (Cambridge: Cambridge University Press, 1993)

14 Alison and Peter Smithson, *Changing the Art of Inhabitation* (London: Artemis, 1994)

15 Brian Finnimore, *Houses from the Factory, System Building and the Welfare State* (London: Rivers Oram Press, 1989)

16 'Steel Houses at Northolt' in *Architectural Review*, February 1945

17 *Arts and Architecture*, July 1944

18 'The Style that Nearly' in *Architectural Review*, June 1993

19 Martin Pawley, 'Can we beat the Japanese at housing single people?' in *Building*, 1 February 1991

20 manchesteronline.co.uk/news, 1 August 2003

21 dailybruin.com/db/archivearticles

22 Lionel Esher, *A Broken Wave: The Rebuilding of England 1940–1980* (London: Allen Lane, 1981), p296

23 Introduction, *Living in the City: An Urban Renaissance* (London: The Architecture Foundation, 2000)

24 *Sky High: Vertical Architecture* (London: Royal Academy of Arts, 2003)

25 *Building Journal*, Hong Kong, April 1999

26 Aldo Rossi, *The Architecture of the City* (Cambridge, MA: MIT Press, 1982), p70

27 Rossi's categorizations are (i) a block of houses surrounded by open space; (ii) a block of houses connected to each other and facing the street, constituting a continuous wall parallel to the street itself; (iii) a deep block of houses that almost totally occupies the available space; (iv) houses with closed courts and small interior structures. Rossi, p49.

Selected bibliography

Alpern Andrew: *Apartments for the Affluent: A Historical Survey of Buildings in New York* (New York: McGraw-Hill Book Company, 1975)

Banham Reyner: *Theory and Design in the First Machine Age* (London: The Architectural Press, 1960)

Beattie Susan: *A Revolution in London Housing* (London: Greater London Council/The Architectural Press, 1980)

Bliznakov Milka: *Russian Housing in the Modern Age* (Cambridge: Cambridge University Press, 1993)

Boyer M. Christine: *Manhattan Manners* (New York: Rizzoli International Publications, Inc., 1985)

Brayer Marie-Ange and Simonot, Beatrice: *Archilab's Futurehouse: Radical Experiments in Living Space* (London: Thames & Hudson, 2002)

Cantacuzino Sherban: *Wells Coates: A Monograph* (Gordon Fraser, 1978)

Colquhoun Ian: *RIBA Book of 20th-Century British Housing* (London: Butterworth Heinemann, 1999)

Colquhoun, Ian and Fauset, Peter G.: Housing Design: *An International Perspective* (London: BT Batsford, 1991)

Cromley Elizabeth C.: *Alone Together: A History of New York's Early Apartments* (New York: Cornell University Press, 1990)

Esher Lionel: *A Broken Wave: The Rebuilding of England 1940–1980* (London: Allen Lane, 1981)

Evans Robin: *Rookeries and Model Dwellings in Translations from Drawing to Building and Other Essays*, AA Documents 2 (London: Architectural Association, 1997)

Finnimore Brian: *Houses from the Factory, System Building and the Welfare State* (London: Rivers Oram Press, 1989)

Gausa Manuel and Salazar, Jaime, eds: *Housing: New Alternatives, New Systems* (Actar: Barcelona, 2002)

Grinberg Donald I., with forward by J.B. Bakema: *Housing in the Netherlands 1900–1940* (Delft: Delft University Press, 1977)

Ibelings Hans: *20th Century Urban Design in the Netherlands* (Rotterdam: Nai Publishers, 1999)

Le Corbusier: *Towards A New Architecture*, original edition 1927 (London: The Architectural Press, 1946 edition)

Muthesius Stefan: *The English Terraced House* (New Haven and London: Yale University Press, 1982)

Rossi Aldo: *The Architecture of the City* (Cambridge, MA, and London: The MIT Press, 1982)

Rowe Peter G.: *Modernity and Housing* (Cambridge, MA, and London: The MIT Press, 1993)

Saint Andrew: *Richard Norman Shaw* (New Haven and London: Yale University Press, 1976)

Schittich Christian, ed.: *In Detail: High-Density Housing* (Basel: Birkhauser, 2004)

Sherwood Roger: *Modern Housing Prototypes* (Cambridge, MA, and London: Harvard University Press, 1978)

Smithson Alison and Peter: *Changing the Art of Inhabitation* (London: Artemis, 1994)

Schneider Friederick, ed.: *Floor Plan Manual: Housing* (Basel: Birkhauser, 2004)

Spier Steven, ed.: *Urban Visions, Experiencing and Envisioning the City* (Liverpool University Press and Tate Liverpool, 1993)

Tarn J.N.: *Working-class Housing in 19th-century Britain* (London: Architectural Association, Paper No 7, 1971)

Yorke F.R.S. and Gibberd, F.: *The Modern Flat*, original edition 1937 (London: The Architectural Press, 1948 edition)

Zukowsky John and Thorne, Martha, eds: *Skyscrapers: The New Millennium* (Munich: Prestel Verlag/Chicago: The Art Institute of Chicago, 2000)

Exhibition catalogues

Living in the City: An Urban Renaissance (London: The Architecture Foundation, 2000)

Berlin Modern Architecture (Berlin: The International Building Exhibition 1987, 1988)

Henri Sauvage 1873–1932 (Brussels: Archives d'architectures modernes, 1978)

Sky High: Vertical Architecture (London: Royal Academy of Arts, 2003)

Unpublished papers

Kerr Robert: 'On the problem of providing dwellings for the poor in towns', in *RIBA Transactions*, series 1, vol xvii, 1866

Muller Emile and du Mesnil, M. le Docteur: 'Report on the Construction and Sanitation of Model Dwellings' (extracts in Thomas Locke Worthington), Universal International Exhibition, Paris, 1889

Worthington Thomas Locke: 'Report on the housing of the working classes in Paris and some large provincial centres in France', RIBA Archive, 1892

Project credits

Schieflstätte Housing Complex
Graz, Austria
architect o.Univ. Prof. Arch. DI Karla Kowalski,
o.Univ. Prof. Arch. DI Michael Szyszkowitz
website www.szy-kow.at
project architect B.Arch.OAA Rolf Seifert
structural engineer DI Wendl, Graz
client Neue Heimat, Wastiangasse 7,
A-8010 Graz

Condensed Housing Development
Berlin, Germany
architect Léon Wohlhage Wernik Architekten,
Berlin
website www.leonwohlhagewernik.de
team Anne Kleinlein, Abdullah Motaleb,
Bettina Storch
client Wohnungsbaugesellschaft Marzahn,
Berlin
project management IMBAU Hamburg
(Contractor)

Nieuw Terbregge
Rotterdam, The Netherlands
architect Mecanoo architecten b.v., Delft
website www.mecanoo.nl
client Proper Stok Woningen b.v., Rotterdam
structural engineer Adviesburo J.J. Datema
b.v., Woudenberg
project management Proper Stok Woningen
b.v., Rotterdam
building physics consultant W/E Adviseurs
Duurzaam Bouwen, Gouda
main contractor HBG Woningbouw b.v. –
Volker Bouwmij., Rotterdam

Housing Block 16 x 68
Ljubljana, Slovenia
architect Rok Oman, udia MArch (AA)
& Spela Videcnik, udia MArch (AA)
website www.ofis-a.si
investor LB Hipo, IMOS Engineering,
Vegrad Engineering
technical engineering Biro 71, Ljubljana

In-between Terrace
Whatcott's Yard, London, UK
architect/developer/contractor A. Riches,
S. Ullmayer, B. Garibaldi
structure Birdwood Trembath Associates
Structural Design
mechanical Camtech
groundworks Stag Civil Engineering
timber frame first fix Wilkinson Builders
parallam façade Moca lab
sedum roof Erisco Bauder/E.J. Roberts
Roofing

Stuivesantplein Housing
Tilburg, The Netherlands
architect Erick van Egeraat, Monica Adams
website www.eea-architects.com
project team Gerben Vos, Ard Buijsen, Joep
van Etten, Kerstin Hahn, Birgit Jürgenhake,
Colette Niemeijer, Stefanie Schleich

Yoakum Street Town Houses
Houston, Texas, USA
client and builder Tribus, Inc., Houston, Texas
architect Wittenberg Partnership, Architects,
Houston, Texas
website www.wittenbergpartnership.com

Housing on the Shore of Lake Gooi
Huizen, The Netherlands
team Willem Jan Neutelings, Michiel Riedijk,
Willem Bruijn, Evert Kolpa, Tania Ally, Gerrit
Schilder, Lennaart Sirag, Bas Suijkerbuijk
client Bouwfonds Wonen Noord-West,
Haarlem
**technical design and construction
consultancy** Bureau Bouwkunde, Rotterdam
structure phase 1, Ingenieursgroep van
Rossum, Amsterdam; phase 2, Bierhaus
Konstrukteurs, Rotterdam
contractor Coen Hagedoorn Bouw bv, Huizen

Westfield Student Village
Queen Mary College, London, UK
architect Feilden Clegg Bradley Architects LLP
client Queen Mary, University of London
contractor Laing O'Rourke Construction
structural engineer Adams Kara Taylor
m & e engineer Max Fordham LLP
acoustic engineer Paul Gillieron Acoustic
Design
building control officer Rexon Day
quantity surveyor Turner & Townsend
planning supervisor Turner & Townsend
cdm Turner & Townsend

La Maquinista
Barcelona, Spain
project team Jordi Pagès (project leader),
Jaume Avellaneda, Marc Camallonga, David
Carim, Virginia Daroca, Luis Falcón, Rafael
Franco, Anna Llimona, Alexis López, Xavier
Monclús, Yolanda Olmo, Marta Poch, Ursula
Schneider, Maria Viñé, Beatriz Würst
website www.mateo-maparchitect.com
client Inmobiliaria Colonial
builder Ferrovial-Agromán/ Guinovart-OSHSA
surveyor Josep M. Forteza, Joan Gurri
landscaping Manuel Colominas
structural engineer Manuel Arguijo

High Cross Road
London, UK
architect Walter Menteth Architects
(Walter Menteth, Nick Hill, Larissa Johnston)
website www.menteth.co.uk
Client Ujima Housing Association Ltd.
structural engineering Barton Engineers
quantity surveyor Corrigan Gore and Partners
services consultant Pearce and Associates
main contractor LAD Construction Ltd.

Dwellings for Young People
Leipzig, Germany
architect HPP Hentrich-Petschnigg & Partner
KG, Leipzig
website www.hpp.com
client Wohnungsbau-Genossenschaft
Kontakt e.G., Leipzig
partner Dipl.-Ing. Gerd Heise, BDA
project manager Dipl.-Ing. Clemens
Woltereck
technical equipment IKL & Partner
Ingenieurgesellschaft mbH, Leipzig
structural engineer Ingenieurbüro Fankhänel
& Müller, Leipzig
contractor Rochlitzer & Rübner GmbH,
Markkleeberg

Town House
Wimbergergasse, Vienna, Austria
project team Delugan_Meissl, Anke Goll,
Peter Döllmann, Christine Hax
website www.deluganmeissl.at
client Kallco Projekt
building contractor PORR AG, Vienna
artwork Herwig Kempinger (loggias),
Susanne Korab (underground car park),
Leo Zogmayr (foyer)
Susanne Dworzak-Kallinger (courtyard)
consultants DI. Schweiger (structural
consultant); Ing. Ernst (heating/ventilation/
plumbing); Ing. M. Künzl (electrical
planning); Dr. Schütz (air conditioning);
DI. Dworak (construction physics); Grainer,
Rohrbach (façade); Eckelt, Steyr (glass
loggia); DI. Johann Wöss, Vienna (surface
water drainage): Kone, Vienna (elevators)

Mondrian Apartments
Sydney, Australia
architect Stanisic Associates
Frank Stanisic
Ben Giles
Adam Russell
Aleksander Jelicic
Jessie McNicoll
website www.stanisic.com.au
developer St Hilliers Developments
builder St Hilliers Constructions
landscape architect McGregor and Partners
structural engineer Van der Meer Bonser

Integrated Housing
Ingolstadt, Germany
architect Dipl. Ing. Andreas Meck, Architekt
BDA DWB
collaborators Dipl. Ing. Matthias Goetz, Dipl.
Ing. Michaela Busenkell, Dipl. Ing. Christoph
Engler, Dipl. Ing. Brigitte Moser
website www.meck-architekten.de
site supervision Andreas Meck, Dipl. Ing.
Architekt BDA with Klaus Greilich, Dipl. Ing.
Architekt
client Gemeinnützige Wohnungsbau-
Gesellschaft Ingolstadt GmbH

Harold Way Apartments
Hollywood, California, USA
owner Hollywood Community Housing
Corporation, Hollywood, CA
architect Koning Eizenberg Architecture,
Santa Monica, CA
website www.kearch.com
principals in charge Julie Eizenberg, AIA;
Hank Koning, FAIA
project architect/manager Brian Lane, RA
project team Roderick Villafranca, Eleanor
O'Neill, Erin Mclaughlin
structural engineer Parker-Resnick Structural
Engineering
mechanical and electrical engineer
Helfman\Haloossim & Associates
civil engineer Robert K. Kameoka, RCE
landscape architect Dry Design
contractor Fassberg Construction

Donnybrook Quarter
London, UK
architect Peter Barber Architects, Peter
Barber, Phil Hamilton, Jan Kattein, Chee Kit
Lai, Chrysanthi Staikopoulou, Emmanuel
Vercruysse, Peter Mueller, Gemma Noakes
website www.peterbarberarchitects.com
builder Wilmott Dixon
client Circle Anglia Housing Association

Estradenhaus
Berlin, Germany
client Wolfram Popp, Berlin
architect Wolfram Popp Architekt BDA; popp
planungen
website www.popp-planungen.de
engineers Dipl. Ing. Johann Schneider,
Bauingenieurbüro Berlin (structural design),
Dipl. Ing. Uwe Hannemann, IbW
Ingenieurbüro Berlin (building services)

Rue Pelleport apartments
Paris, France
architect Frédéric Borel Architecte, Paris
website www.fredericborel.fr

Alfonso Reyes 58 Apartments
Mexico City, Mexico
architect Dellekamp Arquitectos
website www.dellekamparq.com
principal in charge Derek Dellekamp
project team Alejandro Santillanes, Honore
Carmona, Juan Pablo Wolffer, Erick Mass
structural engineer Ingeniería Integral
Internacional
installations Sergio Tapia García
general contractor MSG Arquitectura Diseño y
Planeación
façade contractor Tactsa Val y Val
structural contractor ESISA

Simmons Hall
MIT, Cambridge, Massachusetts, USA
client Massachusetts Institute of Technology
design architect Steven Holl, Timothy Bade
website www.stevenholl.com
project architect Timothy Bade
assistant project architects Ziad Jameleddine,
Anderson Lee
project team Peter Burns, Gabriela Barman-
Kramer , Makram elKadi, Annette
Goderbauer, Mimi Hoang, Ziad Jameleddine,
Matt Johnson, Erik Langdalen, Anderson Lee,
Ron-Hui Lin, Stephen O'Dell, Christian
Wassmann
associate architect/architect-of-record
Perry Dean Rogers | Partners, Boston
design team Charles Rogers, Peter
Ringenbach (Partners in Charge), Michael
Waters (Project Architect), Jeff Fishbein,
Samantha Pearson, Brent Stringfellow, Gerry
Gutierrez, Brad Prestbo, Alejandro Soto,
Mark Wintringer (Project Team)
design structural engineer Guy Nordenson
and Associates
project engineer Christopher Diamond
structural engineer of record Simpson
Gumpertz & Heger Inc.
partner James Parker
mechanical engineer Ove Arup & Partners,
New York and Cambridge
lighting design Fisher Marantz Stone
contractor Daniel O'Connell's Sons,
Holyoke, MA
construction manager Dennis Cavanaugh,
Alan Harwood
precast concrete Beton Bolduc, Ste-Marie,
Quebec, Canada (Yvonne Bolduc,
Charles Theriault, Michel Martin)
cast-in-place concrete S&F Concrete
Corporation, Hudson, MA
concrete supplier Aggregate Industries
rebar Harris Rebar
rebar installer Bartlund
windows Wausau
cabinetwork and custom woodwork Beaubois
atrium furniture Schmidinger Modul
custom-designed student room furniture
Bludot

Yerba Buena Lofts
San Francisco, California, USA
design Stanley Saitowitz/Natoma Architects,
Inc.
website www.saitowitz.com
structural Watry Design Group
acoustic Charles M. Salter Associates
general contractor Pankow Residential
Builders

Housing in Auwiesen
Winterthur, Switzerland
client Gesellschaft für Erstellung billiger
Wohnhäuser in Winterthur
project management Sulzer Immobilien AG;
Winterthur
architect Werner Kreis, Ueli Schaad, Peter
Schaad, Zürich
website www.kreis-schaad-schaad.ch
project architect Markus Gresch
assistants Angelica Crola, Martin Hug
structural engineer IEP, Ingenieurbüro Eng +
Partner AG; Olten
quantity surveyor/site management Ruedi
Dürsteler Bauleitungen, Winterthur

D Residential Building
Venice, Italy
architect Cino Zucchi, Alessandro Acerbi,
Ida Origgi, Franco Tagliabue, Federico Tranfa
with Natascha Heil, Gaudia Lucchini,
Anna Morandi, Luca Zaniboni
website www.zucchiarchitetti.com
client Judeca Nova spa
field assistant Paolo De Luigi-Systematica srl
construction Flli Carnieletto costruzioni

Apartment Building Gasometer B
Vienna, Austria
planning COOP HIMMELB(L)AU, Wolf D. Prix,
Helmut Swiczinsky + Partner
website www.coop-himmelblau.at
project architect Sepp Weichenberger
project team Rainer Enk, Stefan Fussenegger,
Friedrich Hähle, Stefan Hochstrasser, Ronald
Kesmann, Georg Kolmayr, Martin Mostböck,
Markus Pillhofer, Karolin Schmidbaur
model builders Ana-Claudia Gonzalez, Walid
Kanj, Napoleon Merana, Giulio Polita
client WBV Wohnbauvereinigung für
Privatangestellte, Vienna, Austria
structural engineering Fritsch-Chiari, Vienna,
Austria
hvac + acoustics Dr. Pfeiler GmbH, Graz,
Austria and Dipl. Ing. Pacher, Vienna, Austria
lighting consultant Kress & Adams, Köln,
Germany
elevator consultant Otis GmbH, Vienna,
Austria
mall consultant BDG/McColl, London, UK

**CODAN Shinonome Canal Court Centre
Block, Block 1**
Koto-ku, Tokyo, Japan
architects Riken Yamamoto & Field Shop +
Urban Development Corporation +
JV of Mitsui, Konoike, and Dai Nippon
Construction
website www.riken-yamamoto.co.jp
structural engineers Takumi Orimoto
Structural Engineer & Associates + Urban
development corporation + JV of Mitsui,
Konoike, and Dai Nippon Construction
mechanical engineers Sogo Consultants,
Environmental Equipment + Urban
development corporation + JV of Mitsui,
Konoike, and Dai Nippon Construction
general contractors JV of Mitsui, Konoike,
and Dai Nippon Construction

Schots 1 + 2
Groningen, The Netherlands
architect S333 Architecture + Urbanism bv
website www.s333.org
S333 project team Burton Hamfelt, Chris
Moller, Dominic Papa, Jonathan Woodroffe
with Hotao Chow, Stig Gothelf,
Zvonimir Prlic, Jacob Sand, Line Thorup
Schultz, Melanda Slemint, Fabien van
Tomme, Francesca Wunderle
client Development consortium IMA: ING
Vastgoed, Amstelland Ontwikkeling,
Bouwbedrijf MoesBV, Amvest Vastgoed and
Nijestee Vastgoed
public space Alsop Architects, London, UK

173 Perry Street/165 Charles Street
New York, USA
Perry Street:
client West Perry, LLC
architect Richard Meier & Partners
Architects LLP
website www.RichardMeier.com
principals in charge Richard Meier,
Donald Cox
project architect Carlos Tan
project team Chris Ford, Kevin Hamlett,
Kevin Lee, Hans Put, Adrian Ulrich
structural engineer Robert Silman &
Associates
mep engineer Ambrosino, DePinto &
Schmieder
landscape architect Zion Breen & Richardson
Associates
lighting consultant Fisher Marantz Stone
energy consultant Ove Arup & Partners
acoustical consultant Arup Acoustics
curtainwall consultant Gordon H. Smith
Corporation
curtainwall engineer Enclos Corporation
architectural concrete consultant Reginald D.
Hough Architect
elevator consultant Lerch Bates & Associates
zoning consultant Development Consulting
Services
expeditor Metropolis Group
building graphics Vignelli Associates
general contractor Gotham Construction
Corporation

Charles Street:
Architect Richard Meier & Partners
Architects LLP
website www.RichardMeier.com
principals in charge Richard Meier,
Bernhard Karpf
design partner Don Cox
project manager/project architect Carlos Tan
job captain/project architect Kevin Lee
collaborators Clay Collier, Michael O'Boyle,
Gil Evan-Tsur, Hyunjoon Yoo, Aaron
Himmelfarb, Milton Lam
developers Alexico Management Group, Inc.
Development, Izak Senbahar and Simon Elias
graphic designer Vignelli Associates
sales agent The Sunshine Group, Ltd.
general contractor Bovis Lend Lease
structural engineer Arup
mechanical engineer Ambrosino, DePinto &
Schmieder
electrical engineer Ambrosino, DePinto &
Schmieder
façade consultant Ava Shypula Consulting, Inc.
lighting consultant Fisher Maranz Stone, Inc.
acoustic consultant Shen Milsom Wilke
landscape architect Zion Breen & Richardson
Associates
zoning consultant Development Consulting
Services
expeditor Construction Consulting
Associates
elevator consultant Jenkins & Huntington

Contemporaine
Chicago, Illinois, USA
project team Perkins + Will, architecture
Ralph Johnson, Design Principal
Dave Gutierrez, Project Manager
Nicol Chervenak, Project Manager
Fereidoon Afshari, Technical Principal
Bryan Schabel, Project Designer
Marius Ronnet, Project Architect
Raymond Coleman, Specifications
additional team members Curt Behnke,
Cengiz Yetken, Nicolete Daly, Steve Santucci
structural engineering C.E. Anderson &
Associates
mep and fire protection McGuire Engineers
civil engineering Terra Engineering
mechanical design build contractor AMS
Mechanical systems
electrical design build contractor New Aspen
Electric
plumbing design build contractor C.J. Erikson
Plumbing Co.
fire protection design build contractor US Fire
Protection Illinois, Inc.

Housing Tower
Munich, Germany
client Montos, Munich/Cologne, Investa
Unternehmensgruppe and Bauconsult
GmbH
team Professor Otto Steidle with
Johannes Ernst, Siegwart Geiger, Xaver Moll,
Audrey Shimomura, Georg Thiersch
Astrid Dycka, Tanja Gerst
website www.steidle-partner.de
workshop competition Prof. Otto Steidle
with Johann Spengler, Johannes Ernst,
Tom Repper, Audrey Shimomoura, Michael
Guggenbichler
colour concept Erich Wiesner, Berlin
light design Ingo Maurer GmbH, Munich
landscape design Aubück + Karasz, Wein
construction engineering Seeberger Friedl +
Partner, Munich, Hochtief Construction AG
Munich
installation engineering Schurtz +
Lommatzsch GbR, Munich
general contractor Hochtief Construction AG
Munich

Flower Tower
Paris, France
architect Edouard François
website www.edouardfrancois.com
client OPAC de Paris
contractor Leon Grosse

Apartments
Maia, Porto, Portugal
architect Eduardo Souto de Moura
client Sr. Ribeiro
collaborators Tomás Neves, José Carlos
Mariano
structural/electrical/mechanical consultant
Enarte – Engenharia e Arquitectura, Lda.
general contractor Ribeiro de Sousa & Silva
Correia, Lda.
landscape design Laura Costa

Macquarie Street Apartments
Sydney, Australia
architect Renzo Piano Building Workshop
website www.rpbw.com
client Lend Lease Development
consultants Ove Arup & Partners, Lend Lease
Design Group, Taylor Thomson Whitting,
Group GSA Pty Ltd

Social Dwellings
Lakua, Vitoria, Spain
architect Roberto Ercilla, Miguel Angel
Campo, Francisco Mangado
site management Roberto Ercilla, Miguel
Angel Campo
collaborators
Eduardo Martín, Architect (structural
calculation)
Ana Aizpuru, Architect (site coordinator)
Javier Valdivielso, Architect (technical)
Javier Acilo, Architect (technical)
developer Visesa, Vivienda y Suelo de Euskadi
S.A.
construction Lagunketa S.A.

Sejima Wing, Kitagata Apartments
Gifu Prefecture, Japan
architect Kazuyo Sejima & Associates
website www.sanaa.co.jp
team Kazuyo Sejima, Ryue Nishizawa,
Kouichirou Tokimori
client Gifu Prefecture
structural engineer O. R. S. Office
mechanical engineer Yamasei Design Ltd.

Mirador Apartments
Madrid, Spain
client EMV del Ayuntamiento de Madrid
architect MVRDV, Rotterdam + Blanca Lleó
asociados, Madrid
team
MVRDV: Winy Maas, Jacob van Rijs and
Nathalie de Vries with Ignacio Borrego, Stefan
Witteman, Pedro García Martinez, Gabriela
Bojalil, Antonio Lloveras, Nieves Mestre,
Marjolijn Guldemond, Fabien Mazenc,
Dagmar Niecke, Renzo Leeghwater, Florian
Jenewein
Blanca Lleó asociados: Blanca Lleó, Ignacio
Borrego, Maria Espinosa, Helena Aguilar,
Beatriz Fierro, Miguel Tejada, Juan Andrés
Antolin, Maria Gonzáles Campo
technical architect Enrique Gil, Apartec
Colegiados S.L.
structural advisor Jesús Jiménez, NB35

Photographic credits

192

8bl	Reproduced by permission of English Heritage. NMR
10bl	Museum of the City of New York, Von Urban Collection
11tl	City of London, London Metropolitan Archives
12bl	Musei Civici, Como
13tl & br	Fonds Sauvage, 18 Ifa, Direction des Archives de France/Cité de l'architecture et du patrimoine/Archives d'architecture du XXe siècle
14t	© DACS 2006
14b	© DACS 2006
15tl	© ADAGP, Paris and DACS, London 2006
15tr	Morley von Sternberg
17 tl	Fredrika Lökholm
17 br	Chicago Historical Society
18	RIBA Library Photographs Collection
19	Bill Tingey/arcaid.co.uk
20	Martin Charles
21	Anthony Ng Architects Ltd
23	Amsterdam City Archives (photographer: Jan Zeegers)
24tr	Bildarchiv Foto Marburg
24bl	Hilary French
25bl	Balthasar Burkhard
26–29	Szyszkowitz.Kowalski
30–37	Christian Richters
38–39	Tomaz Gregoric
40–43	Killian O'Sullivan, Karoline Mayer, Julian Cornish
44–45	Christian Richters
46–49	Evans Wittenberg
50–51	Hisao Suzuki
53	Jeroen Musch
55	RIBA Library Photographs Collection
56t	Museum of the City of New York, Wurts Collection
57b	Museum of the City of New York, Print Archives
58	R.M. Schindler Collection, Architecture & Design Collection, University Art Museum, University of California, Santa Barbara
59tl	The Builder Group
59tr	PRP Architects
60–61, 63	© Peter Cook/VIEW
62t	Fredrika Lökholm
64t	© X. Basiana & J. Orpinell
65b	Xavier Ribas
66–67	© X. Basiana & J. Orpinell
68–71	Andy Keates
72–75	Punctum Hans-Christian Schink, Leipzig
76t	Delugan_Meissl
77–79	Margherita Spiluttini
80–85	Brett Boardman Photography
86–89	Dittmann & Dittmann
90–93	© Benny Chan/Fotoworks
94–95	Morley Von Sternberg
97t	Anderson & Low, London
97b	© FLC/ADAGP, Paris and DACS, London 2006
98	AP Archive/ RIBA Library Photographs Collection
99	© FLC/ADAGP, Paris and DACS, London 2006
100t	Stefan Meyer
100br	Isabel Simon
101–03	Stefan Meyer
104–07	Nicolas Borel
108–11	Oscar Necoechea
112t	Andy Ryan Photography, Inc.
113–17	Paul Warchol Photography, Inc.
118–23	Tim Griffith
124–27	Atelier H7, Winterthur and Kreis Schaad Schaad
128tl	Cino Zucchi
129	Piero Savorelli
130bl	Cino Zucchi
131	Piero Savorelli
132tl	Peter Korrak
133	Gerald Zugmann
135t	Alexandra Koller
135b	Toni Rappersberger
136t	Riken Yamamoto & Field Shop
137t	Riken Yamamoto & Field Shop
137b	Tomio Ohashi
138	Riken Yamamoto & Field Shop
139tr	Nacasa & Partners, Inc.
140–45	Jan Bitter
147t	©Georges Fessy
147b	Philippe Ruault/© ADAGP, Paris and DACS, London 2006
149	RIBA Library Photographs Collection
150t	Edward Sudentas. Wired New York
151	Richard Schulman
152t & 153	Courtesy Richard Meier & Partners LLP/dbox
154–57	© 2004 JRS @ Steinkamp/Ballogg Photography, Chicago
158t	Franziska von Gagern
158bl	Johannes Ernst, Steidle + Partner
159	Tommy Lösch–Black Box
160t	Stefan Müller-Naumann
162–65	© Paul Raftery/VIEW
166–69	Duccio Malagamba
170t	John Gollings
171	Martin van der Wal
172tl & tr	Martin van der Wal
173	Martin van der Wal
174–77	César San Millán
178–81	Shinkenchiku-sha/The Japan Architect Co., Ltd.
182–85	© www.rob-thart.nl

Drawing credits

Plans, sections and elevations of the individual case studies are generally as provided by the architects. All other drawings, including site plans and historical examples in the introduction and chapter introductions, have been drawn by the author from information supplied by the architects, published in architectural journals or based on information in the publications listed in the bibliography. Every effort has been made to ensure accuracy in the drawings.

Thanks to Samson Adjei, Jolanta Dzikowska, Nicholas Evans, Kathryn Hewitt, Yan-ki Lee and Zoe Lewis.

Author acknowledgements

Thanks to Philip Cooper, Liz Faber and Kim Sinclair at Laurence King, and to picture researcher Fredrika Lökholm and designer Mark Vernon-Jones.